D1095401

Liz Wilhide and Susie Hodge

The Great Pottery Throw Down

Based on a BBC Programme **B|B|C**

The Great Pottery Throw Down

The Great Pottery Throw Down is a BBC TV series that fuses an investigation into one of the oldest creative art forms with a lively and competitive contest. Over its episodes, the programme compellingly explores the emotions and endeavour of ten accomplished, creative and ambitious home ceramicists working together in a studio in Stoke-on-Trent in Staffordshire, the home of British pottery. Each week, viewers learn about the rich and diverse history of pottery as well as the ideas and skills of the contestants, the personal difficulties and anxieties they experience, and all that goes into the making of ceramics that we all use every day.

Personable radio DJ Sara Cox presents the show, empathetically bringing together the contestants and the expert judges, Kate Malone and Keith Brymer Jones. Known for her large sculptural vessels and bright glazes, Kate Malone is a London-based studio potter and ceramic artist, while Keith Brymer Jones has become renowned for his retro-style Word Range homeware. However, it is the readiness with which he sheds a tear at contestants' work that has especially endeared him to viewers.

Selected from across the UK, the ten potters bring a diversity of talent and experience to the programme, undertaking a succession of technical and creative projects to ultimately win the coveted title of Top Potter. Through

tension, humour, pathos and unpredictability, each programme reveals the individual talents of the contestants and the expertise, creativity and science behind successful ceramic production. Overall, it is a fascinating insight into an international art form that originated in around 30,000 BCE, and has become an indispensable aspect of all human existence ever since. After watching, suddenly, a humble egg cup takes on the air of a great work of art; a toilet bowl demands a new respect.

Unless you're a potter, the art of throwing, decorating and firing pots is unfamiliar, a mystery, almost akin to the secrecies of medieval alchemy. Yet ceramics – or pottery – is an intrinsic everyday part of all our lives. Clay is a remarkable medium that, upon being shaped and heated at high temperatures, is permanently changed. It can be pushed to its limits by a clever ceramicist.

A good potter combines artistic quality with industrial processes, a commitment to experimentation and expression, and a certain understanding of both science and art. With clay being one of the first materials used for practical purposes, the history of ceramic art is fundamental to the history of human development. For at least 30,000 years, it has been moulded, thrown, fired, decorated and glazed. Different cultures have invented various processes, mixtures and methods using both clays and glazes, a range of temperatures and many techniques, resulting in an incredible range and variety of objects.

This book takes you through all this, including investigating pottery's vast heritage, considering its broad international interpretations over centuries and continents, introducing some of the greatest ceramicists, major styles, influences, artistry and technicalities, and the steps involved in various basic and more advanced methods. It is an informative, accessible and lively exploration into one of the world's most fascinating and tactile forms of art.

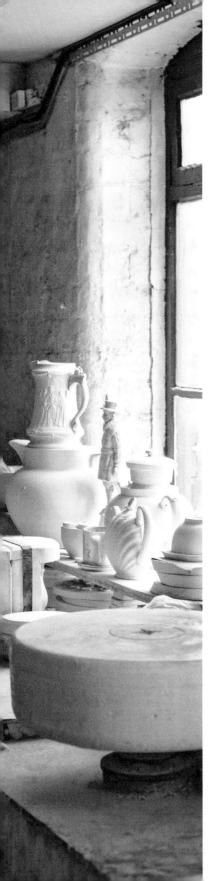

First published in the United Kingdom in 2017 by
Pavilion
43 Great Ormond Street
London
WC1N 3HZ

ISBN 978-1-91121-642-1

A CIP catalogue record for this book is available from the
British Library.

10 9 8 7 6 5 4 3 2 1

Reproduction by Mission Productions Ltd, Hong Kong
Printed and bound by GPS Group, Slovenia

This book can be ordered direct from the publisher at
www.pavilionbooks.com

Executive Producers: Sarah Thomson-Woolley and
Richard McKerrow.
Director of Legal and Commercial Affairs: Rupert Frisby
BBC Commissioning Executives: Maxine Watson and
Clare Patterson
Special thanks to Elliott Gerner and Clair Carney

Contents

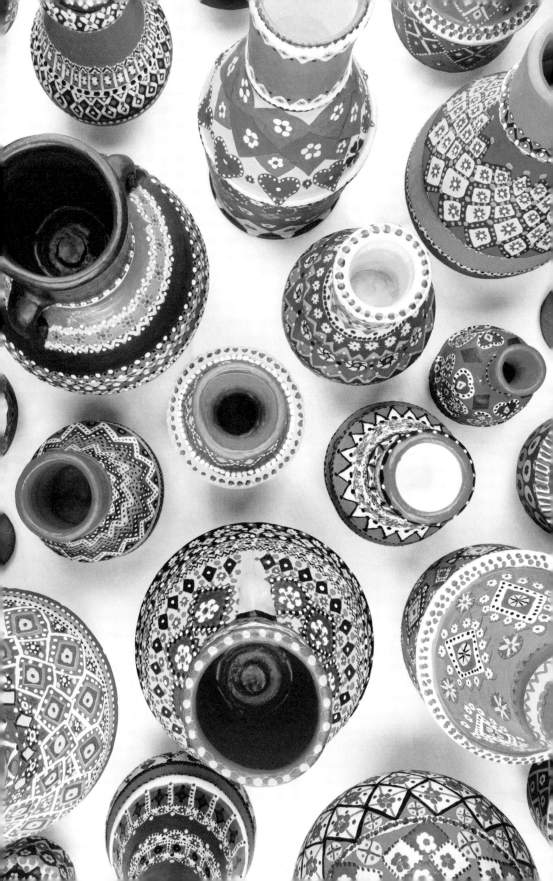

Introduction

In an increasingly virtual and standardized world, there is something immensely satisfying about working with clay. Shaping the raw material connects us to the subtle intelligence in our hands, and to a heightened awareness of the role of touch. Learning the skills of coiling, slabbing and throwing brings alive techniques that have been practised for thousands and thousands of years. Decorating with slips, glazes and textural effects meets an age-old human need to put an individual stamp on our surroundings. It is a grounding experience – literally – as we explore a material that comes from the earth we stand on.

If malleability is one of the defining characteristics of clay – its ability to be manipulated into an infinite variety of shapes and forms, limited solely by the imagination – it is only the start of the story. When clay is subjected to intense heat, it becomes transformed into something permanent and unalterable that has the potential to last for years. With the application of glazes and other decorative elements, the scope for creative expression is greater still.

Like many crafts, pottery is enjoying a resurgence of popularity. Workshops and evening classes are full of enthusiastic amateurs eager to be shown the ropes. Studio ceramicists revive old techniques, experiment with new ones, and produce one-off distinctive wares for which there is an increasingly ready market. Tapping into this lively renewal of interest in hand-making, *The Great Pottery Throw Down* offers a journey of inspiration for contestants and viewers alike.

Yet for all its meditative qualities, working with ceramics undoubtedly has its inherent challenges – not to say frustrations. Long before the heart-stopping moment when the kiln is finally opened, before there is the chance to see whether firing has wrought its magical alchemy or brought crushing disappointment, there are many hurdles to overcome and skills to perfect. And because the entire process draws on such a broad range of diverse abilities, there is always room for improvement and always something new to discover. For every potter who is delighted to find they have an instinctive touch at the wheel, there is another who struggles long and hard to master throwing. Requiring dexterity and physical strength, delicacy and control, an eye for proportion and imaginative flair, ceramics makes a broad range of demands on its practitioners and that is one of its enduring attractions.

Left: Ceramics allow for great creative expression
in both pattern making and sculptural form.

Even for experienced makers, unpredictability can still be the name of the game. Pottery involves taking into account many variables, some of which can be anticipated and to some degree controlled and others that can not. Those attracted to high-wire techniques such as raku and pit firing, for example, must embrace the unexpected and accept that breakage and failure is a price worth paying for the glorious, happy accident or the stunningly beautiful outcome.

'Have nothing in your houses that you do not know to be useful or believe to be beautiful', wrote William Morris in 1880. Here is another reason why pottery exerts such an appeal. Nothing could be more practical than the everyday objects that have accompanied domestic life for centuries – the earthenware cooking pots and drinking vessels, the bone china plates, bowls and jugs. And at the same time, such commonplace items have often been a source of pure delight, from the exquisite refinement of an antique porcelain vase to the cheery sight of an Art Deco tea service. Beauty and usefulness go hand in hand when it comes to ceramics. A teapot that pours properly and a handle that feels pleasant and right to grip are as much markers of successful design as a particularly lustrous glaze or a jaunty pattern.

Nowadays, there is also an increasing appreciation of ceramics as an art form in its own right. Grayson Perry (b.1960, see page 216), Antony Gormley (b.1950, see pages 212 and 214) and Edmund de Waal (b.1964, see page 198) are but three examples of those who have chosen ceramics as a medium for fine art.

If pottery is intimately bound up with both the domestic sphere and the rewarding pursuit of hand-making, it also roots us firmly in a tradition that stretches right back to prehistory. When we roll a coil of clay and build a pot, we are practising an ancient art that dates from the dawn of time. Almost all civilizations have made ceramics, as archaeological evidence has repeatedly demonstrated – 100,000 vases have been recorded from ancient Greece alone. Earthenware, stoneware and porcelain are the most common items found in digs the world over. Sometimes, in fact, the only evidence we have that a civilization has existed at all lies in the tantalizing pottery fragments it has left behind.

Right: Pottery is put out to dry in the sun beside the River Arno in the small Tuscan town of Capraia in 1950.

Overleaf: An Indian potter makes earthen diyas in Hyderabad, 2015. Diyas are oil lamps that are lit and placed around the home during the festival of Diwali.

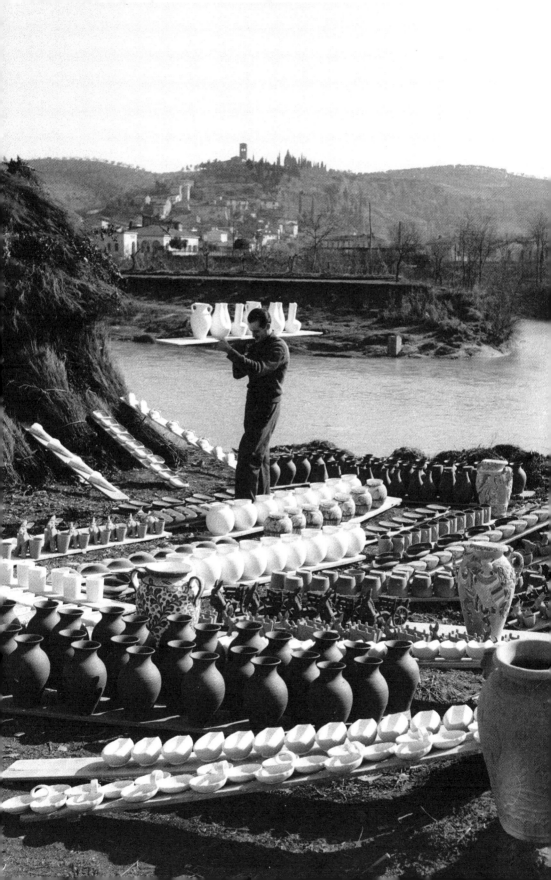

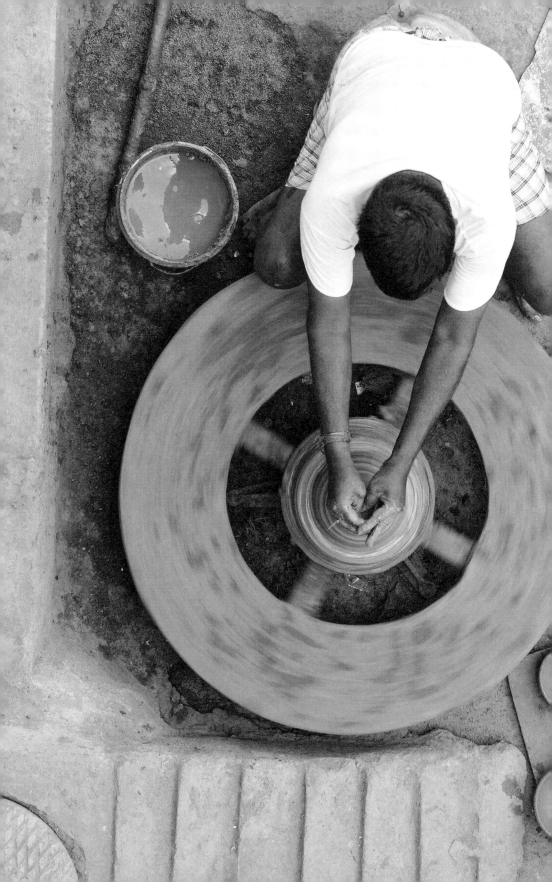

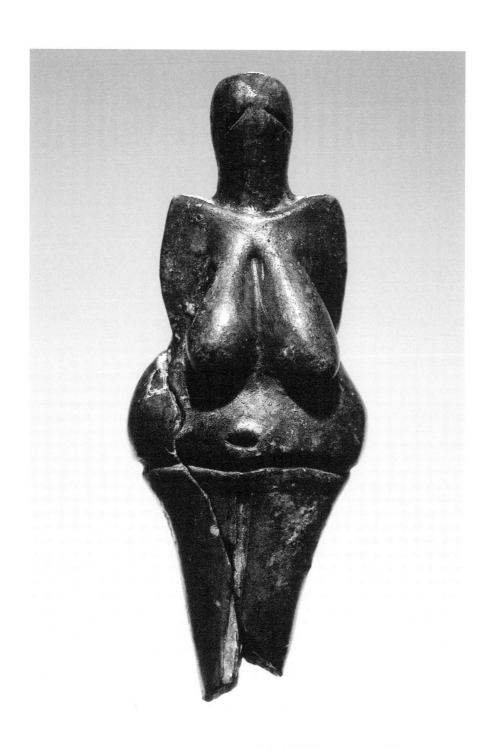

Paleolithic Venus statuette, of clay and bone
powder, from Dolní Vestonice, Czech Republic.

A Brief History

The history of ceramics is one marked by leaps of technical innovation, from the first time a pot was heated in a fire or thrown on a wheel, to the invention of porcelain. It is also a record of centuries of trade and influence, of cross-currents that span the globe, of jealously guarded manufacturing secrets and dogged experimentation. Over the years, in both form and decoration, ceramics have displayed the artistic visions of single makers or expressed a prevailing aesthetic style rooted in a historic period or a particular location. As such, they are powerful and evocative markers of changing taste.

The word 'ceramics' derives from the Greek *keramikos* meaning 'pottery'. But the practice of making figures, vessels and other objects out of clay goes back much, much further in time. Unlike other materials – wood, for example – pottery is durable, which is why so much survives from prehistoric times. Such finds have been unearthed all over the world, wherever there have been readily available deposits of clay, and they provide invaluable insights into the social and cultural practices of ancient civilizations in the absence of written records.

Prehistory

Among the oldest ceramic artefacts are clay figurines, such as the nude Venus statuettes, discovered in 1925 in the present-day Czech Republic, which are thought to date back to 29,000–25,000 BCE and whose significance, ritual or otherwise, is unknown. The oldest examples of pottery vessels, probably used for storing liquids, are Chinese and date from 20,000 BCE. In Japan, Jōmon pottery, Shōji so called after the rope-shaped impressions on the surface of the clay body (jōmon means 'cord-marked'), has been traced back to 14,000 BCE. Later, between 11,000 and 10,000 BCE, pottery also emerged independently in Africa and South America.

Prehistoric ceramics were chiefly made by coiling or winding long rolls of clay and smoothing them to create a vessel. Pinching and slabbing were other early shaping methods. Although glazing was as yet unknown, incised and other forms of textural decoration were not uncommon. At this early stage, pots were fired in bonfires; most of these vessels had rounded bottoms to prevent them from cracking in the intense heat. From the bonfire, it was a logical progression to pit or trench firing in holes dug in the ground, which allowed more control.

An important turning point in the history of ceramics was the invention of the potter's wheel, which emerged in Mesopotamia some time between 6,000 and 2,400 BCE, spreading from there along the trading routes to Eurasia and Africa.

This development coincided with improved kiln designs, which were able to reach higher temperatures. New types of ceramic objects, beyond cooking vessels and storage containers, proliferated.

Around the Mediterranean, ceramics also played an important role in the early cultures that predated the ancient civilizations of Greece and Rome. Both Minoan and Etruscan pots were often decorated with painted figures or representations of natural forms. Pithoi, or huge storage containers, have been unearthed at Minoan sites, notably on the Greek island of Santorini.

Ancient Greece

Ancient Greek civilization, dating from around 1,000 BCE to 400 CE, saw ceramics of all types reach new heights of beauty and sophistication. Geometric patterning, typical of early Greek ceramics, gave way to detailed representations of the human form engaged in a wide variety of everyday activities. Painted with slips in relief, rather than being glazed, and invariably thrown on the wheel, surviving examples provide a unique window into a vanished world.

Much of the Greek output were vessels designed for the practical purposes of storing wine, oil, perfume and water, and their shapes tended to remain unchanged over long periods of time. Distinct types were amphorae for wine storage, stemmed cups with handles for drinking, kraters for mixing water and wine, hydra for storing water, jugs, bowls, and jars for perfume and oils.

Although the types and shapes of the pottery vessels that were produced were relatively unmodified during this era, the styles in which they were decorated went through distinct changes over the course of the classical period. The earliest examples took the form of minimal geometric designs – circles, semicircles and horizontal lines – which matured into all-over geometric patterning. The Greek key or 'meander' design, used as a border, dates from this time. By 800 BCE stylized plants, animals and figures were beginning to appear, culminating in the black-figure pottery that was made from about 700 BCE onwards. With human figures represented in black, featuring details finely worked with engraving tools, such decoration depicted lively scenes from mythology and history. In red-figure pottery, which followed on from black-figure, the outlines of humans were painted in black slip. This late style of decoration reached new heights of representative realism, and scenes of everyday life were typical.

Right: Greek red-figure pottery reached a height of sophistication. This amphora depicts Heracles and the bull.

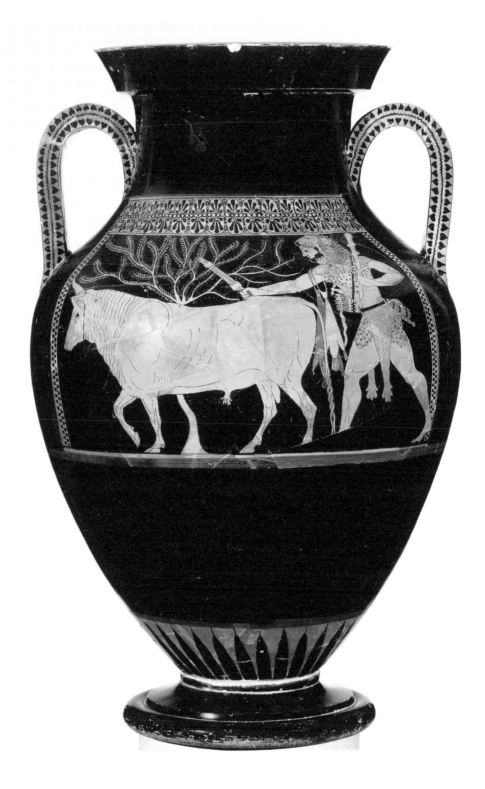

The Terracotta Army

At Xi'an in the northwest of China, the remains of more than 6,000 life-sized terracotta figures have been recovered in three vast trench-like pits. The Terracotta Army, first discovered in 1974, was buried with the first Emperor of China, Qin Shi Huang (c.259–210 BCE) in 210–209 BCE, and was intended to guard his tomb and protect him in the afterlife. Qin Shi Huang was famous for unifying many warring states into what became China, initiating the building of China's Great Wall, standardizing coins, weights and measures, and easing communication and travel across China by connecting many states with canals and roads.

The Terracotta Army is part of a 20-square mile (50-square km) burial compound.

Every one of the warriors is unique and intricately modelled; each one varies in height according to his role (generals are the tallest), and each wears armour and has individual hands, hair, facial features and expressions rendered in meticulous detail. Most of the warriors originally held real weapons, including swords, spears, scimitars, shields and crossbows. Because the pits have been only partially excavated, it is possible that more figures remain buried. Many others that are not warriors have also been found. So far, as well as the army, there are approximately 130 chariots, 670 horses and many non-military figures, including lively-looking acrobats, dancers and musicians, each contrasting with the rigid, warlike poses of the soldiers. Although the colours have

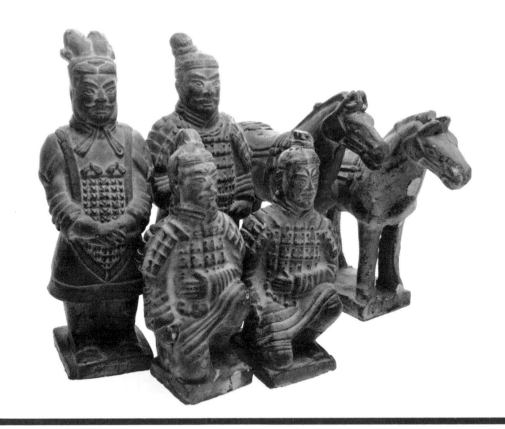

faded or flaked away, patches of different coloured paint remaining in places suggest that everything was once brightly painted.

The figures were made in workshops using local materials and moulds for different parts of the bodies, which were then constructed in an assembly-line process before being fired. It is believed that eight different face moulds were used for all the figures, with individual facial features built up after they had been assembled, using more clay with great sculptural skill. As each figure was completed, it was placed in the pit in precise military formation commensurate with its rank and duty.

According to the first great Chinese historian Sima Qian (c.145–c.87 BCE),

who wrote the history of China during the following Han Dynasty, Qin ordered his mausoleum to be constructed in 246 BCE when he was 13 years old, soon after ascending the throne. More than 700,000 labourers worked on the project, but a year after Qin's death, work on it stopped when the workers rebelled. So far, four pits have been partially excavated; three have been found to contain the terracotta soldiers, horse-drawn chariots, weapons and other figures, but the fourth is empty, apparently unfinished because of the insurrection after Qin's death.

Every one of the life-sized terracotta figures has different facial features and expressions.

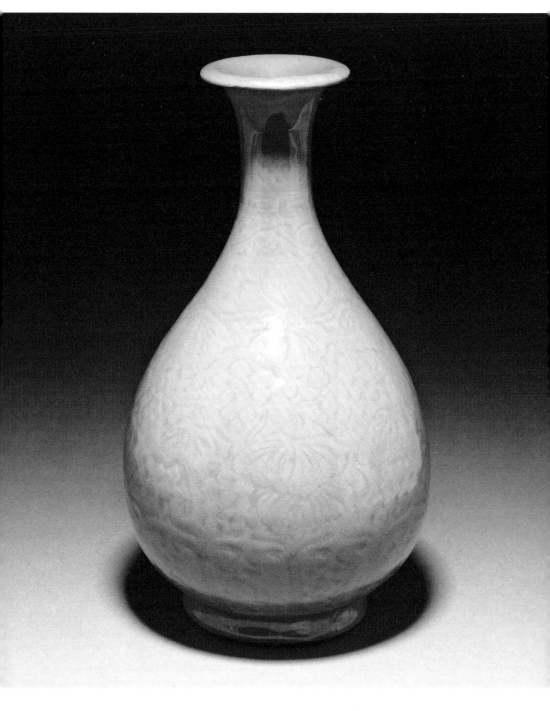

Celadon vase dating from the Ming Dynasty,
in the collection of the British Museum.

The Far East

One of the most significant chapters in the history of ceramics is the invention of porcelain. Although precise dates are unknown, it was believed to have been first made in China during the Eastern Han Dynasty (25–220 CE). Fired at much higher temperatures than earthenware, and made of kaolin clay, porcelain bodies were white, strong, hard and impervious. They also provided the perfect vehicle for glazing. The exact origins of glazing are unknown, but the first glazes were probably developed in China as a way to make earthenware impenetrable to moisture. With the development of porcelain, glazing as a decorative medium began to come into its own.

Early Chinese porcelain was either translucent white or glazed in celadon to imitate the appearance of jade, with the recipe for the blue-green glaze being jealously guarded. The chief centre for the production of celadon porcelain was the ancient state of Yue. By the Tang Dynasty (618–907 CE), tea drinking had become very popular in Chinese society and the demand for porcelain tea ware accordingly grew. Trade with the West also increased along the northern Silk Road during this period, which brought porcelain to the Middle East, where it became highly prized. In the kind of cross-cultural exchange that typifies the history of ceramics, it is thought that around this time cobalt was introduced from the Middle East to China, where it would become a defining element in the production of blue-and-white porcelain.

By the Song Dynasty (960–1279 CE), Jingdezhen in Jiangxi Province had been designated the imperial production centre for porcelain, a role it continued to play for the next 900 years as a result of the extensive kaolin deposits located near the town. But it was during the Ming Dynasty (1368–1644 CE) that blue-and-white Chinese porcelain reached a height of perfection. It had been discovered that adding manganese to the cobalt kept designs crisp and unblurred during the high temperatures of the porcelain firing. Both blue-and-white porcelain and ivory-white Dehua porcelain ('blanc de Chine') reached Europe during this period, launching a craze for the luxurious wares and a race to see who would be first to solve the mystery of how it was produced.

Japan had produced glazed pottery from an early date. During the sixteenth century the craft gained a new lease of life when Korean potters brought their skills and kiln designs into the country. Another significant development was the raku process (see page 90); the unassuming simplicity of the resulting rustic ware made it an essential element of the traditional tea ceremony (see page 142). Kakiemon wares, produced in Arita, were widely exported and imitated in the West, being prized for their vibrant colours and intricate decorations (see page 138).

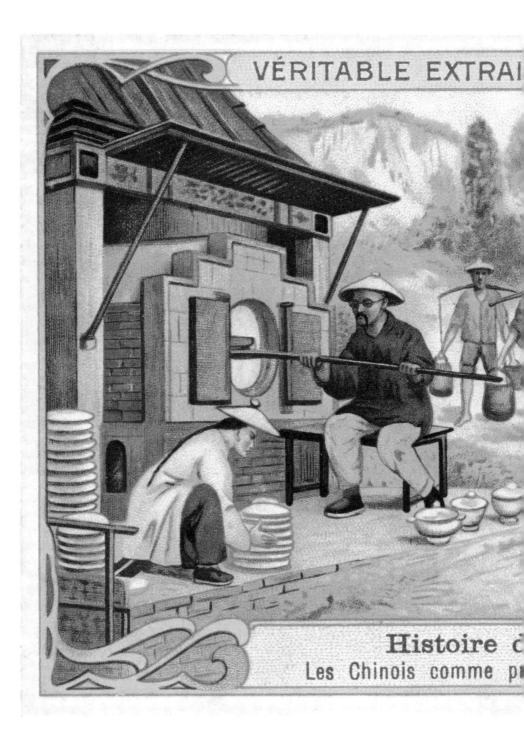

One of the popular, collectable 19th-century illustrated advertisements
for Liebig's Extract of Meat, this depicts the origins of porcelain.

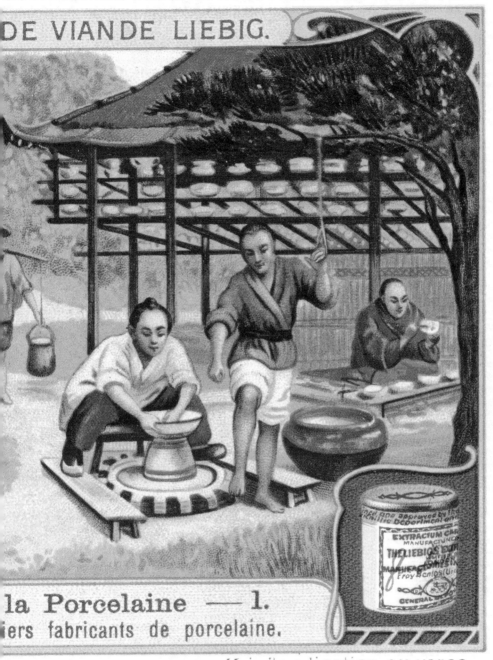

la Porcelaine — 1.

iers fabricants de porcelaine.

Voir l'explication au verso.

Islamic Pottery

Glazed bricks had been used as a form of wall decoration for thousands of years in Mesopotamia, a notable example being the Ishtar Gate of Babylon (575 BCE). After the spread of Islam across the region (which encompasses modern-day Iraq, together with parts of eastern Syria and southeastern Turkey), elaborate panels of glazed tiles became a particular feature of mosques.

Tin glazing, an invention of Islamic potters, dates back to eighth-century Iraq, where it was found that adding tin oxide rendered a glaze opaque white, providing an ideal base for decorative painting. Such a discovery was thought to have been prompted by the high prestige enjoyed by Chinese porcelain and a desire to imitate these expensive imports. A later development was lustreware, where metallic compounds mixed with clay are fired over the top of a previous glaze to produce iridescent finishes of great depth and beauty.

Later, during the Ottoman Empire (late thirteenth century to 1922), primarily from the latter part of the fifteenth century to the end of the seventeenth century, the Turkish town of Iznik became established as a centre of tile production. Iznik pottery displayed rich colours and an increasingly free type of decoration, based on floral motifs.

Trade and Influence

Trade, colonization and conquest spread ceramics techniques and styles around the world. So, too, did the design ideals of the Italian Renaissance, which permeated Europe throughout the fifteenth and sixteenth centuries.

In the thirteenth century the Moors had brought the technique of lustred tin glazing to southern Spain, specifically Malaga in Andalucia, where Islamic potters produced the widely admired lustred vases of the Alhambra, along with the geometric tiling that covered large surface areas of the palace. An extensive export trade developed from other Spanish centres and the technique (along with the wares) found its way to Italy, where it was termed maiolica.

By 1500, Italian maiolica was well established and displayed a range of colours; even the secret of lustre had somehow been learnt. No longer a poor imitation of Spanish imports, it was becoming increasingly sought after in its own right. Decoration became progressively sophisticated and often featured narrative scenes. The value placed on the wares can be judged by the fact that they were often exchanged as gifts among noble and influential families. The export market was not the only disseminator of ceramics styles and techniques: potters often travelled where their skills would be valued.

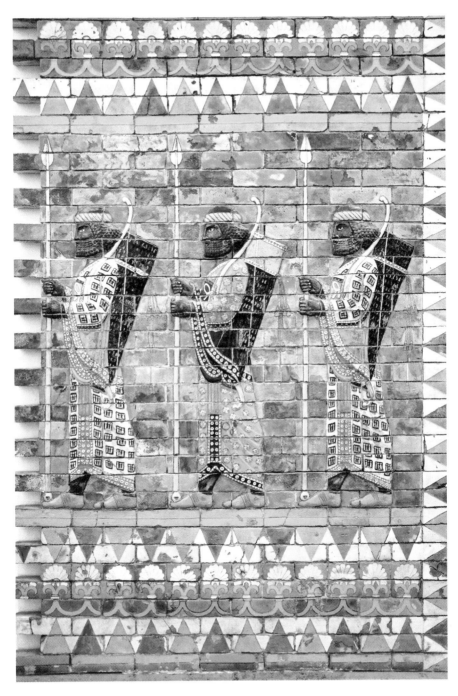

In c.575 BCE, King Nebuchadnezzar II ordered the building of the Ishtar Gate as the northern entrance to the city of Babylon. Featuring original bricks, this is a reproduction of the gate at the Pergamon Museum in Berlin.

Out of this type of creative cross-fertilization came the *azulejo* pictorial tile panels that became such a feature of first Spanish and then Portuguese ceramics; in due course, such tilework was produced in Spanish and Portuguese colonies in Central and South America. Similarly, by the early sixteenth century tin-glazed earthenware was being produced in the Low Countries, the skills having been brought there by Italian potters. This soon took on a more local character, evolving into what would become known as Delftware (see page 123), which, in turn, borrowed the motifs of Chinese porcelain. The Delft tradition travelled to England along with Flemish potters, whereas faïence, as tin-glazed earthenware was known in France, was also introduced by Italian makers.

The Birth of an Industry

While European potteries were evolving their distinctive styles, Chinese porcelain remained the ultimate prize. Widely coveted, yet hugely expensive, only the very wealthy could afford these luxurious imports.

The first European imitations of Chinese porcelain were soft-paste, and therefore not as durable and prone to cracking. When, in the early eighteenth century, Johann Friedrich Böttger (1682–1719) discovered how to make hard-paste porcelain at Meissen, near Dresden, he gave this royal factory an immense trade advantage (see page 71). Nevertheless, the secret began to leak out and by the end of the century Sèvres was Europe's leading producer of exquisite porcelain.

It was an English potter, Josiah Wedgwood (1730–95), however, who was responsible for leading ceramics production into the age of mass manufacturing. Wedgwood's popular Queen's ware, along with his development of jasperware and black basalt, products that typified the spirit of enquiry and technical experimentation of the age, came out at a time when a more settled and leisured middle class was beginning to emerge.

Before long, the particular area of north Staffordshire where Wedgwood set up his ground-breaking factory, Etruria (see page 26), had attracted other makers, such as Minton and Spode, and the seeds were sown for the development of the industrial heart of the ceramics industry: The Potteries. As the Industrial Revolution got underway, ceramics production dramatically increased in response to a growing market for household goods. Cheaper wares brought tea sets and dinner services within the financial reach of ordinary families for the first time.

Right: A catalogue page from the 1880s, illustrating Wedgwood
Jasperware patterned jugs, teapots and coffee pots.

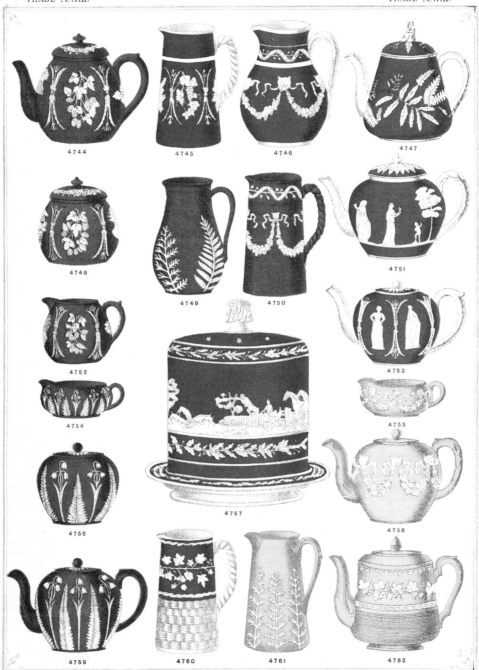

Etruria

Josiah Wedgwood (1730–95), founder of what is arguably the world's first global brand, launched his pottery business in 1759 in Burslem, Stoke-on-Trent, north Staffordshire. Less than ten years later, in the wake of the Europe-wide success of his Queen's ware, he was looking to expand and build new premises. After protracted negotiations, he secured a 350-acre rural site, the Ridge House Estate, in 1767. A section of the proposed Grand Trunk Canal (later known as the Trent and Mersey Canal) was planned to run through the site. Wedgwood, who was involved with its development to the extent that he could influence its route, knew what an asset the canal would be to his business. When it was complete, a decade later, it proved indispensable in bringing the raw materials to the factory and shipping the finished goods to other centres.

Wedgwood's new state-of-the-art factory, which first opened in 1769, was named Etruria, after the Italian district that was home to the Etruscans. Designed by the architect Joseph Pickford (1734–82), it was symmetrical, with a central cupola over the gate that housed a bell to announce meal breaks and the beginning and end of the working day. The impression of order and efficiency was carried through in the working practice, with stages of manufacture broken down into distinct processes – an early example of the division of labour that became a hallmark of the Industrial Revolution.

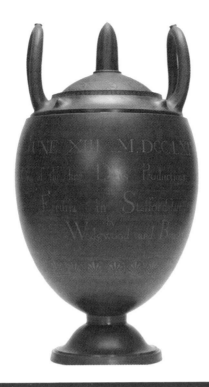

Although workers and equipment from Wedgwood's Burslem pottery made the move to Etruria, labour continued to be in short supply. As an incentive to his workforce and to attract new labour, Wedgwood built Etruria Village between 1769 and 1770. The simple, two-up, two-down dwellings, with shared pumps and privies, were of a higher standard than most workers' cottages of the day. A bakehouse was provided and, as time went on, communal facilities expanded to include churches, a bowling green, school, library and a couple of pubs. The villagers themselves became known as 'Etruscans'. While there was an element of philanthropy in the creation of the village, which accommodated 300 people, there was sound business sense, too. With the provision of decent housing, Wedgwood bound his workforce to his factory and made it more likely that they would not only repay him with their loyalty but also be on their best behaviour for fear of losing their houses as well as their jobs.

Within sight of the factory, Wedgwood built his own house, Etruria Hall, between 1768 and 1771. Also designed by Pickford, the original brick building was three storeys high and five bays wide. Its interiors were elaborately decorated with Wedgwood plaques and panels.

The First Day's Vase, commemorating the first day of production at the Etruria factory.

A Return to Craft

Reaction to the mass-produced, standardized goods that poured out of European and North American factories in the nineteenth century was not long in coming. In the second half of the century, the Arts and Crafts movement, one of whose leading lights was William Morris (1834–96), advocated a return to pre-Renaissance craftsmanship and methods of working. William De Morgan (1839–1917; see page 176), Morris's associate, rediscovered the secret of making lustreware and was extensively involved in creating the Moorish-tiled interiors at Leighton House, London. Yet such attempts, although influential, rarely led to commercial success.

It was not until well into the twentieth century that a craft revival began to take root. Art or studio potters working in Europe and the United States went out of their way to study old traditions, often from cultures far afield. One of the leading lights of studio ceramics was Bernard Leach (1887–1979; see page 94), who became fascinated with raku while studying and working in Japan. On his return to England in the early 1920s, he set up a pottery in Cornwall, building a raku kiln and a wood-fired climbing kiln in association with Shōji Hamada (1894–1978). Hans Coper (1920–81) and Lucie Rie (1902–95; see page 206) had equal influence in re-establishing the tradition of the artist-maker.

Fine artists, too, had a hand in the present-day revival of pottery. Pablo Picasso (1881–1973; see page 210) produced a vast number of ceramic editions and one-off pieces between 1947 and 1971. In his playful forms, with their lively, expressive brushwork, and in the mute terracotta figures of Antony Gormley's seven iterations of Field (1989–2003; see pages 212 and 214), you can sense the wheel turning full circle, to the works produced by the unknown prehistoric potters who first practised this ancient craft.

Right: Shaping one of the many terracotta
figures that comprise Antony Gormley's
Asian Field (2003).

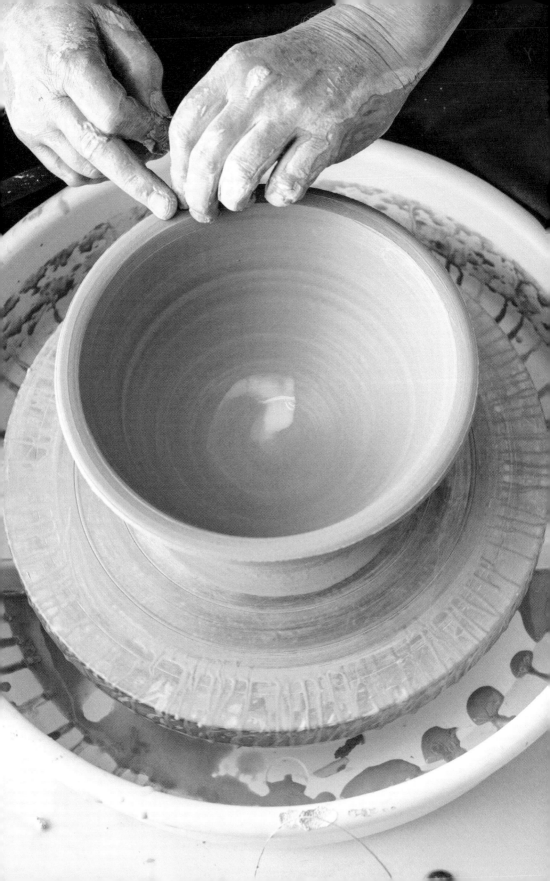

Earth & Water

The alchemy of pottery begins with the interaction of two basic elements: earth and water. Clay is the result of solidified magma wearing down over millennia, creating thin platelets that slide; with the addition of water, the material becomes sticky.

Beginning as molten rock, and transformed over millions of years by decomposition and weathering, clay occurs naturally almost everywhere on earth. Predominantly made up of the mineral feldspar, it also contains silica (silicon dioxide) or alumina (aluminium oxide), plus small quantities of various other oxides. Thousands of years ago it was discovered that this unique material could be shaped, dried and then baked in a fire to transform it into waterproof vessels.

All clay is made up of tiny platelets that cling together through an electrical charge. The addition of water enables the platelets to slide over each other without breaking apart and they become plastic, or malleable. If the water evaporates, the platelets fix together and the clay shrinks and becomes hard and brittle. When fired in a kiln at a high temperature, the platelets fix together permanently, turning the clay into a hard ceramic material.

There are two types of clay: primary and secondary. Primary clays are found at source, in the place where they first formed, while secondary clays have been transported over centuries from their original locations by water and earth movements, and deposited as sediment, often at the bottom of rivers or lakes.

The Raw Ingredients

Clay mixtures, known as clay bodies, are composed of several kinds of raw clay, plus other ingredients, including tempers that make it look and feel a certain way, resulting in various handling qualities. These can produce different types of pottery, such as earthenware, stoneware, porcelain, ironstone, raku and bone china.

Earthenware is a fine-grained clay body that is fired at relatively low temperatures – up to about 1000–1180°C (1830–2150°F) – which makes it more porous and

Left: Precision, sensitivity, artistry and steadiness
are all required in the making of a clay vessel.

slightly more fragile than stoneware or porcelain. The addition of sand or grog enables it to be fired at higher temperatures. Because it is porous, once fired, some earthenware is given a nonporous vitreous glaze to make it waterproof and smooth in texture, although some earthenware, such as terracotta, is often left unglazed to retain its breathability.

Faïence, maiolica, Delftware, creamware and lustreware are all forms of earthenware, and most primitive forms of pottery were made out of this type of clay. Red earthenware contains a small amount of sand, which strengthens the clay, while white earthenware contains no sand and is white or buff-coloured after firing.

Stoneware is a coarse-grained clay body with a grey or brownish cast, usually composed of mixtures of clay, sand or grog, plus other minerals, and fired at medium to high temperatures of around 1200–1300°C (2190–2370°F). As a hard, nonporous material, it only needs glazing for hygienic or aesthetic reasons, not to make it waterproof. Salt-glazed stoneware has a slightly textured, glossy and translucent glaze, formed by throwing salt into the kiln during firing. Sodium from the salt reacts with silica in the clay to form a glassy coating of sodium silicate.

Porcelain is a fine-grained white clay body that is fired at high temperatures of 1240–1400°C (2260–2550°F) to produce a durable, vitreous and translucent ceramic. Formed with a high content of china clay (kaolin) and china stone (petuntse), with no other ingredients such as iron, it is usually pure white. Of all the clay bodies, porcelain has the least plasticity, so it must be handled gently before firing as it can become misshapen and susceptible to cracking.

Ironstone is made of a dense type of earthenware containing china stone. It's white and hard, and resembles Chinese porcelain, but the body is generally opaque not translucent. Because of its hardness, most ironstone items are practical rather than decorative.

Raku is formed by the rapid firing and cooling of the clay, which is removed from its special kiln while it is still red hot. For this reason, the clay body has to have a coarse, open texture, so a white clay base is usually mixed with grog, molochite or another similar temper to make it resistant to warping. The addition of talc also helps it to withstand thermal shock. Raku pieces are traditionally shaped by hand rather than being thrown, and are usually decorative. The word 'raku' derives from a Japanese expression meaning enjoyment or happiness.

Rght: Fired but not yet glazed clay is called biscuit. These jugs have had their first 'bisque' or 'biscuit' firing..

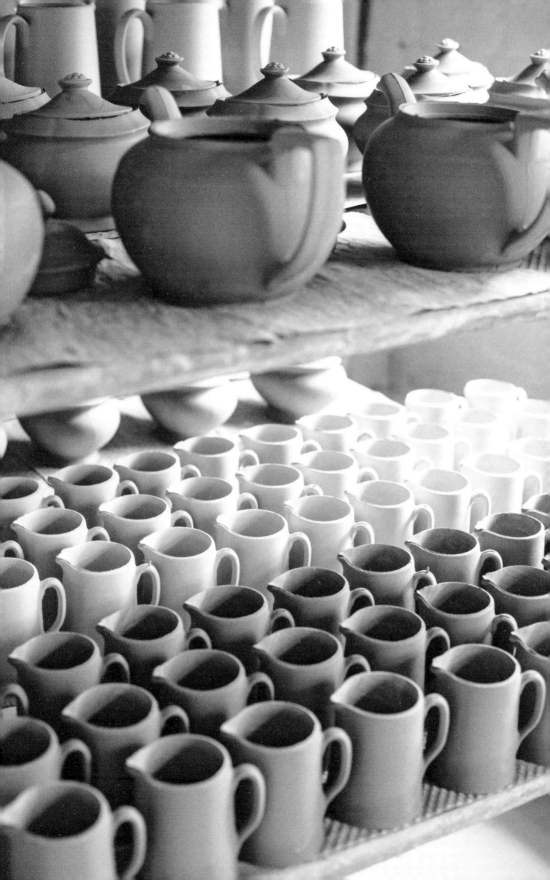

Bone china is a strong, extremely white body composed of 50 percent bone ash, 25 percent china clay and 25 percent Cornish stone. It's the only body to have a fixed recipe, sometimes with cobalt chloride added to enhance its whiteness further. It is fired at 1260°C (2300°F). The development of bone china is attributed to Josiah Spode (1733–97) in about 1750; it finally went into production in the early 1800s.

Grog and Other Additions

Clay is only useful for pottery if it has good plasticity, which is assessed by how it responds to rolling, pressing, pulling and bending. These properties can be altered and made more suitable through the addition of various ingredients, known as aggregates or 'tempers', which can be bought, found or made from other substances.

One of the most common additions is grog, a gritty material made from fired, ground clays, sand and coarse-ground quartz, which adds strength and texture and reduces shrinkage during firing. Grogs can vary from fine to coarse consistencies, which will produce different effects. Other options include fine-ground quartz, talc, crushed porcelain, which impart a heavy texture, and molochite, which is the vitrified form of china clay (kaolin) and acts comparably to grog but retains the whiteness of the clay. Clay's natural colour can vary from white to grey, buff to pink and brown to orange, and, as with ingredients that alter the clay's behaviour, various additives can also change the basic colour, such as metal oxides that react – sometimes quite surprisingly – during firing.

Not all clays or ceramics need such additions, but for those that do, potters must know how much or how little to use. Too little and the clay body may crack while drying or firing; too much and it may crumble, become brittle or not hold together well. Any aggregate or temper that is added must be spread as uniformly as possible for overall evenness of the final ware. It must also be coarse enough to bind with the clay. A good ratio to the clay is often about 25 per cent, or one-quarter of aggregate to three-quarters of clay, but it is a fine balance. To add the new substance, the required amount of prepared clay is formed into a ball and squashed into a thick disk. A proportion of the clay is taken away and replaced with the same proportion of aggregate, and the two materials are thoroughly kneaded together.

Left: Wooden shelves lined with bone china dishes directly after firing, at the Middleport pottery in Stoke-on-Trent, UK.

Medici Porcelain

When Chinese porcelain first arrived in the courts of fifteenth-century Europe, the hard, pure white, translucent material was widely admired. In 1461 the Doge of Venice, Pasquale Malipiero (1392–1462), received a gift of 20 pieces of Chinese porcelain from Sultan Khushqadam of Egypt (r. 1461–7). In 1487 a subsequent sultan, Al-Ashraf Sayf ad-Din Qa'it Bay (1416/18–96), presented the ruler of Florence, Lorenzo de' Medici (1449–92), with a piece of porcelain that became one of the family's most cherished possessions.

Porcelain became so highly prized in Renaissance Italy that various powerful rulers spent huge amounts of time and money attempting to produce their own. In the 1568 edition of his book, Lives of the Most Excellent Painters, Sculptors and Architects, Giorgio Vasari (1511–74) reported that Bernardo Buontalenti (c. 1531–1608) was working on identifyng the art of porcelain. The first successes were finally reported in 1575, when it was recorded that Grand Duke Francesco I de' Medici (1541–87) had discovered the means of making 'the porcelain of India' (the East Indies).

After years of experimentation, Francesco's alchemists, working in a purpose-built laboratory in the Casino Mediceo di San Marco in Florence, developed an 'artificial' or soft-paste porcelain, using glass, powdered quartz, sand, clay from Vicenza and white earth from Faenza. This composition is different from true hard-paste porcelain and is fired

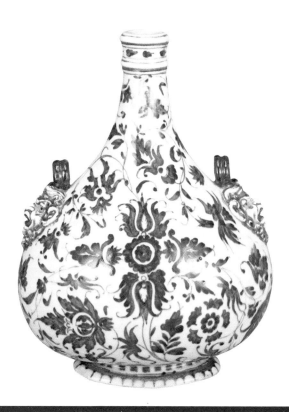

at lower temperatures, but it is generally considered to be the first European porcelain. The body and glaze are based on Persian, Iznik and indigenous maiolica pottery. Both Iznik fine white pottery and Medici porcelain have a high silica content, obtained by mixing quartz or sand with clay, and the glaze contains calcium phosphate, which came from the Islamic technique of using calcined bone to make an opaque white glaze.

Generally blue and white, with motifs inspired by Turkish Iznik and Persian pottery, Italian majolica and early Chinese porcelain, Medici porcelain was thicker than true hard-paste Asian porcelain and its glaze was slightly cloudy and pitted. It was distinguished by its base marks

of the dome of Florence Cathedral above the letter F, while some pieces feature the Medici *palle*, the family's coat of arms.

Medici porcelain was never a commercial venture. The formula and high temperatures needed for firing were difficult to achieve and proved extremely expensive. After Francesco died, production dwindled. No further attempts to make true porcelain took place in Europe for about a century. A 1588 inventory lists 310 pieces of the porcelain, but today fewer than 70 pieces are known.

A Medici porcelain 'pilgrim' vase, c.1575, that emulates the shape of water bottles carried by pilgrims.

Clay Preparation

Before clay can be either thrown on a pottery wheel or shaped by hand, any air bubbles or lumps must be removed to create a smooth, even consistency and to avoid any explosions in the kiln. It should be given a thorough kneading to achieve this. Involving the physical manipulation of the clay using upper-body strength to achieve a homogeneous state, there are several kneading methods, including pushing, rolling, pressing and slamming. Some potters prefer to use a pug mill to do this mechanically, and different potters find different methods more successful than others, but they are all roughly similar. For all methods of clay preparation, the clay should be worked on a plaster or canvas surface, and it is easiest if the potter is standing with feet astride.

The goal is to squeeze and compress the clay. Folding it will have the opposite effect of creating more, rather than fewer, air bubbles, while squashing and then stretching it forces out air bubbles, so the clay should be kept in a lump and not flattened. A large piece of clay is slammed onto the porous surface, and then repeatedly and rhythmically pressed firmly. Short, quick compressions work better than long, slow movements. Next, the clay is cut in half with a wire and the potter checks for any remaining air bubbles, unevenness or lumps. The method of repeatedly slamming the clay onto the surface, cutting it in half with the wire and squashing, rocking, pressing and turning it continues until all air bubbles are expelled and all lumps are eliminated. Any aggregates, tempers or other ingredients can be added to the clay during the process. A dust mask should be worn while doing so.

Hand-Building Techniques

Hand building or hand forming describes working clay by hand using simple tools (see overleaf). Before the invention of the wheel, all potters created ceramics using their hands, basic tools and a few simple methods. The most common of these techniques are pinching, coiling, pulling and slabbing, all of which are explained in more detail over the following pages.

Right: An engraving of a workshop in the Sèvres factory; a worker creates a deep Sèvres dish by moulding several layers of clay by hand, c.1870.

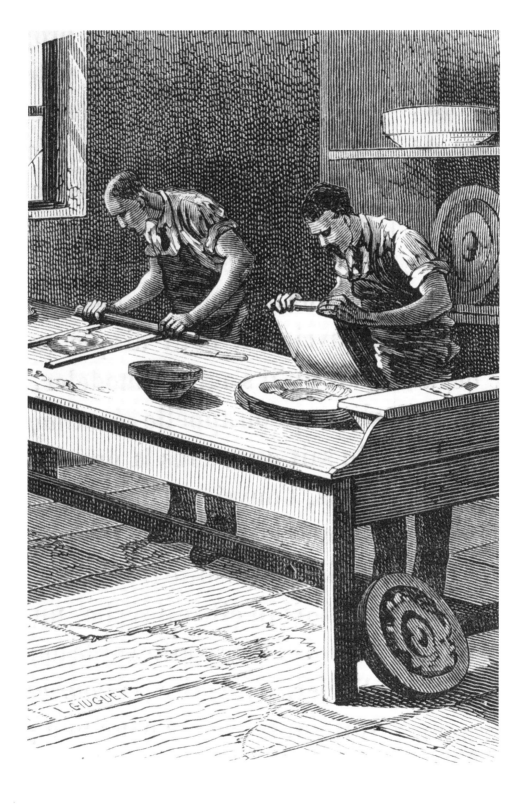

Basic tools for hand working clay

» Canvas-covered work board

» Natural or man-made sponges, to smooth and clean the clay body

» Sponges on sticks, to wipe and smooth inside tall or narrow forms

» Wires, with handles at each end, to cut through clay, both during wedging and while shaping clay

» Rolling pin or slab roller, to roll flat, smooth and even slabs

» Ribbon or loop tools, which are sticks with a fine metal loop at each end, to remove 'ribbons' of clay while shaping and smoothing

» Water spray, to keep the work damp

» Craft knives, to trim or cut details

» Hole cutters, to cut small holes in the surface of the clay

» Bamboo tools, which are varied and used for sealing joins and creating surface textures

» Ribs and kidneys, made of wood, plastic, rubber or thin steel, used for shaping, smoothing, scoring and trimming

» Wooden and plastic tools, including knives, spatulas and other shaping tools, for a variety of uses

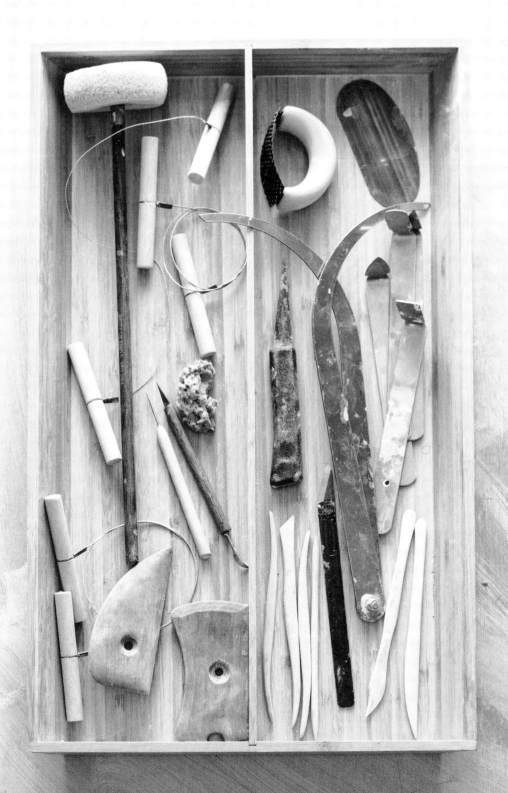

Pinching

Pinch pots are made by rolling a small ball of any type of soft clay in one hand, then pushing the thumb of the other hand into the middle of the ball (figs 1 & 2) and rotating it while pressing and squeezing the clay between the thumb and fingers to gently thin the walls (figs 3 & 4). Once the walls are thin and even enough, the pot is pressed gently on the work board to flatten the base before drying and firing.

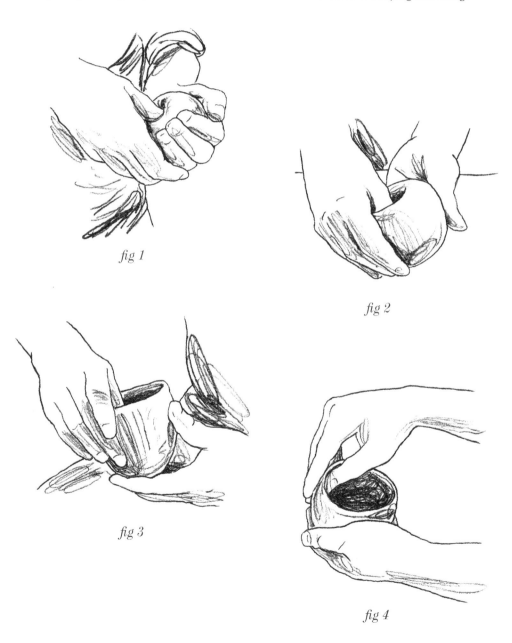

fig 1

fig 2

fig 3

fig 4

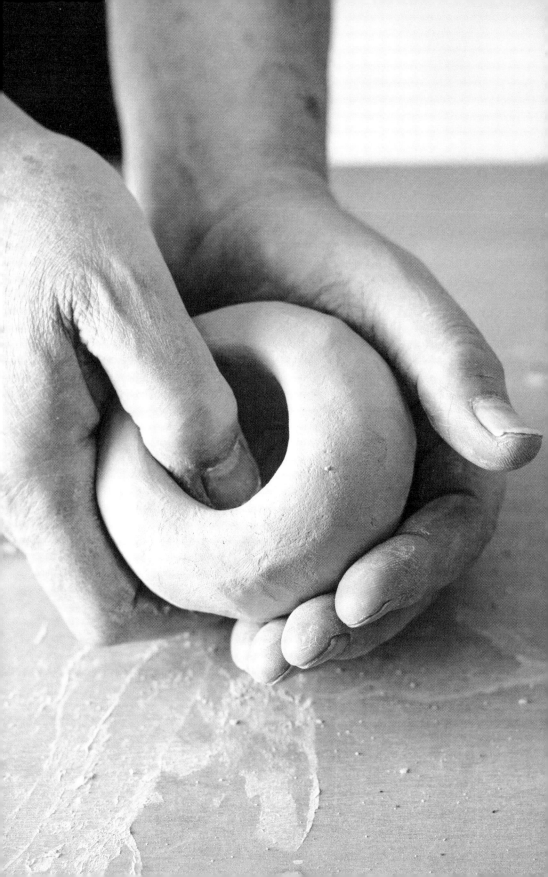

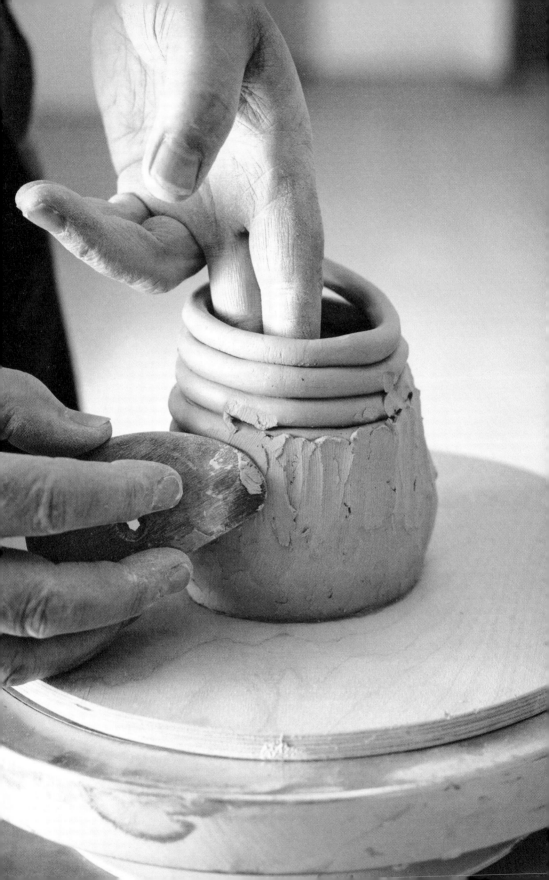

Coiling

Coils of clay can be used to create any vessel. To make a coil or ring pot, a disk of clay is flattened and cut to shape for the base (fig 1), then pieces of clay are rolled into even sausage or rope lengths (fig 2), using water to keep them soft and avoid cracking. The edge of the clay disk is scored, and slip (clay softened with water and sieved) is added to make a sticky surface. The long, thin lengths are wound around this outer edge and pressed on (fig 3). Further coils are joined to build up the sides of the pot (fig 4), then the coils are smoothed into a wall using a rib (see page 40) (fig 5).

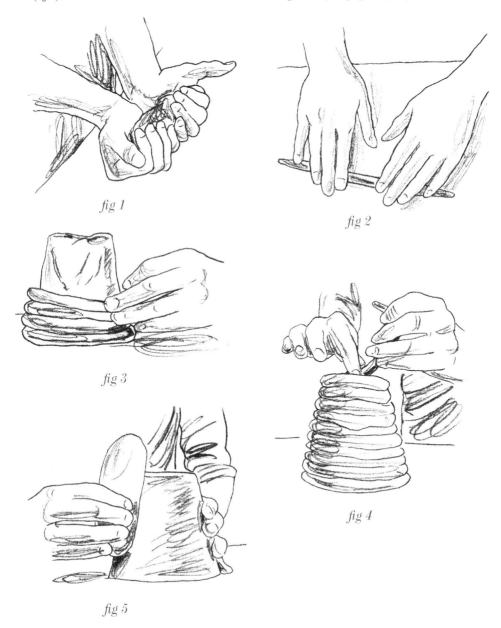

fig 1

fig 2

fig 3

fig 4

fig 5

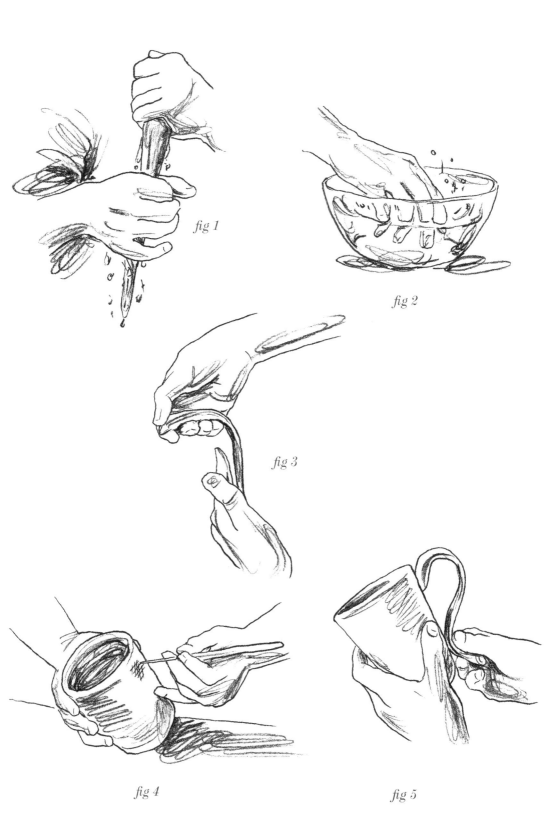

fig 1

fig 2

fig 3

fig 4

fig 5

Pulling

The most traditional method used to create handles, pulling begins with a lump
of moist clay. Through gentle stroking and pulling, using water to keep it smooth,
the clay is formed into a conical shape (figs 1, 2 & 3). The vessel that will take the
handle should be leather hard (unfired and fairly dry – soft enough for a fingernail
to be pressed into it, but firm enough to hold its shape). A small area where the top
of the handle will be attached is scored with a bamboo tool, knife or fork prongs,
and slip is applied (fig 4). The thicker end of the pulled clay is pressed firmly on this
area and merged with a blending tool until it is firmly attached. Then, with a wet
hand, the pulled clay is once again stroked and pulled until it reaches the required
length and thinness. Directly below the now-fixed top part of the handle, where
the bottom of the handle is to be attached, the vessel is scored and slip is added.
The tapered end of the pulled-clay handle is curved in and pressed firmly onto this
spot, then the two parts are merged together (fig 5).

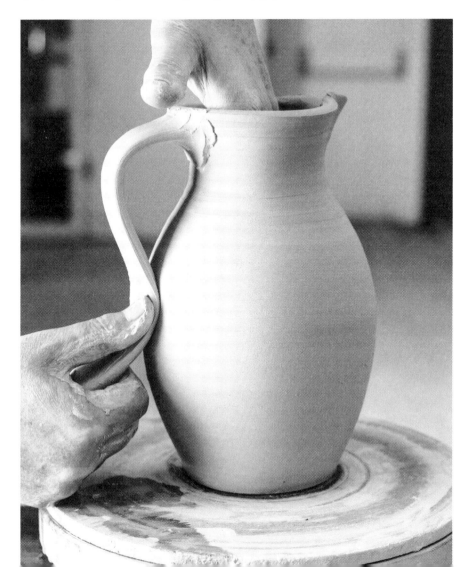

Slabbing

Slab building is one of the ways in which geometric or angular forms can be made with clay, and involves flattened pieces of clay that are then cut up and reassembled. The method has the advantage of using pieces of clay of uniform thickness, which is helpful when drying and firing. After wedging, a lump of clay is smoothed and flattened with a rolling pin or slab roller (fig 1). As rolling can make the clay stick to the board or table, it has to be moved around. With a craft knife or pointed tool, the slabs are cut to the sizes and shapes required (fig 2). The slabs are left to partially dry before constructing the final form – they can be leather hard or just a bit drier. Then, with a bamboo tool, knife or fork prongs, scores are made around the edges of each slab and a wet finger is rubbed along (fig 3). The slabs are assembled and pressed firmly together (fig 4). Thinly rolled coils of sticky clay can be used to bond the edges, which are then smudged together with a rib (see page 40) (figs 5 & 6).

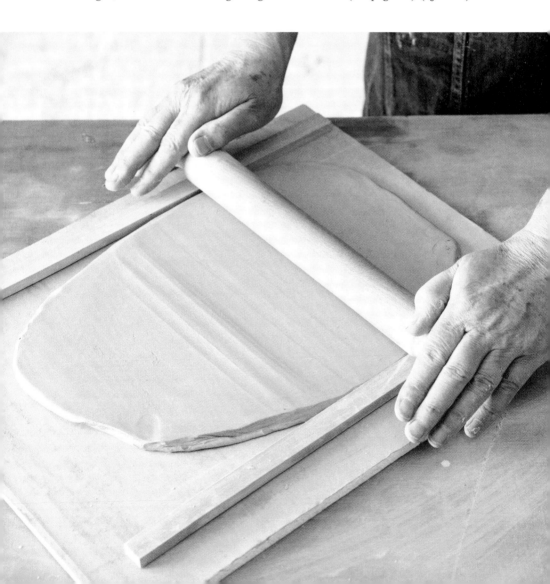

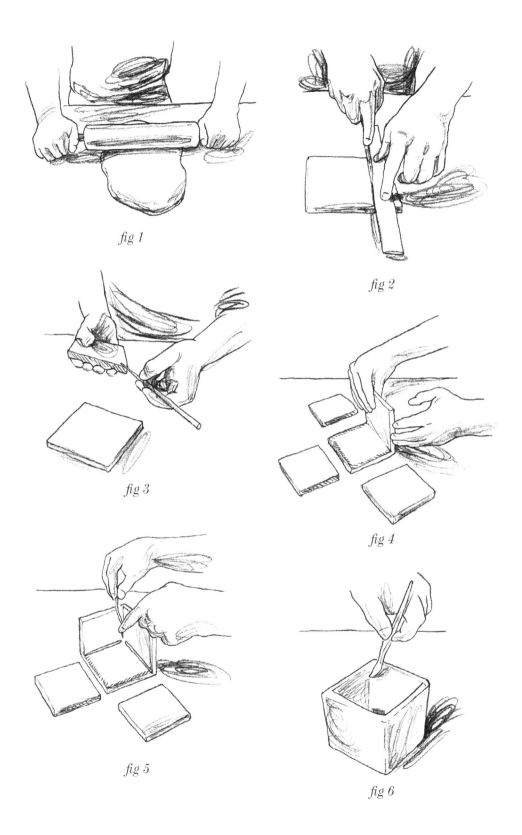

fig 1

fig 2

fig 3

fig 4

fig 5

fig 6

Inventing the Wheel

The principle of the wheel was discovered in what is now southern Iraq (then Mesopotamia) in about 4500 BCE by the Sumerians, the first urban civilization to inhabit the area. Originally used on carts and chariots, wheels were soon turned on their sides and adopted by potters.

Initially, in both Mesopotamia and Egypt, these wheels were made of either wood or stone. In the Middle Minoan Period (2100–1500 BCE), evidence has been found of the first use of potter's wheels, which resulted in sophisticated, symmetrically shaped vessels and ornaments. Ancient Greek potter's wheels (betweeen approximately 3000 and 2000 BCE), also made of wood or stone, were balanced on stone supports and rotated by assistants while craftsmen shaped the pots. In a similar way, across Europe throughout much of the eighteenth century, young apprentices turned the wheel for their masters.

These first potter's wheels were either pushed by hand with a stick or kicked, and the resulting momentum was enough for pots to be made. The advantages of using wheels, even this basic, were speed, efficiency and the symmetry that could be achieved. What might previously have taken hours or even days to make could now be completed in minutes.

Eventually, small turntables (or tournettes), usually made of animal bone or stone and frequently operated by foot pedal, were developed, which enabled easier turning. Turntables became refined and improved over the centuries, with potters perfecting and advancing their techniques accordingly. There are several types of wheel available, some manual and others electric.

There are two basic categories of manual wheel. One is the kick wheel, which is usually made of wood or metal and is operated by kicking a heavy, revolving flywheel connected to the turntable (wheelhead) by a long, heavy, vertical shaft. The other type is the treadle or momentum wheel, which is moved by the foot repeatedly pushing a plate that returns automatically. These wheels usually have large and heavy flywheels.

The most popular throwing wheels, because of their ease of operation, are electric wheels, which come in a variety of sizes and are usually operated by the foot, which uses pressure to control the speed. Other types of electric wheel incorporate variable-speed electric motors. Some larger wheels have integrated seats.

Right: China, 1812; a potter sits at his wheel, while the man in the centre steadies himself by holding a rope and rotates the wheel with his foot.

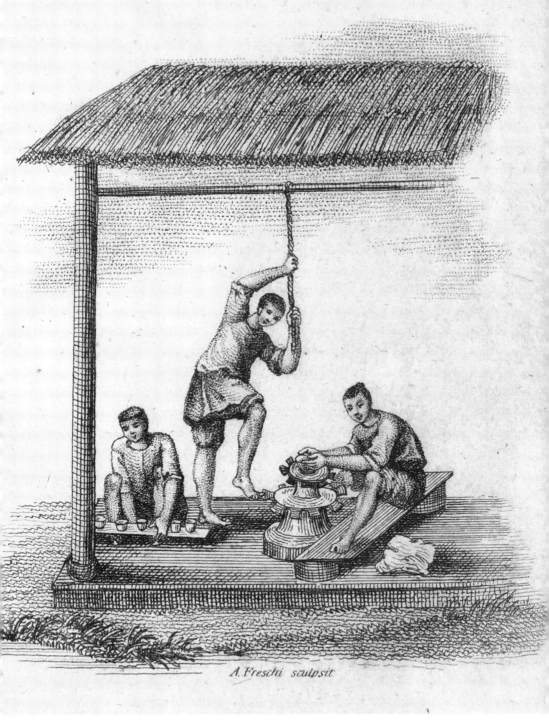

A. Freschi sculpsit

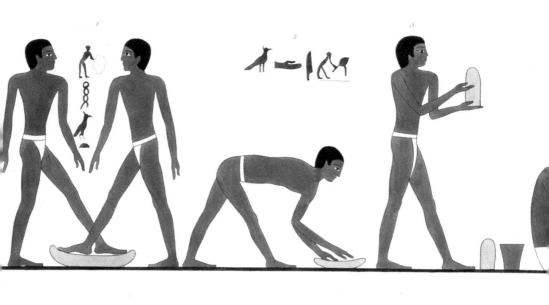
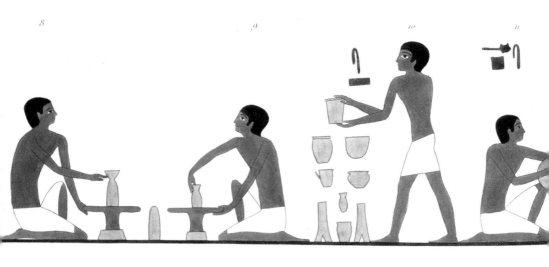

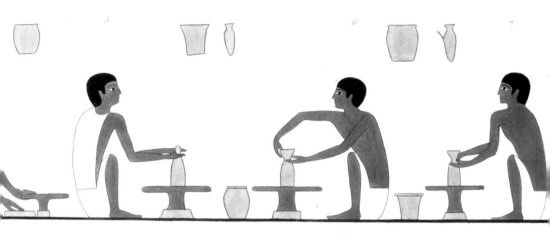

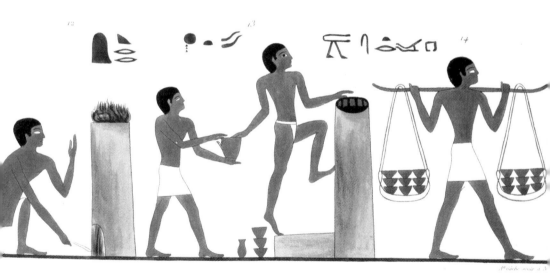

From a wall painting in Thebes, this is a
depiction of ancient Egyptian potters wedging,
throwing, forming and firing pottery.

Throwing Techniques

Clay used with a wheel has to be more plastic than clay used for hand shaping, as wheel-thrown pottery involves more complex techniques. The expression 'throwing' derives from the Old English word *thrawan*, meaning to twist or turn, because wheel throwing requires potters to keep their wheels turning steadily. The correct amount of water is also imperative to keep the clay pliable but not sloppy, and this is achieved by a large bowl of water being placed close to the wheel so that the potter is able to wet his or her hands regularly to keep the clay pliable.

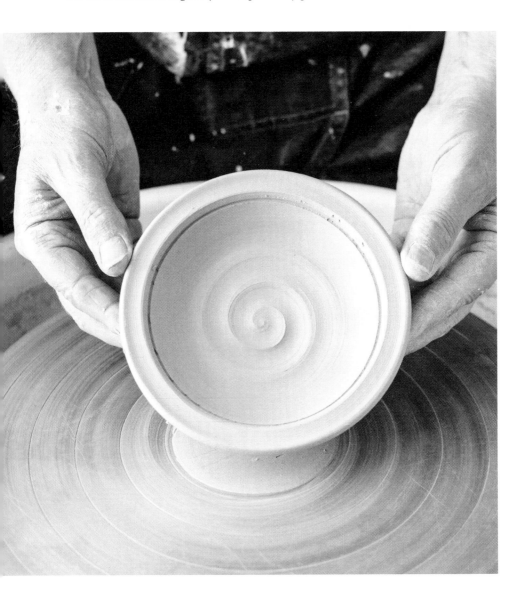

Basic tools for working on a potter's wheel

» Natural or man-made sponges, to smooth and clean areas on the clay body, or to dampen areas

» Sponges on sticks, to wipe and smooth inside tall or narrow forms

» Wires, with handles at each end, to cut through clay and to remove items from the wheelhead

» Ribbon or loop tools, to remove excess clay while trimming, shaping and smoothing

» Water spray, to keep work damp

» Bowl, bucket or other container for water, to keep hands and clay wet or damp while working

» Craft knives, to trim or cut details

» Hole cutters, to cut small holes in the surface of the clay

» Wooden and plastic tools, including knives, spatulas and other shaping tools, for a variety of uses

» Ribs and kidneys, made of wood, plastic, rubber or thin steel, for shaping, smoothing, scoring and trimming

» Old towel or cloth

» Wooden throwing stick

Centring

The first throwing technique that has to be mastered with a wheel is centring, which requires a great deal of control. It means positioning the clay in the exact centre of the wheelhead to ensure that whatever is being made is symmetrical. The wheelhead must first be clean. A ball of clay is slapped onto the centre so that it adheres, then the wheel is set in motion. One hand cups around the clay, with the thumb resting on top. The other hand is brought across to overlap the first hand, with forearms resting on the slip tray and the shoulders and neck rigid (figs 1 & 2). As the clay spins, the hands – which need to be dipped frequently in water – pull the clay gently but firmly towards the body, not to move it from the centre, but to keep the sides smooth and the shape symmetrical (fig 3). Then, with both hands firmly on either side, and fingers overlapping, the potter presses his or her palms into the clay, drawing it up into a cone shape. Keeping one hand on the side of the clay, the other hand pushes down, with both hands squeezing in an inward direction, from above and from the side, pushing the clay more firmly into the wheel's centre (fig 4). Still supporting the clay from the outside with one hand, the thumb or fingers of the other hand are pressed downwards to create a hollow shape (fig 5).

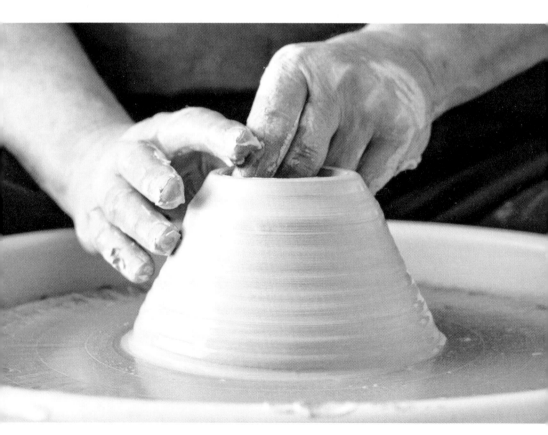

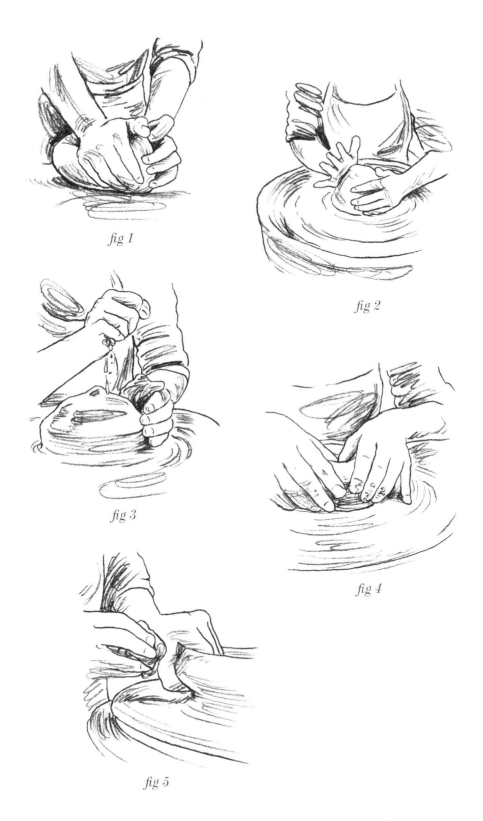

fig 1

fig 2

fig 3

fig 4

fig 5

Throwing off the hump

Making many small vessels from one solid lump of clay is called throwing off the hump. It can be precarious, but it allows potters to make several small pots or bowls fairly rapidly. A large cone of clay is placed on the wheel. The fingers of both hands squeeze a small lump on the top of the cone, enough to use for the vessel, and the thumb presses in to open it. Using the fingers and thumb, the sides are raised, shaping the clay, and the edges are smoothed and made even. When the vessel is ready, a wire is used to cut it off the larger lump. The process continues until all the clay is used and the required number of bowls or pots have been made.

Collaring

This is a method of making a bottle or jar with a thin-necked collar or lip. A lump of clay is prepared, thrown and shaped on the wheel. As it is shaped and pulled up, the neck is tightened by gently squeezing it with the thumb and index finger of one hand, using slight pressure to reduce the neck's diameter, while the thumb or fingers of the other hand shape the neck. The clay is allowed to slide between the fingers, moving in an upward direction. This must be done gently, and the collar area can be wetted with a damp sponge as it is evened out.

Using gauges

To make multiple forms of the same size and proportion, the eye can be an accurate gauge, but to be perfectly consistent, a throwing gauge can be used to measure every piece. There are several types of throwing gauges, some based on designs from Eastern or Western cultures, and some improvized solutions, made by individuals.

The Western gauge has been used by potters in America and Europe for centuries. It usually consists of a metal or wooden stand with an arm that can be adjusted in and out and up and down, to measure diameter and height. The Japanese gauge, known as a *tombo* (which means 'dragonfly' in Japanese), measures the inside dimensions of a form, unlike the Western gauge, which measures the outside. The *tombo* is a thin, vertical piece of wood or bamboo with one or more sticks or pieces of dowelling pushed through it at right angles. When placed inside a vessel, the length measures the depth and the sticks or dowelling measure the inside width. Not adjustable like the Western gauge, the *tombo* is nevertheless inexpensive and easy to make, and potters who use them often keep several of varying dimensions.

Right: A bowl being thrown off the hump. This technique allows multiple small vessels to be thrown from a single piece of clay.

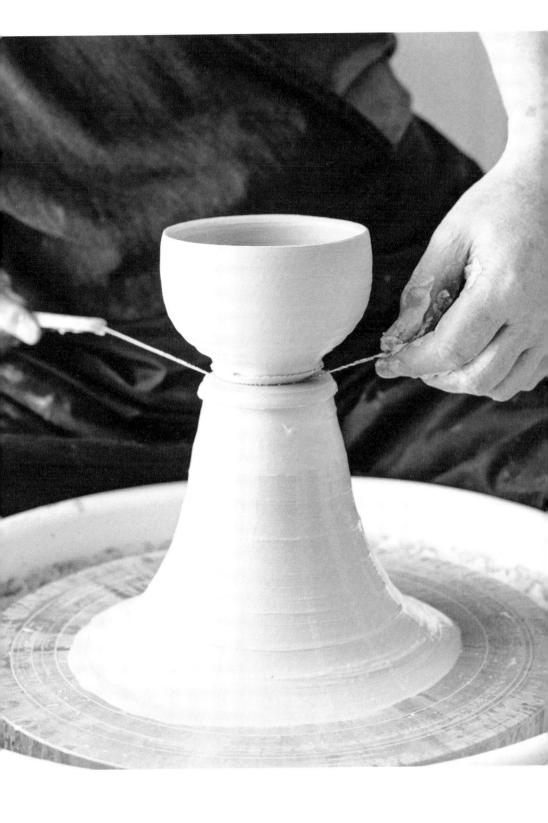

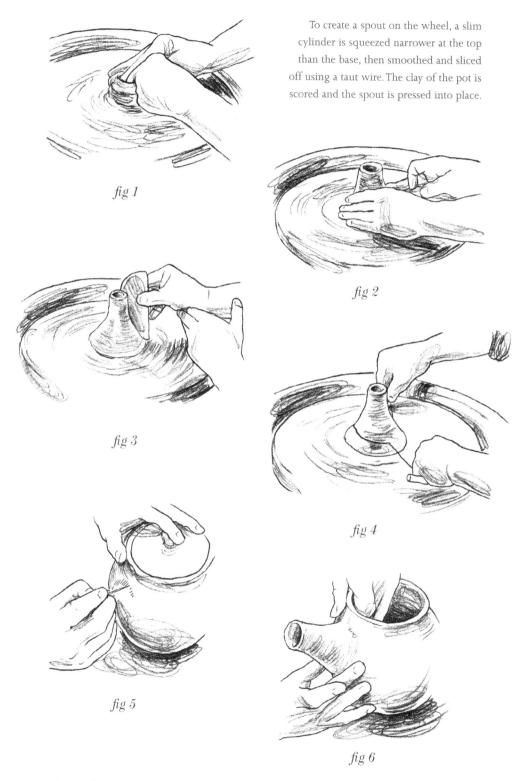

To create a spout on the wheel, a slim cylinder is squeezed narrower at the top than the base, then smoothed and sliced off using a taut wire. The clay of the pot is scored and the spout is pressed into place.

fig 1

fig 2

fig 3

fig 4

fig 5

fig 6

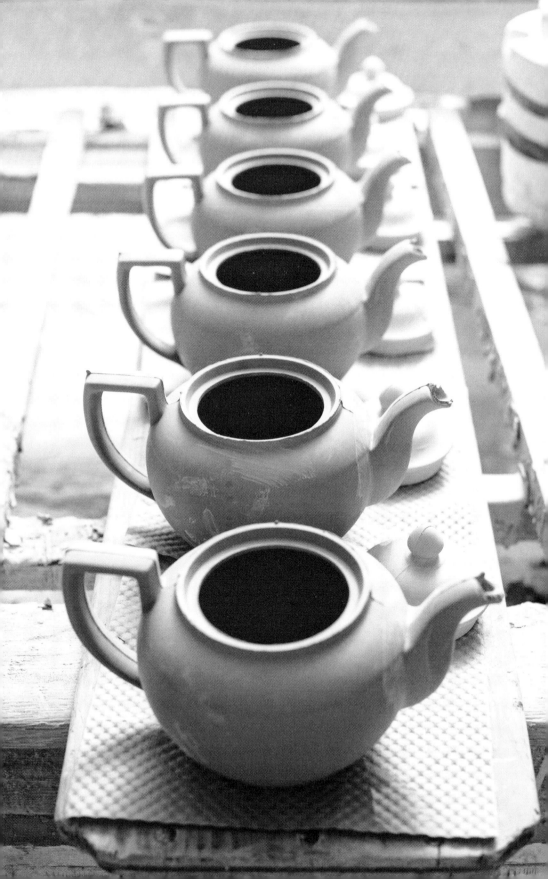

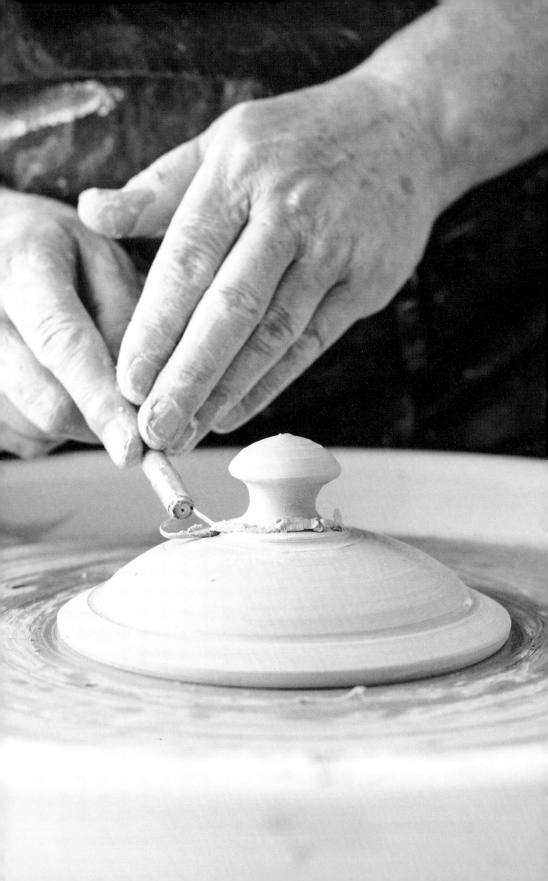

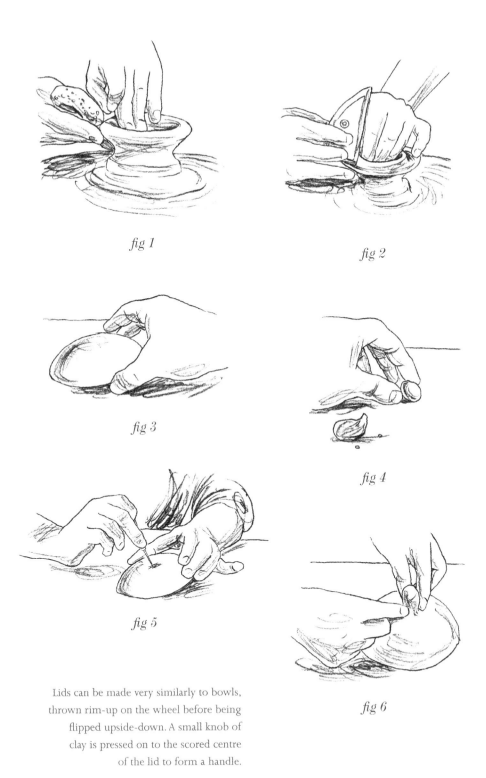

fig 1

fig 2

fig 3

fig 4

fig 5

fig 6

Lids can be made very similarly to bowls, thrown rim-up on the wheel before being flipped upside-down. A small knob of clay is pressed on to the scored centre of the lid to form a handle.

Beyond the Wheel

Without a wheel, and in addition to the basic methods of hand forming, there are several ways in which forms can be made, especially when producing quantities of identical objects, or forms or patterned objects that are difficult to achieve. Moulds and slip casting are two common methods in these instances.

Press moulding

This technique can be used for making vessels, tiles, sculpture and art objects. Like templates and stencils, press moulding works in two ways: with clay pressed inside a mould to take on a convex form, or pressed around the outside to create concave forms. Moulds can be bought ready made or you can make your own with plaster.

A naturally occurring gypsum, plaster was first mined in Montmartre, Paris, in the late eighteenth century, hence the name 'plaster of Paris'. When plaster is mixed with water, it becomes fluid and heavy, and when the water evaporates, the plaster forms a solid, set mass. Many objects can be used as moulds, including ordinary vessels, found objects and bisque-fired ceramics (pottery that has been fired but not yet glazed).

Found objects, such as shells or brooches, for instance, can be turned into moulds. These are pressed into a slab of wedged clay, and a wall of cardboard is created around the objects, also pressed into the clay. Plaster is mixed and poured inside this wall, on top of the clay and the found objects, and left to set. Once the plaster is dry, the cardboard walls, found objects and clay are removed (you may need to coat the mould with a thin layer of releasing agent), revealing the plaster mould ready for fresh clay to be pressed into the shapes. To use a convex, pre-prepared shape for a mould, clay is pressed firmly onto it and only removed when it is leather hard.

If the mould is shallow, a large slab of clay is rolled out on a soft, clean cloth, then the cloth is lifted, holding the clay slab, and placed over the mould. The clay is eased into place and pressed firmly into the mould, either with the fingers or a rubber rib. Excess clay is removed from the edges of the mould with a craft knife or bamboo. This trimming to make clean edges is called 'fettling'. For a large or deep mould, it is often necessary to press numerous smaller pieces of clay into the mould, blending it together with fingers or a rib.

The clay is left in the mould to dry. Once it is leather hard, it will shrink slightly and can be removed from the mould. Further work is then undertaken on the clay, or, if that is not necessary, it is fired.

Right: Creating a vessel with use of a plaster mould.

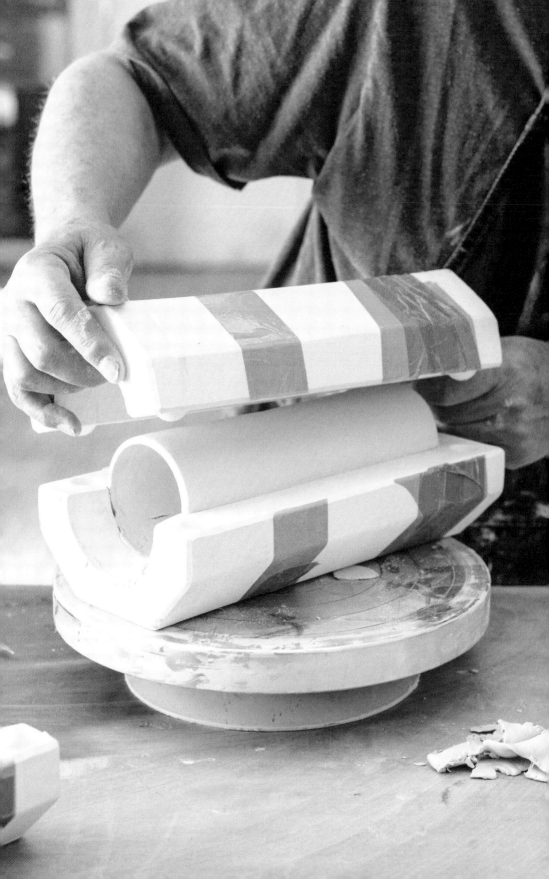

Slip casting

For mass-produced designs, to make large items or to create complex or intricate shapes that are not easily made on a wheel, such as figurines, slip casting is often used. As in press moulding, moulds are either obtained ready made or individually created from plaster, and casting slip – clay in a liquid state – is poured into them. Moulds should be dampened slightly or there is a risk of the clay cracking as it dries. The casting slip must be well blunged (mixed) and free from lumps before being poured slowly into the mould, right up to the top, and allowed to form a layer of the appropriate thickness on the inside wall. Excess slip is then tipped out and the cast is left to stiffen before being removed from the mould ready to be fettled (trimmed and tidied up), sponged (in order to smooth any rough seams or ridges) and ultimately fired.

Drying

Prior to firing, all clay pieces must be dried evenly in the air so that excess moisture evaporates. For this reason, clay should be placed on slatted shelves or wire racks so that air freely circulates. Three factors are important for this part of the drying process: a warm temperature to encourage evaporation, low humidity in the air, and air movement. Drying the clay too quickly can result in it cracking, but clay can only become as dry as the atmosphere around it.

'Leather hard' is a term used to describe clay that has partially dried and shrunk, and become firm enough to be picked up without losing its shape, but is still wet enough that other pieces of clay can be joined to it. Leather hard is the ideal state for handles to be attached, for instance. At this stage, also, any lids and bases should be put together, as they are dry enough to retain their forms but not so damp that they could become welded together. At the leather-hard stage, clay can be reshaped by strong pressure or the reintroduction of water, so it is a suitable time to make sure that lid and base fit each other. Firing can cause a certain degree of warping, so if bases and lids are put together before they are fired, the two parts will warp in accordance with each other.

As the water content evaporates due to drying and then firing, clay decreases in size. After drying, shrinkage cannot simply be reversed; dry clay can only be reclaimed by adding it to water, allowing it to disintegrate (or 'slake') and then reprocessing. Once clay has been fired and the resulting chemical and physical changes have occurred, the shrinkage is permanent. There are three stages of shrinkage: wet to dry; dry to biscuit (see page 80); and biscuit to glaze (see page 86), provided that the glaze firing is done at a higher temperature than the biscuit firing.

How much certain clay bodies will shrink can be determined by the use of clay strips. Small pieces of clay are rolled into strips 15cm (6in) long and a straight line of 10cm (4in) is scored down the centre of each one. The clay is allowed to dry naturally and then the scored lines are measured. Next, the strips are bisque fired and the scored lines are measured again. Finally, the strips are fired to the top temperature and the scored lines are measured for the last time and then compared to their original length to assess the total shrinkage.

Trimming

The process of trimming clay bodies is also sometimes called turning, because it involves trimming and tidying up the clay while it is turning on the wheel. Generally, objects are trimmed at the leather-hard stage when there is less likelihood of the clay becoming misshapen. It is best to keep trimming to a minimum, as it results in leftover clay that needs to be recycled. Once again, the appropriate moment to perform this technique has to be assessed by the potter: if the clay is too wet, it could become distorted as it is trimmed, but if it is too dry, the clay will be flaky and could chip. A plastic bag or clingfilm can be used to cover any objects that are going to need trimming to extend the drying time.

Trimming is also known as shaving or skimming, because unwanted clay is shaved or skimmed off the form to shape it, to thin a wall or to create a foot rim, for example. To trim a vessel, it must be secured on the wheel. Unwanted clay is removed in a series of long shavings, taken off with a ribbon or loop tool, craft knife, bamboo tool, rib and kidney or spatula. These tools need to be firm and sharp, as clay will blunt the tools, and blades must be stiff enough to shave the clay without bending and so losing control. Sponges are also useful for damping the clay, where necessary, and ribs for smoothing the trimmed vessel to add a professional finish.

Trimming is undertaken for various reasons, including to finish a pot by removing excess clay on the lower part that could not be accessed while throwing; to create even, uniform walls and base; to enhance a pot's appearance; to create a foot; to shape and neaten edges; and to correct proportions. It is not always necessary, however, and sometimes a rub with sandpaper once the item is dry is all that is needed, though it is very important to wear a mask to avoid inhaling any toxic silica dust.

A nineteenth-century pottery workshop, with workers
using moulds to create individual items.

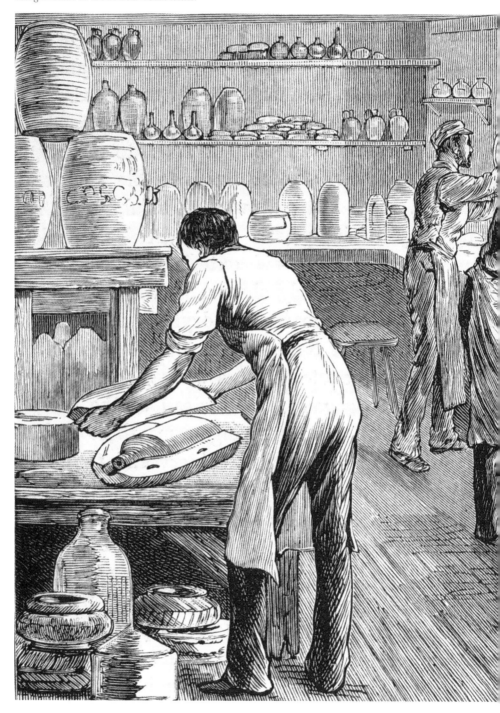

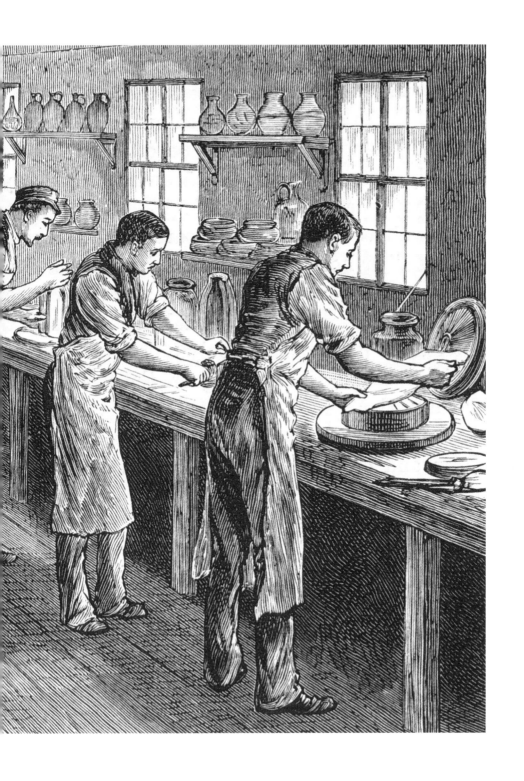

Meissen and the 'White-Gold' Story

Harder, whiter and more translucent than any European ceramics, porcelain became coveted from the time Marco Polo (c.1254–1324) brought the first items to Europe from China in the fourteenth century. To appease European curiosity, he wrote an (incorrect) account of its manufacture: 'The dishes are made of a crumbly earth or clay which is dug as though from a mine and stacked in huge mounds and then left for 30 or 40 years exposed to wind, rain and sun. By this time the earth is so refined that dishes made of it are of an azure tint with a very brilliant sheen.'

Although some porcelain was given to European rulers during the late Middle Ages, it remained rare in Europe until 1503, when the Portuguese began to import it. Dutch merchants increased exportation, and at the turn of the seventeenth century, after the Dutch captured two Portuguese ships carrying large consignments, around 100,000 pieces were sold at a public sale in Holland. Between 1604 and 1657, more than three million pieces reached Europe and demand pushed prices so high that it was nicknamed 'white gold'.

In 1590 Ferdinando I de' Medici, Grand Duke of Tuscany, gave Christian I, Elector of Saxony, 16 pieces of Ming porcelain. In 1686 King Narai of Siam gave Louis XIV of France 1,500 pieces of Chinese porcelain. By 1727 August II, Elector of Saxony (1670–1733), had collected more

than 24,000 porcelain items. Porcelain became more desirable than gold, and a race ensued to uncover the mystery of its production, which was closely guarded by the Chinese and then also the Japanese.

Although porcelain-like products were created in sixteenth-century Florence and seventeenth- and early eighteenth-century France, it was not until 1709 that the first true hard-paste porcelain was fired under the patronage of August II of Saxony. Desperate to make his own 'white gold', August employed scientist and mathematician, Ehrenfried Walther von Tschirnhaus (1651–1708). He also engaged the alchemist Johann Friedrich Böttger (1682–1719) to produce gold from silver and base metals. Having

imprisoned him for failing, August forced Böttger to work with von Tschirnhaus on porcelain experiments. Von Tschirnhaus worked with nearby deposits of kaolin and Böttger built kilns that could reach especially high temperatures. After von Tschirnhaus's death, Böttger refined their experiments; in 1708 he produced Europe's first hard-paste porcelain. August established the Meissen factory near Dresden to produce it. Despite huge efforts at secrecy, industrial spies and defecting workmen spread their knowledge of the formula and process.

Since the early eighteenth century, Meissen has produced delicate and detailed figures and groups.

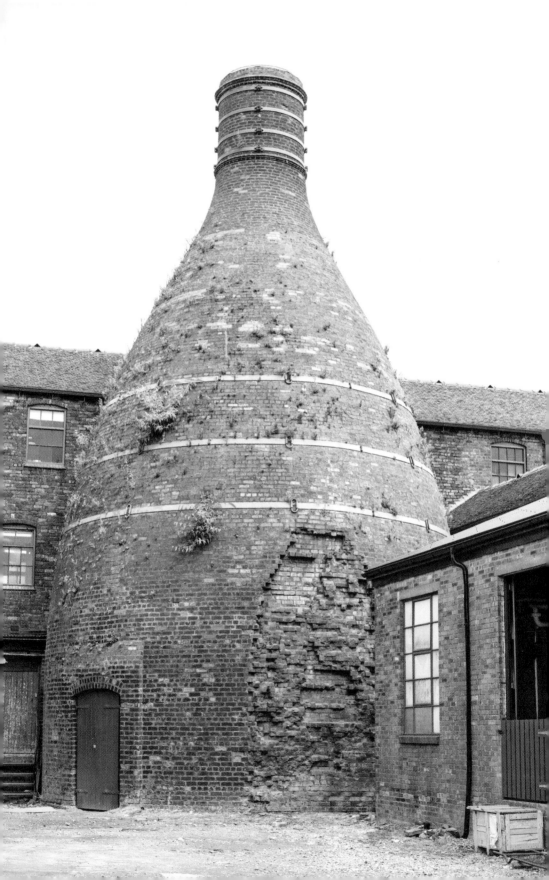

Fire & Air

Firing is pottery's moment of truth. The kiln has cooled and is ready to be opened. After many hours, perhaps days, of work, what will the outcome be? Has the pot survived intact? How has the glazing turned out? Firing is a process that involves a great many variables and even the most experienced potters still find themselves surprised, pleasantly and otherwise, at what emerges.

By whatever method it is achieved, firing is the process by which clay bodies are subjected to extremely high temperatures for a sufficient length of time to bring about chemical and physical changes. The first firing, known as bisque or biscuit firing, strengthens the pot while leaving it porous enough to be glazed. The second or final firing, which may be accomplished in a number of ways, is when the glazing fuses with the body.

Early Kilns and Firing Methods

The earliest and most primitive form of firing is the open-air bonfire method, where pots are laid on a layer of brushwood, covered with another layer and the entire pile set alight. Thicker wood, added as the fire burns, raises the temperature. The method reproduces what was possibly an accidental discovery made some time in prehistory, when a clay vessel used for cooking was retrieved from the fire and found to be stronger and more durable than one baked in the sun. Closely related to this technique is the pit-firing process (see page 97), which has been used for thousands of years all over the world.

An early development in firing technology was to enclose the fire within a purpose-built chamber and thus concentrate the heat. The addition of a chimney ensured that air was drawn through the chamber so that the fuel was completely burnt.

Many early kilns, such as the wood-burning anagama kiln, introduced to Japan from Korea in the fifth century, and the noborigama kiln, a design that evolved from it, were built on slopes to create a through draught. The firebox would be at the lowest point and the flue at the highest. Anagama kilns had openings along the sides through which pottery could be introduced, and there was no separation of firebox

Left: There were more than 2,000 bottle kilns in operation in
The Potteries by the end of the nineteenth century. Few remain today.

and chamber. They needed to be kept stoked with fuel at very frequent intervals. Noborigama kilns had more than one chamber; holes at the sides were used for stoking the fire once it was well established.

Kilns installed at Sèvres, near Paris, in the nineteenth century were designed to generate the very high temperatures needed to make porcelain and, in particular, to impart the special enamel quality that is associated with Sèvres ware. These structures consisted of three cylindrical chambers mounted on top of one another, the topmost being a chimney and the bottommost fed by a firebox. Birch wood was used exclusively as fuel because it burns quickly and relatively cleanly.

Muffle kilns, on the other hand, were designed to fire over-glaze decoration at much cooler temperatures. Smoke was drawn away through sealed flues to provide a clean, oxidizing atmosphere.

By the time the Industrial Revolution was well under way, the most familiar sight in pottery-producing areas was the bottle kiln (see page 72). These coal-fired kilns were enclosed by tall, bottle-shaped 'hovels', the purpose of which was to draw away the smoke and promote airflow.

Types of Kiln

Kilns today are principally distinguished by the fuel that powers them, which may be electricity, gas, wood or, more rarely, oil or some form of solid fuel. Over the centuries, however, kiln design has also evolved to suit different types of ware, with the raku kiln being a case in point.

One of the most popular types of kiln, used widely in home studios, schools and workshops, is the electric kiln. Relatively easy to manage and available in a range of sizes and capacities, the principal distinction is between designs that are front loaded and those loaded from the top. Another variant is the trolley kiln, which is used by the large ceramics businesses. Here, the entire floor of the front-loaded kiln can be rolled out on wheels, which allows it to be stacked and unloaded more easily. Most modern electric kilns have sophisticated temperature controllers that measure the rise in temperature and turn off the kiln when the appropriate heat is reached.

Price varies widely according to specification. Large and commercial kilns need a three-phase electrical supply because they use so much power, with special cabling required. Smaller kilns and those used at home are generally single-phase and can be run off a domestic power supply. Good ventilation is also recommended because certain fumes are toxic. If in doubt, install a sealed flue or extraction of some kind.

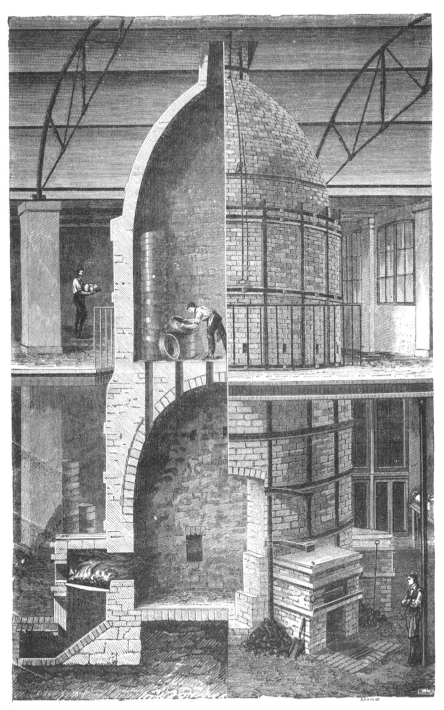

A nineteenth-century engraving showing a cross-section through
the great porcelain kiln at Sèvres, with its multiple chambers.

Front-loaded kilns generally have heat-radiating elements arranged horizontally on either side, and sometimes at the back, as well. In top-loaded kilns the elements are coiled from top to bottom. Kilns are lined with a range of insulating materials, typically refractory ceramic, firebrick or ceramic fibre. The better the insulation, the lower the heat loss and fuel consumption will be.

A feature of some electric kilns are bungs, or ceramic stoppers, inserted at intervals around the kiln. When the kiln is first turned on, the bungs should be left out to allow any moisture to escape and prevent unnecessary corrosion and wear on the elements. After the kiln reaches a temperature of between 400°C (750°F) and 600°C (1110°F), the bungs should be reinserted to prevent excessive heat loss. Bungs cover open inspection or spyholes that allow the potter to check on the progress of the firing by monitoring the performance of pyrometric cones. Such cones, which are short pyramidal shapes with triangular bases, are assigned a number from 01 to 09 and from 1 to 12, which corresponds to a temperature. Each cone is made from a different clay that melts at a given temperature. The cones are positioned around the interior of the kiln; when they reach the assigned temperature indicated by their coding, they melt and bend over.

Electric kilns are cleaner than gas or wood varieties, but they can only be used for one kind of firing, which is oxidation firing, where there is a high level of oxygen in the kiln. Most aesthetic results can be achieved using an electric kiln, from bright colours to more muted shades, but not the particular effects gained from reduction firing, where air intake into the kiln is reduced (see page 86).

Many potters prefer gas kilns because of various advantages they offer. In particular, they are the best kiln type for reduction firing, which produces more interesting glaze effects. They can also be built much bigger than is possible for electric kilns on a domestic supply. Gas kilns can be self-built using a variety of brick types or ceramic fibre, and can be fuelled by natural or bottled gas. The firing cycle is generally quicker but much less predictable since the temperature increases rapidly in the early stages, so great care must be taken if used to biscuit-fire pots. Kilns of this type are best constructed outside under cover; if indoors, they require ample ventilation and ideally some form of extraction, as noxious gases can build up, especially when reduction firing.

Kilns can also be fired with other combustible materials, such as wood, oil, coal or anything that burns. The construction of the kiln is much the same as for gas,

Right: The gas kiln at Middleport pottery, used by *Throw Down* contestants. The 'door is bricked shut for each firing.

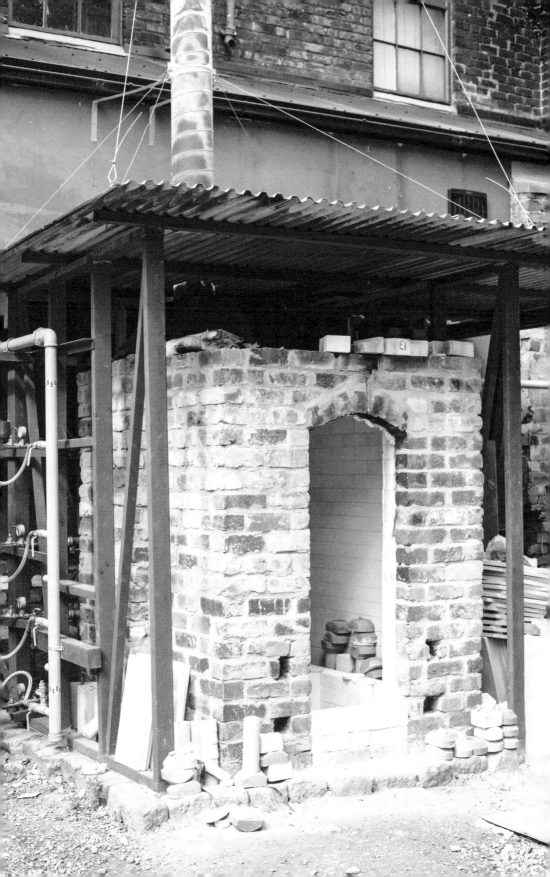

except for the provision of a fire box as opposed to burner ports. All the same safety provisions apply, plus this type of kiln must be supervised constantly, making it more of a labour of love. At its most basic, a wood-fired kiln can be cobbled together by filling a metal drum with wood, placing pots in the drum and setting the fuel alight. Traditional designs include the catenary arch kiln, where the kiln chamber is in the form of a self-supporting arch. Most wood-fired kilns are constructed outdoors.

Results depend on the type of wood used and the way the fire is fed. Suitable wood includes dry, seasoned hardwood, brushwood (for generating quick bursts of heat), along with sawdust and wood chippings; softwood can also be used. Depending on the way the fire is controlled, the process can be over very quickly or drawn out for up to a week. Placement of the pottery within the kiln is very important.

Wood firing, like raku, pit firing and soda firing, is a form of atmospheric firing, which means that the atmosphere in the kiln has a dramatic effect on the end result. Once the top temperature is reached, air intake is gradually reduced and the atmosphere in the kiln becomes saturated with ash, which reacts with both clay and glazes in distinctive ways. Colours will be softer and richer; glazed areas may be speckled from ash deposits. Wood firing also lends itself to creating patterns by masking out areas on the clay body to contrast with unprotected areas that will typically display flaring or scorch marks.

One of the most common industrial kilns today is the tunnel kiln, which allows continuous production. It consists of a structure, often many metres long, through which ware is transported. The kiln is cool at the point where the pottery enters. Then the temperature gradually increases until the ware reaches the central, hottest point. From there the temperature is gradually decreased.

Kiln Furniture and Stacking

The removable elements that allow a kiln chamber to be correctly stacked so that the maximum number of pieces can be fired, and in the case of final glaze firing, without touching, are known as kiln furniture. In addition to flat kiln shelves, which may be round, square or rectangular, kiln furniture comprises a variety of different props and supports. Cranks are self-standing supports that allow a number of multiple wares, such as tiles or plates, to be stacked in a stable fashion. Props, which come in various heights and diameters, are cylindrical supports for shelves. Stilts are rests that support a form on three small points and are designed for wares that are glazed on the base.

Although kiln furniture is made of a type of refractory material and designed to withstand high temperatures, over time items can warp, crack or become damaged

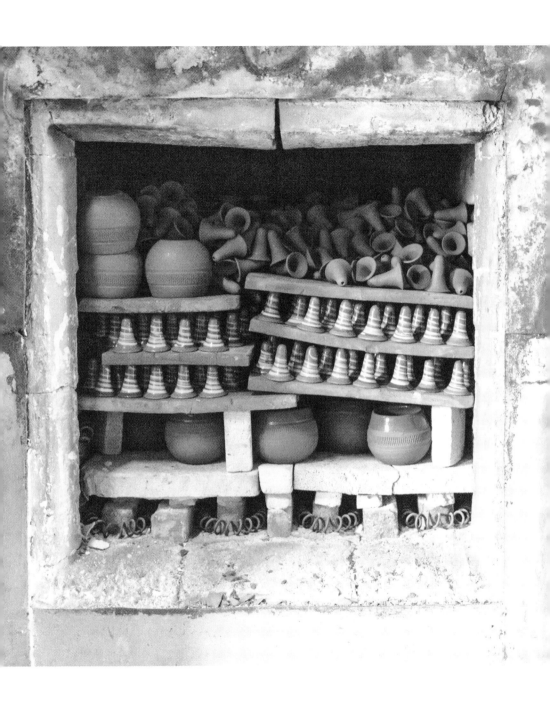

Ceramics stacked inside the kiln at
Casa del Alfarero, a pottery in Cuba.

in some fashion, at which point they should be discarded. To protect kiln shelves from glazing drips, they should be coated with nonstick batt wash, a thin paint composed of alumina and ball clay, which can be renewed as required.

The aim of stacking is to support pieces all the way up the kiln, with the weight distributed evenly. Stacking methods vary according to the type of firing. In all cases, however, kilns should be thoroughly cleaned of dust and debris beforehand and the kiln furniture checked for any damage.

For bisque or biscuit firing, kilns can be stacked very densely, with forms stacked inside one another and lidded designs with their lids in place. The general method is to work up from the base of the kiln, and from the smallest items to the largest, which requires an element of planning ahead to gauge the spacing of the shelves. Shallow props should be used to raise the bottom shelf off the floor of the kiln by about 3cm (1¼in) to allow air and heat to circulate. There should also be a gap between the kiln wall and shelf of about 2cm (¾in).

Once the bottom shelf is stacked with small, low pieces (ensuring there is a gap of 2.5cm (1in) between the pieces and the kiln elements), three props should be placed on the shelf, two at the front and one at the rear, to provide a stable tripod to support the next shelf up. For larger square or rectangular shelves, four props may be required, one at each corner. These props should be the same height as each other and clear the tallest piece by 1cm (⅜in).

All shelf props should be in line with each other, from those supporting the bottom shelf to those supporting the top. The process is repeated until the kiln is fully loaded. Delicate details protruding from a form can also be supported by small individual props.

Stacking for glaze firing differs chiefly in that the pieces must not touch each other, otherwise they will stick together once the glaze melts. The gap between pieces must be at least 1cm (⅜in).

Bisque or Biscuit Firing

The first firing is known as bisque or biscuit firing, and its purpose is to make the clay stronger and more durable while leaving it sufficiently porous to be glazed. Early on in the process, water content is driven away. Then midway, at a temperature of 573°C (1060°F), a chemical reaction takes place called quartz inversion, which marks the transition from clay to ceramics, which is irreversible. Vitrification begins at a 800°C (1470°F). Top temperatures vary according to the type of clay:

Terracotta	1000°C (1830°F)
Stoneware	1000°C (1830°F)
Porcelain	1000°C (1830°F)
Earthenware	1120–1160°C (2050–2120°F)
Bone China	1260°C (2300°F)

Clay is not the only variable. Both temperature and timing can also be affected by the age and efficiency of the kiln, the outside or ambient temperature, whether or not the kiln is fully loaded and how heavy the pieces are. Large, dense pieces need to be fired more slowly, with the temperature increased in up to four stages, to allow even distribution of heat and prevent cracking.

In all types of firing, it is not merely the top temperature that is the critical factor. More important is what is called 'heat work', which is how the rising temperature affects the way the clay body matures. Great care must be taken in the early stages of firing because if the heat rises too fast the pots may explode. A recommended programme for bisque firing, for example, is to set the temperature to rise by about 30°C (85°F) per hour until it reaches 100°C (210°F), then by 50°C (120°F) per hour until 500°C (930°F), then by 100°C (210°F) per hour until the top temperature for the type of clay is reached. At this point there should be a ten-minute 'soaking' period where the kiln is kept at the top temperature so that the heat evens out. After this, a bisque firing will need about the same amount of time again to completely cool.

The main risks associated with bisque firing are related to moisture. Contrary to popular belief, air bubbles, while not desirable, do not pose the greatest danger to forms being bisque-fired: moisture does. If a clay body goes into the kiln without being properly dried beforehand, the water will rapidly boil off, creating steam, which will escape by shattering the form. The same will happen if the temperature rises too quickly. Air, by contrast, expands more slowly, and any bubbles in the clay body may cause bloating or pop the base. (Clay forms that are entirely enclosed should be pricked with a pin to allow air to escape during firing.) The pieces cooling too quickly may also result in cracking, often referred to as 'dunting'. Other risks are associated with the type of form. Some of the hardest shapes to fire are those with narrow bases and wide tops. At high temperatures, clay naturally starts to relax and droop, and this can result in distortion.

In some cases, bisque firing will be the only firing a pot receives. This is true of unglazed terracotta or earthenware, such as plain flowerpots and planters, and of pieces that are raw glazed (see page 132).

Overleaf: Tending a wood-fired kiln at the Dakhla oasis in the Libyan desert. Such firing methods go back to ancient times.

Life in the Potteries

The area of the West Midlands known as The Potteries comprises six 'towns' – Burslem, Fenton, Hanley, Longton, Stoke and Tunstall – which together make up Stoke-on-Trent. Pottery had been made here since prehistory. Deposits of various types of clay, along with water from the River Trent and the presence of coal, provided all the ingredients necessary for the growth of the ceramics industry.

From the beginning of the eighteenth century, when Burslem was first known as a centre for pottery, the area grew to become one of key birthplaces of the Industrial Revolution. By the end of the nineteenth century more than 200 factories were operating in The Potteries and more than 2,000 bottle kilns belched out smoke that blackened the entire area. It was said that if you could see the other side of the road, it was a fine day.

One of the earliest names associated with The Potteries was Wedgwood (see page 26). It was soon joined by others, such as Minton, which eventually specialized in tiles, and Spode, famous for its 'Willow' pattern bone china. During the height of the area's success, the factories or 'pot banks' employed thousands of people. Illness was rife, with occupation-related conditions such as silicosis, caused by handling lead glazes, being commonplace. Keeping the bottle kilns stacked with wares and stoked with fuel was arduous. The outer structure of the kiln, the 'hovel', which gave the kiln its distinctive shape, was designed to

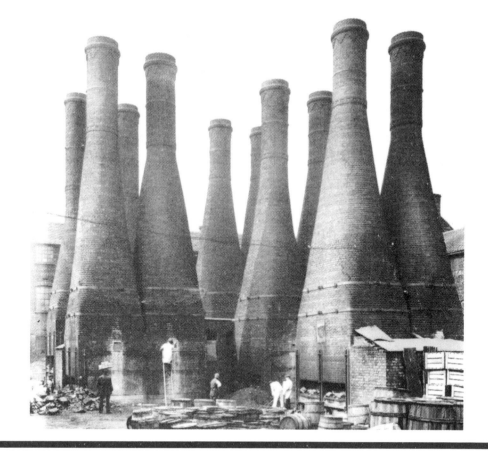

protect the inner oven from the elements and to serve as a chimney; some were up to 21m (70ft) high. The oven, known as the crown, was a round brick structure with walls 30cm (1ft) thick, braced with iron bands to accommodate its expansion and contraction. Boxes made of fireclay, known as 'saggars' (see page 90), were used as protective containers for the wares, both during the first bisque firing and the second glaze or 'glost' firing. The saggars were stacked in towers, or 'bungs', up to the top of the crown before the door to the oven was sealed shut and the fires lit. 'Placers', employed as stackers, carried saggars on their heads or shoulders into the oven. Each full saggar weighed 25kg (half a hundredweight), so to keep it balanced and protect his head, a placer would stuff

the front of his cap with rolled stockings. Bottle ovens were generally fired once a week, with each firing consuming 15 tons of coal. Once the fires were lit, more coal had to be loaded every four hours. After about two days, when the maximum temperature was reached, the fires were left to go out. Dampers in the chimney allowed the temperature to be controlled. Sometimes workmen had to venture into the oven before it was fully cool to fetch the saggars. Wrapped in overcoats, with wet rags over the faces and hands, they ran the risk of serious burns.

Smoke belching from bottle kilns and factory chimneys at Stoke-on-Trent, Staffordshire.

Glaze or Final Firing

In glaze or final firing, unlike bisque firing, the temperature can rise quickly, slowing as it reaches its peak, at which point the glazing materials will start to melt. As with bisque firing, top temperatures vary according to the type of clay:

Earthenware	1080°C (1975°F)
Bone China	1080°C (1975°F)
Stoneware	1200–1300°C (2190–2370°F)
Porcelain	1300°C (2370°F)

Glaze firing typically takes up to 12 hours to reach the top temperature and then the same again to fully cool. Cooling is best done as rapidly as possible to keep the glaze bright and shiny; slow cooling allows crystals to form, which dull the surface. The recommended rate is a rise of 50°C (120°F) per hour to 150°C (300°F), then 100°C (210°F) per hour to 500°C (930°F), then full power to the top temperature. This must be followed by a 'soaking' period of anything from 10 minutes to over an hour.

Because earthenware is porous, it is best to glaze pieces all over to seal them. They should be supported on a stilt during firing so that they do not stick to the shelf. Alternatively, the foot rings or bases can be waxed. It is also worth noting that glossy glazes have a tendency to run, so be careful not to excessively glaze your pot. This is not a problem with matt glazes (see page 121).

Reduction Firing

In reduction firing, the kiln is stifled of air so that free carbon atoms start to take oxygen from the clay and glazes, changing the chemistry of the materials.

There are a huge number of variables and each firing is likely to produce different results. Kiln shelves should be arranged at uneven heights so that the flames are not concentrated at one point in the chamber. At the beginning, the kiln is kept well ventilated to allow the temperature to increase to the point at which reduction can begin, which is between 900°C (1650°F) and 1100°C (2010°F). Then air intake is progressively reduced; if it is reduced too early, before the kiln is hot enough, the free carbon atoms will turn the glazing black before it is fired.

Reduction firing, while unpredictable, results in rich, deep colour effects. Unglazed clay will emerge darker; copper oxide, which turns blue-green in an oxidation firing, comes out red in a reduction firing; iron oxide, which becomes honey-coloured in an oxidation firing, will turn celadon.

Salt-glaze or Soda Firing

A technique that has been around for centuries and was originally used to glaze everyday dishes, salt-glaze firing (see page 132), and its less-polluting variant soda firing, produces a distinctive textured 'orange peel' finish all over the surface of the clay body. Salt glazing can be done as a single firing – there is no need for a previous bisque firing. The method entails the periodic introduction of salt or soda to the chamber once the kiln has reached a certain temperature. The resulting vapour reacts with silica in the clay. Garden salt is generally used in salt-glaze firing, and bicarbonate of soda is used for soda firing. Soda firing gives off fewer toxic fumes than salt glazing and is less polluting.

Salt glazing is done in a similar way to reduction firing, with the shelves of the kiln staggered, and enough space left in between each piece to allow the salt deposits to build up. The kiln is warmed up gently, then reduction begins at around 950°C (1740°F) until 1250°C (2280°F) is reached. Salt is introduced at a temperature of 1260°C (2300°F) and every 10–15 minutes thereafter until 1300°C (2370°F) is reached. This is following by a soaking period. There are various ways of introducing the salt or soda to the kiln. One is by pouring small quantities through an open hatch and another is by pushing in packages of salt or soda through a chink in the firebox.

Kilns that are repeatedly used for salt glazing gradually become 'conditioned', which means that salt deposits build up on the interior surfaces. These deposits adversely affect the lifespan of the kiln.

Alumina, which is salt resistant, can be used to mask out areas on the clay body and so create patterns. Thin oxide washes or coloured slips can be applied before the salt glazing to introduce subtle colour.

Salt-glazed stoneware (1874–84) by H. Wilson
& Co., founded by freed slaves in Texas in 1869.

Saggar Firing

In the days when industrial kilns were powered by coal, saggars, or enclosed boxes, were used as a means of protecting wares from deposits flying around the kiln, which would ruin the glazing. These boxes were made of clay containing a high percentage of grog, which enabled them to survive the high temperatures they were subjected to during firing.

Today, saggar firing is often employed in a reverse fashion to achieve specific colour and textural effects. Combustible material is packed into the saggar, surrounding the pottery, to create a reducing atmosphere.

Raku

Chaotic, elemental, volatile: raku is one of the most spectacular, dangerous and technically demanding of all ceramics techniques. Glazed pieces are fired for a short time at a high temperature in a raku kiln, which is smaller than a regular kiln and pyramid shaped. They are removed from the kiln when they are red hot and then either left to cool in the air, covered in combustible material in a 'reduction chamber' or plunged into water. There is nothing gentle about the process whatsoever – steam hisses, smoke billows and sparks literally fly. The risk of pieces exploding or cracking is high, and the results of glazing are unpredictable. It is truly a high-wire act for experienced potters and novices alike.

The raku style, originating in the sixteenth century, was a significant development in Japanese pottery. From that period onwards, modest hand-shaped *chawan* tea bowls, often crackle-glazed in subdued colours, became an important component of the tea ceremony (see page 142).

The British studio potter Bernard Leach (1887–1979; see page 94) brought his own version of the tradition to the West, installing a wood-fired Japanese kiln at his St Ives pottery in 1922. Since then, many potters around the world have experimented with the technique, notably the celebrated American ceramics artist Paul Soldner (1921–2011), who said: 'In the spirit of raku, there is the necessity to embrace the element of surprise. There can be no fear of losing what was once planned and there must be an urge to grow along with the discovery of the unknown.' The use of a reduction chamber after firing was Soldner's innovation.

Clays used for raku must be able to withstand immense thermal shock. To increase resilience to violent temperature changes, 'grog', or some other form of temper, is added to the basic clay. (Grog is clay that has already been fired, then ground down

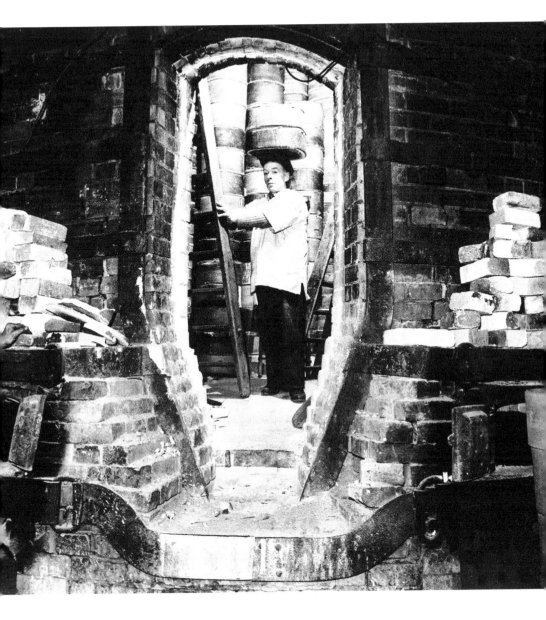

A potter stacking a kiln with saggars,
The Potteries, early 1900s.

to a powder.) After throwing or shaping, forms are left to dry and then bisque fired, the timings determined by their size and mass.

Raku lends itself to experimenting with masking out. Patterns, lines and shapes can be created during the glazing process by covering sections with wax or tape that will burn off in the firing, leaving the clay body exposed. Wax is useful for creating curves, while tape gives a more linear effect. Glazes need to be applied relatively thickly for the best results.

The final stage is where the unpredictability and drama comes in. After an hour or two of final glaze firing at a high temperature – around 1000°C (1830°F) – the forms are removed from the kiln while they are still red hot, in itself a perilous process requiring nerves of steel, steady hands, long tongs and protective clothing to negotiate safely.

What happens next depends on how the pieces are subsequently treated. In traditional Japanese raku firing, the final stage is to cool the forms slowly in the open air. Cooling them quickly, by plunging them into water, produces different chemical reactions in the glazes, instantly fixing them and giving much more vibrant colour effects, but at the greater risk of ruinous cracking and shattering.

Alternatively, fired pieces can be removed from the kiln and dropped into the potential inferno of a 'reduction chamber', typically a metal dustbin filled with some form of combustible material, such as sawdust – although one enterprising *Throw Down* contestant used a mixture of dried gorse, bladderwrack and manure. The bin is then covered with a lid, which can be sealed with clay around its rim to make it more airtight. The heat from the fired pieces sets the combustible material alight and, as it continues to burn, oxygen in the chamber is reduced until it is pulled directly from the glazes and clay. After the charred debris has been cleaned away and the scrubbing process has been completed, any unglazed areas will emerge black, while glazes will have an iridescent sheen. Crackled finishes can be achieved by leaving the piece in the open air before the reduction process.

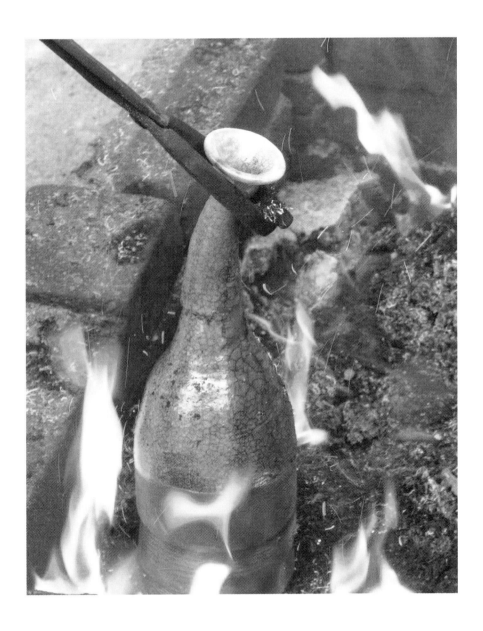

A crackled or crazed finish is characteristic
of raku ware. Here, a thin-necked vase is
carefully lifted out of the fire using tongs.

Bernard Leach
(1887–1979)

Often described as the 'father of British studio pottery', Bernard Leach was the most influential artist-potter of the studio pottery movement. Born in Hong Kong, he lived in Japan for four years, returned to Hong Kong for a while and then lived in Singapore until he was sent to school in England at the age of ten. He went on to study at the Slade School of Art, but left when his father fell ill. He then worked as a bank clerk for a short time, to fulfil his dying father's wishes, before quitting to enrol at the London School of Art.

Leach moved back to Japan in 1909, and studied ceramics and taught etching. Ten years later he befriended the potter Shōji Hamada (1894–1978), and within a year the two men travelled to England together and opened the Leach Pottery on the outskirts of St Ives in Cornwall, close to an existing artists' colony. There they constructed a traditional Japanese climbing kiln, or noborigama, the first of its kind built in the West. This three-chamber, wood-burning kiln enabled them to produce individual items of stoneware, including decorated earthenware dishes, slip-decorated pieces, lead-glazed tableware and raku.

In 1923 Hamada returned to Japan, but Leach remained in England, continuing to develop his pottery and fusing Western and Eastern art and philosophies. He combined influences from Japanese, Korean and Chinese pottery with traditional English and German

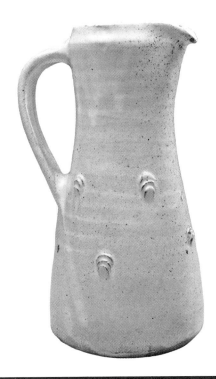

techniques such as slipware and salt-glaze ware. His stoneware methods and styles were inspired directly by ceramics and philosophies from the Chinese Song Dynasty (960–1279 CE) that focused on beauty and usefulness, and he blended this with pre-industrial English slipware techniques. Maintaining that his work was a combination of art, philosophy, design and craft, form rather than decoration was his principal focus.

Leach also organized the production of well-designed, lower-priced ranges of domestic stoneware by a small team in his studio. He also trained pupils, some of whom went on to open their own studio potteries, such as Michael Cardew (1901–83).

Leach's East–West inspired stoneware was, however, fairly difficult to achieve, requiring exacting attention throughout the process, and the resulting wares were costly. He struggled to keep afloat. In 1940, *A Potter's Book* was published. Defining both his philosophy and his methods, it ensured his international reputation. In turn, sales of his ceramics increased. He continued to travel and write books, and he developed a skilful decorative technique of drawing with a brush on the absorbent surfaces of stoneware tiles with Japanese-style flourishes.

A stoneware pitcher made by Bernard Leach, c.1958, typical of his simplified, rustic approach.

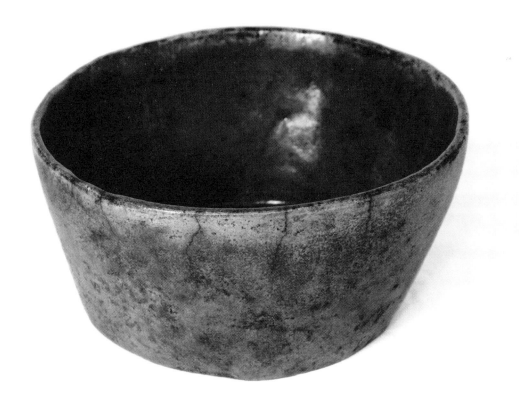

Raku-fired pots, such as this simple tea
bowl, are a key element of the traditional
Japanese tea ceremony.

Pit Firing

During this form of atmospheric firing, the clay bodies absorb colorants from particles in the vapour that is given off by whatever material the fire is burning. Dating back nearly 30,000 years, pit firing is a hugely unpredictable process associated with a high proportion of breakages. When successful, however, the results can be simply stunning.

What goes into the pit are unglazed forms, whether hand built or thrown on the wheel. These can be coated with multiple layers of terra sigillata, a very fine slip (see page 112), and burnished. It is generally preferable to bisque fire them before the final pit firing in order to increase their strength and minimize the risk of breakages. The British ceramicist Jane White, who uses the pit-firing technique at her farm in the Chilterns (see overleaf), likes to wrap her pots with copper wire before the final firing, to produce a vivid red finish.

As the term suggests, pit firing takes place outdoors in a specially dug hole or pit in the earth, which is at least 25cm (10in) deeper than the largest pot being fired. Some pits are lined with concrete or stone for added insulation, although this can increase the risk of breakages if the liner cracks or explodes. All pits should have a surrounding firebreak – an area of cleared ground to ensure that the fire does not spread. Needless to say, this is a firing technique that poses stringent health and safety considerations.

The pit is filled with combustible materials, the first layer of which is generally 20–30cm (8–12in) of either fine sawdust or wood shavings. The pots are then carefully bedded into this layer. Oxides, or powdered glazes, can be distributed around the clay pieces, and then a selection of solid colorants – in the form of a whole host of ingredients, which could include dried nutshells, dried banana skins and fruit peel, salt, dried coffee grounds, manure, dried seaweed and such like – are scattered over the surface of the pit. In the fierce heat of the fire, these natural ingredients vaporize and create different pattern and colour effects on the surface of the clay.

The next stage is to construct the pyre from solid pieces of wood (preferably hardwood), scrap paper and cardboard. Pit firers have their own tried-and-tested methods of building the fire, but the overall aim is to ensure that it catches quickly and burns evenly across the pit. Once the fire is lit, it will blaze fiercely, gradually dying down over a short period. At this point, the pit can be left to do its magic, covered with sheets of metal to trap the heat inside for a further period of time, up to 72 hours in some cases.

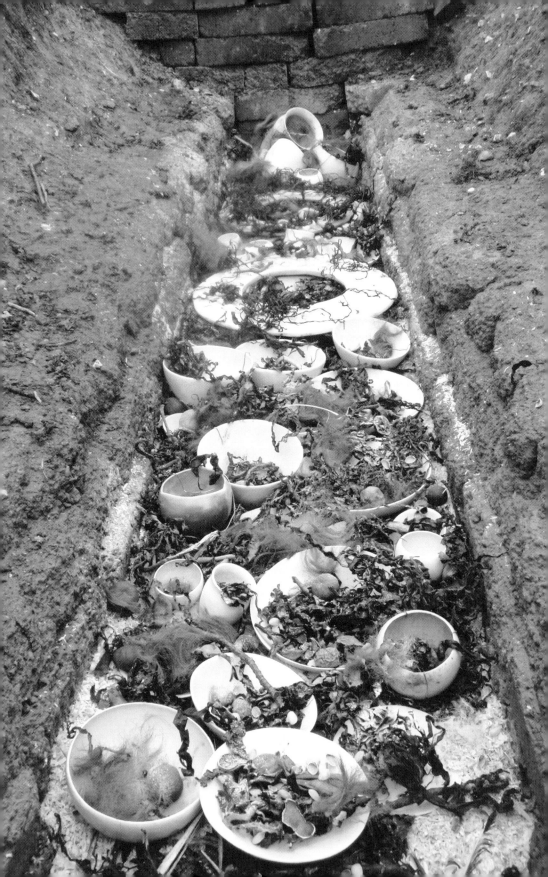

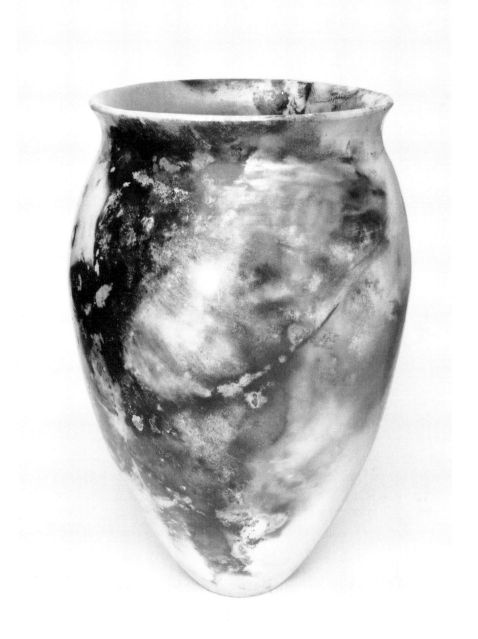

Left: Strewn with a variety of combustible
materials, Jane White's pots await pit firing
at her farm in the Chilterns.

Above: Like raku, pit firing results in
vivid colour effects, as seen in this pot
by Jane White.

Retrieving fired pieces is always a heart-stopping moment. In the case of pit firing, where it is not uncommon for more than a third of the pots to break, it is particularly tense. But what emerges unscathed from the inferno can be staggeringly beautiful, with intense smoky shades, mottled patterns and intriguing textures that have been forged in the flames. After brushing off the soot, ash and other debris, pots can be further enhanced by rubbing them with a fine wax polish or coating them with a seal. No two will be alike.

Cooling

Whichever firing method is chosen, cooling is an important part of the process. If it is rushed, there is a chance that pieces might crack. As a general guide, electric or gas kilns should be cooled to 80°C (175°F) or lower before they are opened. Timings of cooling periods will vary, but will typically be measured in hours, if not a day or more.

After the kiln is opened and the pieces have been retrieved is the time to inspect not only the work but also the kiln itself. A kiln is a substantial investment for the home or studio potter, and every effort should be made to keep it well maintained. Routine cleaning, by brushing or vacuuming after every firing, will help to prolong the working life of the kiln. This is also the time to check both the lining and elements (or burners) for damage. Cracks to the ceramic material lining the kiln can be repaired if they are superficial; alternatively, depending on the design, it may be possible to substitute new bricks for damaged ones. Faulty or worn-out elements can also be replaced. It is generally advisable not to move a kiln from place to place too often or, in the case of an electric kiln, to keep inserting and removing its plug from the socket.

Right: Pueblo pottery first appeared in the Rio Grande valley around 700 CE. Still made today, its characteristic black finish is the result of surrounding the pot with dung, blocking off oxygen.

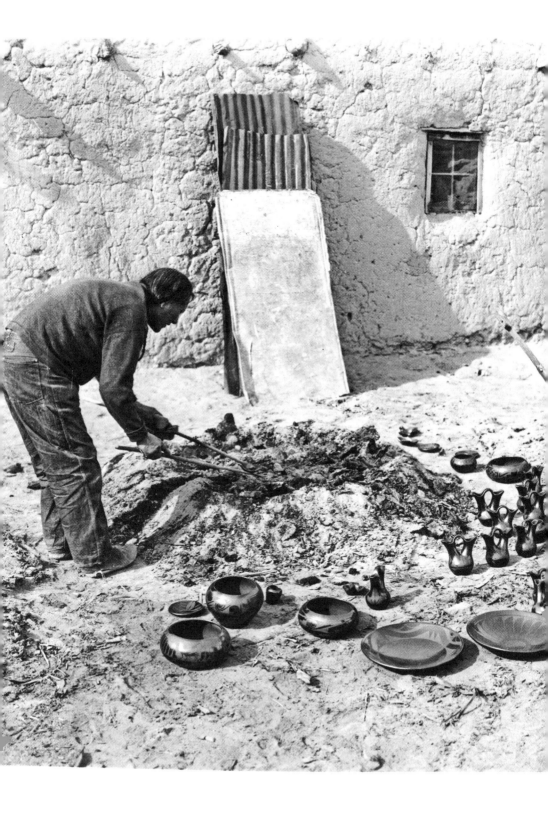

Colour, Texture & Pattern

The interaction between form and surface is crucial in ceramics decoration. Some of the most effective designs convey the attributes of the clay, enhance shape and proportion, and create coherence across a group of related objects, such as a tea service or set of stacking bowls.

From the earliest times, humans have decorated their ceramics in almost every culture. Certain methods have built on national traditions, with subsequent potters refining, adapting and developing elements, resulting in recognizable characteristics. Forms of decoration have also developed through long traditions of borrowing from others and the cross-fertilization of ideas. For instance, Medici porcelain imitated traditions of majolica from Urbino in Italy, as well as Chinese and Middle Eastern patterns and colours, while seventeenth-century Dutch Delftware drew heavily on the decorative styles of Chinese blue-and-white porcelain.

Ranging from complex and intricate to simple and straightforward, methods of decorating clay objects often rely on individual interpretation. While adhering to the basic techniques, many potters find their own ways of achieving their desired results.

Slip Decoration

Either white or coloured, mixed with metal oxides or stains, decorating slips and engobes are often used for coating pottery surfaces before or after bisque firing, to give colour, to create smooth or textured surfaces, and for decoration, as in slipware. Decorating slip is usually applied to clay at the leather-hard stage. Engobes are white or coloured clay slips that also contain fluxing materials – agents that cause mixtures to fuse and reduce the overall melting point of the clay body. Different fluxes have different characteristics.

Left: This matte finish on muted pastel-coloured Swedish crockery
was created with a copper-based glaze, often called Peach Bloom,
that originated in China during the Qing dynasty.

Pre-dating glazing, slipware is one of the earliest forms of ceramic decoration. Ancient Greek black- and red-figure pottery is probably the most well-known early example, even though older fragments of red-slipped pottery, believed to be about 5,000 years old, have been found in Japan, and examples of white-slip decoration dating from 2000 BCE from the Minoan culture have been discovered on the island of Crete. During the seventh century Chinese potters were creating brushed and incised marbled patterns through white-slip washes, and by the European Middle Ages various traditions of slip-decorated pottery had evolved. From the fifteenth century Italian potters were producing red clay ceramics coated with white slip and incised with patterns. Spanish and French potters developed their own slipware traditions during the sixteenth century, while German and Dutch potters experimented with various techniques from the early seventeenth century.

In the mid-seventeenth to eighteenth centuries in Staffordshire and Kent in England, methods of slipware reached an unprecedented level of attainment, displaying vigour and originality, using local materials. These individual uses of slip eventually evolved to become several accepted methods of decoration, both textural and flat, including sgraffito (incising), layering, painting, carving, trailing, feathering, marbling and inlay. Decorating slips have to be sufficiently fluid and thick to enable them to be brushed onto clay bodies; for most techniques, they are applied to damp or leather-hard clay.

Painting
Multiple coloured slips are applied with brushes to create pictures or designs on damp or leather-hard clay. Slip can also be trailed or dabbed on with a sponge or fingers. Early painted slip designs made before 3000 BCE have been found in Mesopotamia, and these and other early coloured slips were achieved by staining with various metallic oxides that occurred naturally in the clay.

Before pottery colours began to be mass manufactured after the Industrial Revolution, the main oxides used were tin, cobalt, copper, iron, manganese and antimony. Tin oxide creates white, and both cobalt oxide and copper or cupric oxide produce various blues that range from a dull grey-blue to a bright sapphire. Cobalt oxide was widely used in East Asia and Europe in blue-and-white porcelain. In the presence of excessive carbon monoxide – which the Chinese achieved by throwing wet wood into their kilns – cupric oxide results in a reddish blue. Copper or cupric oxide and cuprous oxide produce a variety of greens, while iron or ferrous oxide yields a soft grey-green, as in Chinese celadon ware. Manganese oxide creates hues varying from bright reddish purples to extremely dark violet, and antimony produces yellows.

Pouring or dipping slip creates flat, opaque coatings, while brushwork gives more variation. When applying slip with a brush, it should be held almost perpendicular to the vessel with a sure, steady hand, both for sweeping and precise designs.

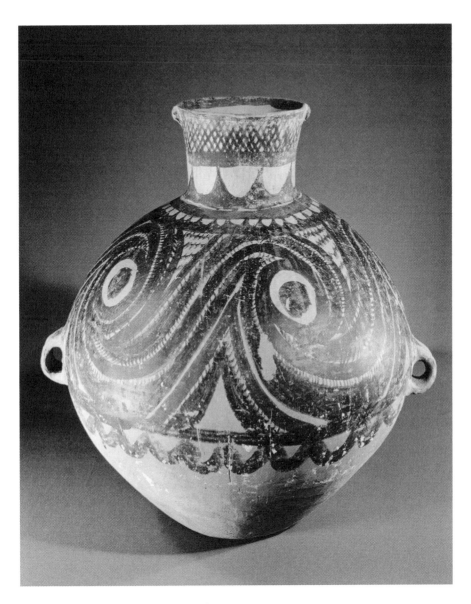

From c.2000 BCE, the Minoans produced
distinctive pottery, often decorated with
curves and spirals.

Sgraffito

The technique of scratching through a layer of coloured slip coating a clay body to reveal the contrasting colour of the clay beneath is known as sgraffito. Several layers of slip can be applied while the clay object – or greenware – is leather hard, and then the incising or sgraffito is undertaken before firing. It is possible to achieve intricate and varied effects, which can be lightly 'drawn' first using a pointed tool. The depth and definition of incised lines are determined by the tools and pressure used, and by the dryness of the clay. If the clay is leather hard, the incised lines will generally be clean and distinct, but once the clay is dry, the incisions will create dust and may also chip. Many sgraffito tools are available with varied nib widths, but any pointed tool, such as a hard, sharp pencil point, may be used.

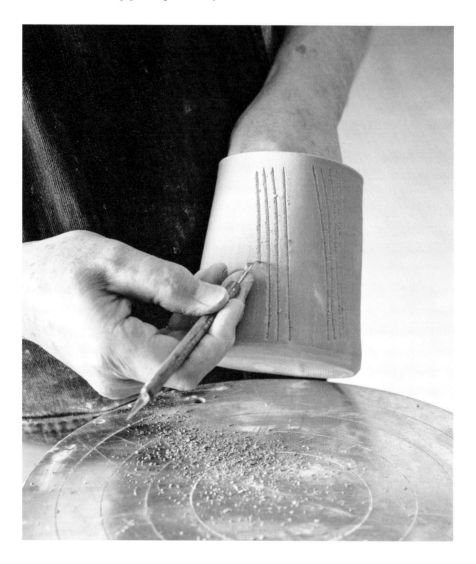

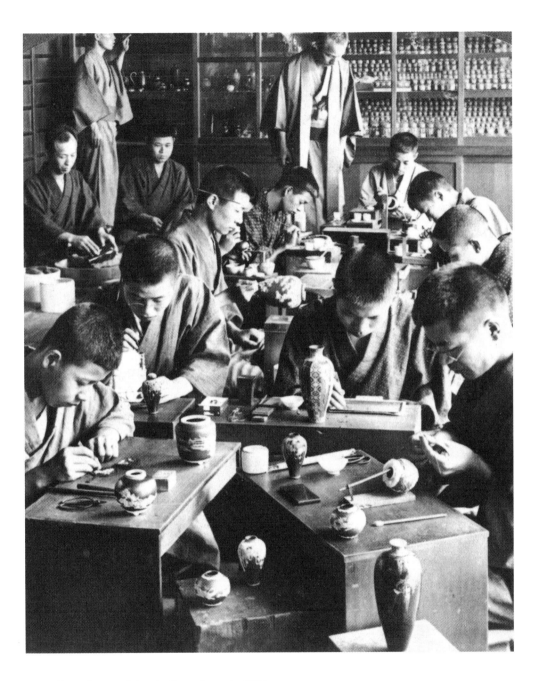

Above: In a workshop in Kyoto, Japan, in 1904, experienced men create cloisonné designs.

Left: Sgraffito involves scratching through a layer of coloured slip that coats a clay body.

Trailing

One of the most popular methods for applying slip since the seventeenth century, trailing creates raised surface designs and textures. The method requires dexterity and control, and the use of a trailing tool, to which different-sized nozzles can be attached.

Feathering

Named after the pattern it produces, feathering is easier to achieve on flat clay objects than on three-dimensional or curved objects. The technique involves applying bands of contrasting slip to damp or leather-hard clay. Usually the bands are applied using the trailing method; they are placed next to each other and may overlap. While the slip is still wet, a sharp but flexible tool is drawn through the bands, usually at right angles. Traditionally, the pattern was created by the end of a feather being dragged across the lines at equal distances, as if making a grid.

Marbling

A similar decorating technique to feathering, marbling begins in the same way, with coloured, wet slip being applied to a leather-hard clay body. While this is still wet, trailed lines of fluid slip in a contrasting colour are applied, and the object is rocked and tilted. As the two forms of wet slip merge and run into each other, the object is tilted and rocked more, creating a simulated effect of marble striations. A similar decorative method was invented by Korean potters during the Koryo Period (935–1392 CE), called Mishima (see page 116).

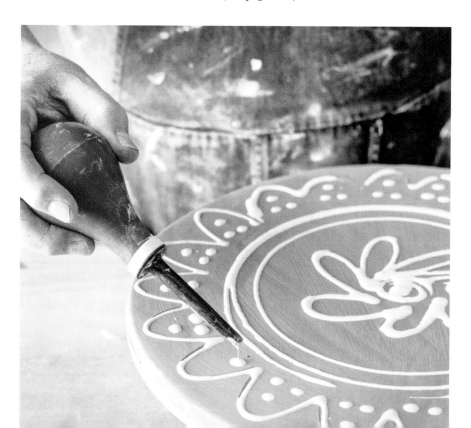

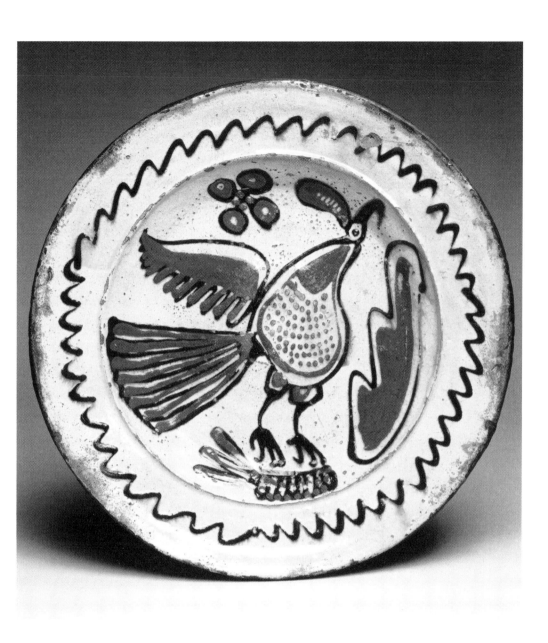

Above: A boldly patterned plate depicting a
characterful bird, made in Staffordshire, c.1690,
using the trailing method.

Left: Requiring both a steady hand and a trailing
tool, trailing has been a popular decorating
technique since the seventeenth century.

Inlaying

This method forces different coloured slips into clay of another colour (see page 94). As with many techniques using decorative slips, it is best for the clay to be leather hard. To begin, a lump of clay is rolled out into a large slab (fig 1). A design is incised on, and any loose clay is smoothed away with a rib (fig 2). It is helpful for the slip to be mixed with fine grog to reduce shrinkage or cracking. This is then smoothed over all the incised lines, but left slightly proud to compensate for shrinkage (fig 3). When dry enough, surplus slip is scraped or smoothed away to reveal the smooth clay with areas of contrasting colour in the chosen design (fig 4). (Another inlaying technique, not using slip, is to roll soft clay in a contrasting colour over pre-prepared firmer clay motifs, which become embedded – or inlaid – into the soft clay.)

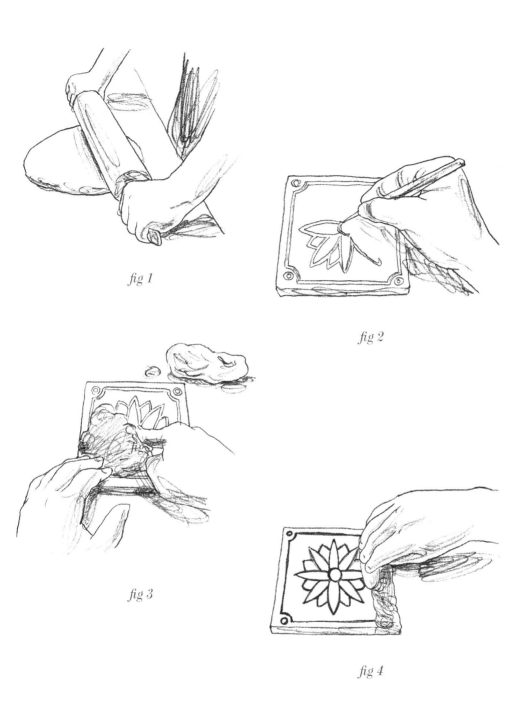

fig 1

fig 2

fig 3

fig 4

Left: The tessellated floor of the entrance hall at Sunnycroft,
Shropshire, c.1899, consists of plain, vitreous and encaustic
tiles that demonstrate inlaid coloured sections.

Terra sigillata

First used in the first century BCE in the eastern Mediterranean, terra sigillata describes a relief-decorated glossy red earthenware. In contemporary ceramics art, the term, which means 'earth seal' in Latin, refers to a particularly fine, watery slip that is used as a surface glaze for burnishing and is also sometimes brushed on as a colorant.

Stencilling

Slips can be brushed onto damp or leather-hard clay over stencils. These may be specially formulated stencils or handmade from plastic-coated fabric or waxed, plasticized or greaseproof paper. A handmade stencil has to be cut out carefully, with any distorting effects of curvature taken into consideration. With the stencil in place – water is often enough to make it adhere to the leather-hard clay – watery slip is brushed over it and left to dry; the stencil must be left on for as long as possible, otherwise the slip may move or run onto the body of the clay. The stencil is gently pulled up and off, any slip that has bled is gently scraped away, and the object is fired.

Relief and Textural Decoration

Relief carving creates illusions of depth and texture. Slip texturing, which is the effect of surface roughness and distortions, is created by adding tempers, such as grog or sand, to slip and applying it either all over or just in judicious areas.

Carving and layering

Low-relief carving involves some surface clay being removed or added to in certain areas, creating gentle images or patterns in shallow contrasts of height and depth. High-relief carving is similar, but requires cutting deeper into the clay so that the depths and heights are more pronounced. With high-relief carving, clay is often added to raise some areas prominently. Both of these forms of carving can be executed directly onto clay or slip. In slip carving, a clay body is covered with a thick coating of slip, which is then carved into with a knife, leaving the slip as a raised design.

Another technique, similar to carving and sgraffito (see page 106), is layering, which involves building up layers of different coloured slips and then carving through them to reveal bands of colour. To begin, multiple layers of slips in contrasting colours are applied on top of each other on damp clay. Once the entire piece, including each slip, is leather hard, the layers are carved through in a design, revealing both the multicoloured layers of slips and the clay body beneath.

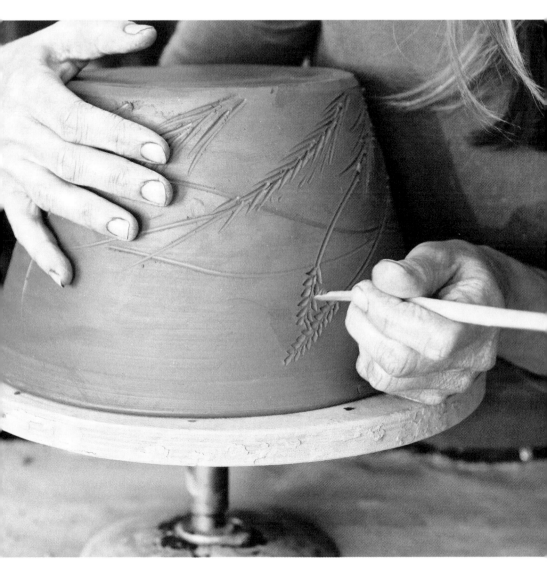

Carving a freehand pattern of corn ears
and grasses onto a large terracotta pot
at the leather-hard stage.

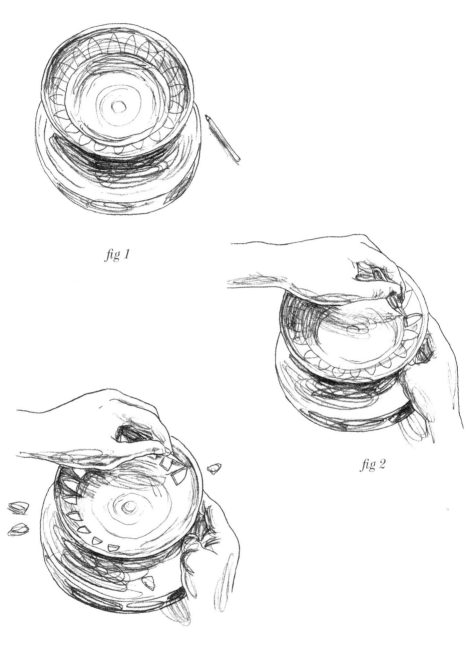

fig 1

fig 2

fig 3

Right: Piercing requires a steady hand and sharp tools. This item is fairly thick and leather hard, so can withstand the cuts without being weakened.

Piercing

As a method of cutting completely through clay to make holes, piercing has to be undertaken with extreme care to avoid weakening the object. As well as being pierced, holes can be cut or pricked into leather-hard or softer clay. Piercing at the leather-hard stage, nonetheless, needs the clay to be dampened slightly to avoid it becoming too brittle, especially if it is a fine body such as porcelain. Once the design has been planned, it is marked on the clay body with a pencil (fig 1). Various sharp tools can be used for piercing, including knives, sharp, narrow blades and boring tools, but it must be executed quickly to reduce the possibility of any cracking. The hand not performing the piercing must support the object carefully (fig 2). When all the piercing is complete, the greenware is wiped gently with a damp sponge to remove any roughness and left to dry, ready for firing (fig 3).

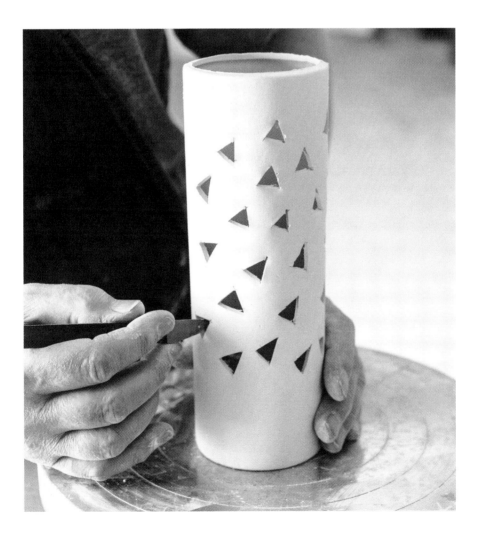

Stamping and rolling

Also called impressing or embossing, stamping involves pressing objects into a clay surface to create textured effects. This has to be carried out while the clay is still soft enough to take clear impressions without cracking, yet firm enough to retain crisp definitions, so in this case, leather hard is too dry. Rather than pressing objects in, a sheet of clay can be rolled over specially prepared stamps or other textured items. The soft clay is forced to form around the textured shapes. A range of objects can be used for this, including specially made clay stamps, pre-prepared stamps, or textured natural or ready-made items, such as brooches, buttons or shells.

Rolling gives similar results to stamping. A specially made roller (roulette) with a textured surface is pushed over a slab of soft clay, or any other firm, cylindrical textured object, such as a carved rolling pin or printing roller, can be used.

Mishima

The technique of inlaying coloured slip into a clay body of a contrasting colour is known as Mishima. It allows for extremely fine, intricate design work with hard, sharp edges that can be difficult to reliably replicate in any other way. Although the name Mishima comes from a city in Japan, the technique was actually first produced in Korea during the Koryo Period (935–1392 CE). The name arose because the style was similar to the script used on calendars created at the shrine in Mishima.

Decorating pottery with this technique begins with leather-hard clay being incised in a design. Unlike some textural decorations, for this technique both the clay and the slip should be fine bodied with no inclusions. Contrasting slip is then pressed into the incisions, making sure that any air is expelled. The slip used at this stage should be proud of the surface, because it will shrink as it dries. Any surplus slip can be brushed away with a soft brush once the entire object has dried. After firing, the slip patterning should be flush with the clay body.

Hakeme

As with Mishima, this technique has been practised in Japan for centuries, but it was invented by Korean potters who called it *gye yal*, meaning 'brushstroke'. White slip is applied to the surface of a leather-hard clay body with a dry straw brush, creating bristle marks in the slip and revealing some of the clay beneath. These brushstrokes generally emphasize the curves and shapes of objects. The method conveys a dynamic, free and artistic style, which was embraced by Japanese potters whose gestural simplicity enhanced the method.

Right: A hakeme tea bowl from the late Edo period
(mid- to late-19th century), made of stoneware
with brushed white slip under a clear glaze.

Combing

The practice of making parallel lines on the surface of a pot, usually by dragging a tool through the clay, is called combing, even though this can be achieved with various implements, such as forks or feathers, as well as special comb tools. The method involves drawing a textured implement through wet slip to reveal lines of the clay body beneath. Combing was frequently used to create patterns and designs in the Staffordshire potteries during the seventeenth century.

Tube lining

A thin line of soft clay is squeezed through a nozzle onto a clay object, defining areas that are then filled with colour. This method of decoration, known as tube lining, can be undertaken on leather-hard or bisque pottery; it was used extensively by William Moorcroft (1872–1945) and his son Walter Moorcroft (1917–2002) in Britain, and by Frederick Hurten Rhead (1880–1942) and his sister Charlotte Rhead (1885–1947) in the United States. Slip trailing is similar, but it can only be applied to leather-hard greenware, not bisqueware.

Sprigging

Sprigging is a method of embellishing pottery with embossed decorations. The technique was first undertaken in the fifteenth century in Germany and reached the height of attainment in the late 1700s, when the Wedgwood company adopted the decorative technique and became famous for its Parian ware, featuring white-sprigged coloured bodies. To create a simple sprig, an object such as a shell can be pressed into the middle of a clay base with a rim or small 'wall' raised around it (fig 1). Liquid plaster is poured over to fill the well between the object and the rim (fig 2). Once the plaster has set, the clay and shell are removed, leaving the piece of dried plaster with the indented shape in it (fig 3). Soft clay is smoothed into the indent using a rib or small trowel (fig 4), then carefully removed. Numerous sprigs can be made from the same mould for pressing on to a bisque-fired vessel using moist slip as glue (figs 5 & 6).

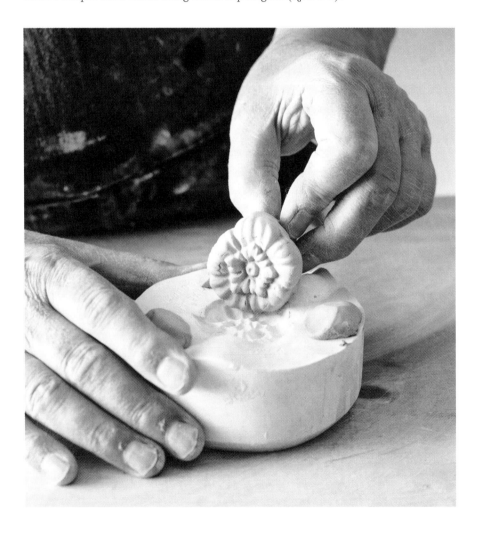

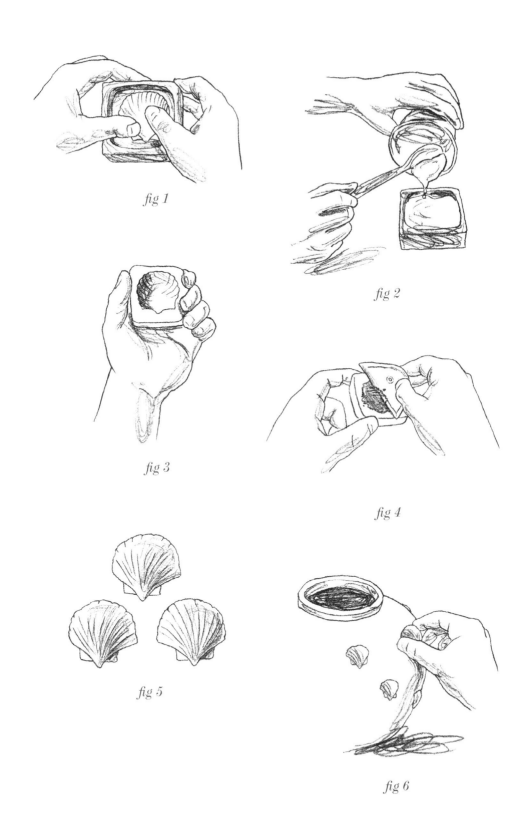

fig 1

fig 2

fig 3

fig 4

fig 5

fig 6

Pâte-sur-pâte

In 1850 in France at the Manufacture Nationale de Sèvres, porcelain workers tried to emulate the decoration on a Chinese vase, but instead mistakenly invented a rather complicated form of decoration that resembles sprigging without the use of moulds. Perfected by the French porcelain artist Marc-Louis Solon (1835–1913), the method became called pâte-sur-pâte, or 'paste on paste'. Solon eventually left Sèvres to work for Minton, where he became the leading exponent of the technique.

Pâte-sur-pâte results in a low- or bas-relief design that can vary from opaque to almost transparent. To begin, successive layers of white slip are applied to an unfired coloured clay body with a brush. This is left to stiffen; once it has reached the desired level of dryness, it is carved in low relief. When fired, the slip layers become translucent.

Glazes and Oxides

Glazes are protective and decorative coatings, which are generally applied to clay at the bisque stage, although they can also be applied at the leather-hard or bone-dry stage and fired togethier (see raw glazing, page 132); firing fuses the glaze to the clay. Glazes can be solely functional, used to make porous clay bodies waterproof; they may be primarily decorative and applied to create various effects, such as colourful or shiny finishes; or they can be used to simultaneously strengthen and enhance.

The earliest potters made glaze from feldspar, ash and any iron-rich clays that were found locally, which usually resulted in earth-coloured pots. Eventually, they began adding metal oxides and other minerals to create colours. Believed to have been first produced by the ancient Egyptians in approximately 2600 BCE, the earliest glass-like glazes – fritware – were made of sand (silica) and salt, and were fused by fire to create a vitreous finish. The ancient Greeks experimented with polychromatic forms of glazing; some early lead-glazed ware has been found in parts of Mesopotamia and the Roman Empire, while three-coloured glazes were used for a short period in China during the Tang Dynasty (618–907 CE). The first Islamic opaque glazes were blue, found in the Iraqi city of Basra and dating from the eighth century, while white, shiny, opaque tin glaze was also developed in Iraq during the ninth century. Approximately 800 years later, tin glaze became used extensively in several European wares, including Delft, faïence and maiolica. Successful glaze recipes, such as celadon, discovered in China probably during the Shang Dynasty (c.1600–c.1046 BCE), became jealously guarded as precious commodities.

The raw materials of most ceramic glazes have continued to include silica, which forms the glassiness, plus flux or frit, which consist of various minerals such

as sodium carbonate, borax and lead that lower the silica's melting point, plus aluminium oxide, or alumina, a stiffening agent that creates stability and helps the melted glaze to shrink by the same percentage as the clay object it covers. Once this basic glaze has been prepared, other minerals – usually oxides – are often added to produce various decorative effects. The most common minerals used for this are cobalt, iron, chrome and copper oxides, manganese dioxide and vanadium pentoxide, which produce a wide range of colours from deep blues and purples to pale yellows, cool greens and vibrant pinks, oranges and reds.

Glazes can be bought ready prepared or they can be mixed by hand. To mix a glaze, a large lidded bucket is required, at least twice the size of the volume of glaze that is going to be made. Water is added first – approximately 100ml (3½fl oz) of water to every 100g (3½oz) of dry ingredients – and then the finely ground dry materials are put into it. The mixture is left to slake (soak) and is then sieved several times until a smooth and workable consistency is obtained.

Types of glazes

Most raw glazes are altered during firing. The heat of the kiln causes a chemical reaction that changes the glaze's appearance, and many glazes turn different colours when they are fired to higher or lower temperatures. Similarly, various finishes can be obtained, such as transparent or semitransparent, or opaque or partially opaque. Even when they are coloured, base glazes are generally transparent, due to the silica, and opacity is achieved through tiny particles or trapped air bubbles being held in suspension within the glaze. White glazes are usually white due to opacity rather than a colorant. Minerals that create opacity include tin oxide, zirconium oxide, zirconium silicate, titanium dioxide and bone ash (the last two also create opalescence). As well as these, 'glaze modifiers' can produce other effects, such as iridescence, or they can enhance the behaviour of the glaze during its application.

Another commonly created effect is a matt finish, acquired through the addition of minerals such as barium, alumina hydrate, lithium carbonate, strontium carbonate or titanium dioxide. Some of these create multiple effects, such as titanium dioxide, which also produces opacity and opalescence. Other glazes can create various textures or a satin finish, which gives a soft sheen rather than the usual high shine.

Blue-and-White Pottery

The ancient Egyptians invented the first synthetic pigment during the Fourth Hakeme Dynasty (c.2613–2494 BCE). Emulating the semiprecious stone lapis lazuli, 'Egyptian blue' was a combination of silica, limestone, sodium and copper oxides. Since then, blue has been a key colour in design, especially in ceramics. Blue was a central element of one of the most famous areas of Chinese art: blue-and-white porcelain, which was first made in large quantities during the second half of the Mongolian Yuan Dynasty (1271–1368) using a vibrant cobalt-blue ore from Persia (now Iran). The finely ground pigment was painted directly onto leather-hard porcelain, mainly in Islamic patterns. It was then coated with a transparent glaze and fired.

During the Ming Dynasty (1368–1644 CE), blue-and-white porcelain reached unprecedented heights of excellence. Diplomatic gift-giving and trading brought it to Europe, where it became the most influential pottery in the world. Exports remained a key aspect of its production throughout the Ming and Qing Dynasties (1644–1911/12). Blue-and-white vessels were painted with Chinese motifs, such as dragons, waves and floral scrolls, while the potters of Jingdezhen produced geometric patterns inspired by Islamic design for the Middle Eastern market. Some red-and-white wares were produced, but export markets preferred blue-and-white pottery. Also, the cobalt oxide used for the blue patterning was far more predictable than the copper oxide used for the red.

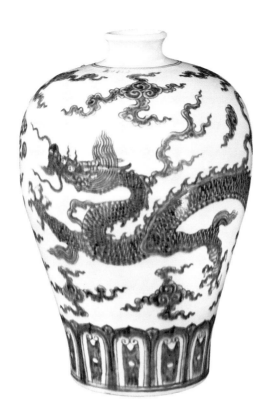

European ceramicists failed to attain a comparable blue glaze until metallurgist David Köhler (1673–1723) created one for Meissen. Between 1600 and 1800, Delft in the Netherlands was one of the most important ceramics producers in Europe. In their attempt to copy Chinese porcelain, Delft potters produced tin-glazed earthenware vases, dishes, tiles and ornaments that became known as Delftware or Delft Blue. Decorated with under-glazes of cobalt oxide and coated with a tin glaze after being fired, Delftware was decorated with motifs such as windmills, fishing boats, hunting scenes, landscapes and seascapes. Over the two centuries, approximately 800 million such tiles were made. Delftware was exported across Europe and even, ironically, to China, where potters produced porcelain copies that were then exported to Europe.

Near the end of the eighteenth century, English ceramic artists began producing 'Willow' pattern pottery, using transfer-printing methods to depict scenes incorporating Chinese details such as willow trees, boats, pavilions and birds. The transfer-printed images were applied to bisque-fired bone china or white earthenware, then glazed and fired again. 'Willow' pattern soon became almost as desirable as Chinese blue-and-white ware.

Blue-and-white Ming porcelain vase created in China during the Xuande Period (1426–35).

Colours and finishes

Small amounts of gum, such as gum arabic or gum tragacanth, are often added to raw glazes to reduce their dustiness and prevent them flaking away. Glaze colorants have to be able to withstand high temperatures without burning off, so most are made with metallic oxides, which can also alter melting points. Other elements that affect colorants include the clay itself, slips, stains or any under-glazes used.

The kiln's temperature and atmosphere can both have an effect; if there is a high level of oxygen inside the kiln, it is called an oxidation firing. If there is little oxygen, it is called a reduction firing, and the difference in results can be astonishing. For example, a basic glaze using copper carbonate will be turquoise after an oxidation firing, but bright red after a reduction firing (see page 86).

Oxides and glaze stains

Oxides are the most common constituents of ceramic glaze colorants, but they are also the most unpredictable. They can only be added in the smallest amounts to any glaze composition – at the most, approximately one to ten per cent of the entire mixture – or the glazes will react erratically when fired. These small amounts are enough to produce a diversity of colours, from pale and subtle to intense and dark. Oxides also react differently depending on the type of ware they coat.

Among the most commonly used oxides are iron, cobalt, chrome and copper. Used in glazes for earthenware, iron oxide produces colours ranging from pale buff to russet, while on stoneware the colours range from dark brown to black. Cobalt almost always produces an intense blue, but cobalt with manganese and iron yields black. Copper oxide and copper carbonate generally produce greens, but turquoise in alkaline glazes. Tin and zirconium oxides both produce white on all clay bodies, while chrome oxide can yield a variety of colours, including red, yellow and green. With the addition of tin, chrome oxide can yield pink, greyish pink and warm brown. High-fire glazes – those that need to be fired at extra-high temperatures – containing bone ash and iron can yield bright oranges, while antimony creates yellow and gold.

As an alternative to oxides, glaze stains, or oxide washes, are oxide based but blended with stabilizing materials, fired and then ground to a fine powder and mixed with water. They may also contain frit or kaolin and are more predictable than oxides in glazes.

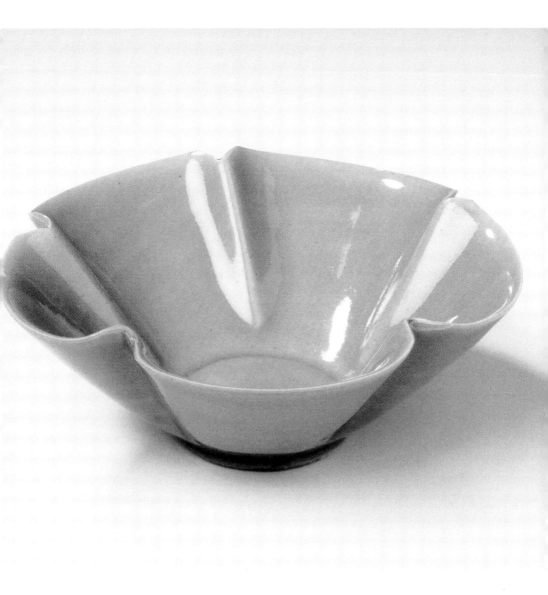

Soft, transparent green celadon
glaze originated in China and
later spread across Asia.

Glazing guidelines

Do

» Wear a mask if you are mixing your own glazes.

» Choose glazes based on their firing temperatures (consult the label on a ready-made glaze; if you are making your own glaze, check what ingredients you are using and what firing temperatures they will require): if more than one glaze is used on the same object, each requiring different firing temperatures, the pottery could be damaged.

» Ensure that the object to be glazed is as clean as possible: even oils from the fingertips may prevent the glaze from adhering correctly, so wear fine, disposable latex gloves.

» Wipe all bisqueware with a clean, damp sponge before glazing, to remove any dust and debris.

» Apply wax to the base of any object to be glazed, to prevent the damp glaze from sticking the base to the kiln.

» Stir all glazes before use, even pre-mixed glazes, to ensure an even, smooth consistency.

Don't

» Use any glazes containing harmful ingredients, especially for objects that will come into contact with food, drink or children.

» Leave any bumps or imperfections on bisqueware; sand any off before the glaze is applied.

» Apply the glaze unevenly, as this will affect the regularity of the firing.

» Allow glazes to mix; keep brushes clean and separate.

Flora's Train: six glazed relief tiles by Walter
Crane (1845–1915) for Pilkington's Tile
and Pottery Company, c.1900–1.

Emma Bridgewater Spongeware

In 1984, after her collection of sponge-printed pottery prototypes sold out at London's Covent Garden Market, Emma Bridgewater opened a ceramics factory in Stoke-on-Trent, Staffordshire. The Emma Bridgewater Company revived traditional sponge-printing methods that had lost popularity for more than a century.

The earliest examples of sponge-printed pottery have been found in Crete, produced by Minoan potters about 4,000 years ago. Using local natural sponges, they stippled coloured stains onto their pottery. But it was not until the nineteenth century that ceramics printed directly with sponges emerged from potteries in Glasgow and Staffordshire. Using natural sponges cut into shapes, dipped in coloured oxides and pressed onto bisqueware, sponge printing was found to be a faster, more affordable and systematic method of decorating mass-produced items than hand painting. Complex repeat patterns were easily achieved, and the technique could be performed on pottery of all shapes and sizes, but it eventually came to be seen as old-fashioned.

Using machines and moulds, pottery production in the Emma Bridgewater factory is overseen and guided by hand. Every piece, including plates, bowls, mugs, teapots and storage jars, is made from cream-coloured earthenware and individually hand decorated, primarily by the sponge-printing technique using hand-cut sponges and bold colours.

Specially trained decorators sponge the patterns onto the bisque-fired pieces by hand, using synthetic sponges shaped with soldering irons. Because bisqueware is so absorbent, some colour from each stain instantly soaks into the pottery and becomes permanent. So while working at speed, and often rapidly changing both their colours and sponges, decorators have to be exceptionally sure and accurate. Although they are extraordinarily skilful, there are nonetheless slight variations between each item, which makes the ware highly prized and collectable. Every piece is designed for practicality and distinguished by its colourful decoration – polka dots, hearts, letters, animals, birds, flowers, flags and other familiar motifs. Some of the decorations are quite simple, while others are more intricate, and every piece is signed by the printer who sponged it. Some of the iconic designs employ several colours – 'Polka Dot' uses five: light green, light blue, yellow, teal and dark red; 'Egg & Feather' uses six colours, with more than 12 sponges to apply them. Relatively inexpensive, fresh and accessible, Emma Bridgewater spongeware attracted wide international appeal from the outset. While some of the more detailed designs are made with lithographic printing, most continue to be produced with the now widely imitated sponge-printing method.

An earthenware teapot by Emma Bridgewater, hand decorated in her signature 'Polka Dot' design.

Glazing Techniques

As with methods of decorating pottery, there are certain techniques that have become common in glaze applications, although each is subject to individual interpretation. To begin, the pottery must be clean, dry and free from dust and grease.

Brushing and sponging

Brushes can be used to apply any type of ceramic colour or glaze. Although commercial glazes smooth out most brushmarks, some will become accentuated during firing, so consideration must be paid to the angles at which brushes are held as the glaze is applied. Brushing can be free and painterly or rigid and precise. For opaque or matt coverage, two or more thin layers should be applied, allowing each layer to dry before adding the next. The most effective brushes for this are generally synthetic sables that retain their shapes.

Sponges can be used at nearly every step of pottery creation, including glaze application. Fine-textured sponges, either synthetic or natural, are useful for a simple coat of glaze. For applying a decorative second layer of contrasting glaze, more textured natural sea sponges can impart interesting patterns that become more pronounced after firing. Sponge printing, with sponges or even florists' foam cut into various shapes and dipped into glazes of contrasting colours and then pressed onto bisqueware – as with slip stamping – can create interesting effects.

Dipping and pouring

One of the fastest methods of glazing pottery, dipping relies on the glazing mixtures being fairly thin and fluid. The method can be used to apply different glazes on the insides and outsides of ceramic items; the entire object or just part of it can be submerged. Dipping gives an even coating and works well if several items are to be glazed similarly. Using tongs, a biscuit-fired piece is held in the glaze for several seconds, which allows the correct amount to coat it. If layering glazes, objects can be dipped several times. When the pot is removed from the glaze, it is rotated gently so that excess glaze drips off. Meanwhile, a pouring technique is useful for glazing interiors of pots or bowls, or the tops of plates, for example. It can result in puddling, or a more concentrated pool of glaze, so, as with dipping, the object should be held with tongs and rotated back and forth to shake off any excess glaze. Another finish can be obtained with pouring, whereby a thicker glaze is poured from a jug or small receptacle to mingle and bleed with a previous, thinner glaze, which creates painterly and unpredictable effects.

Right: Sponge printing is believed by many to have originated in Crete 4,000 years ago.

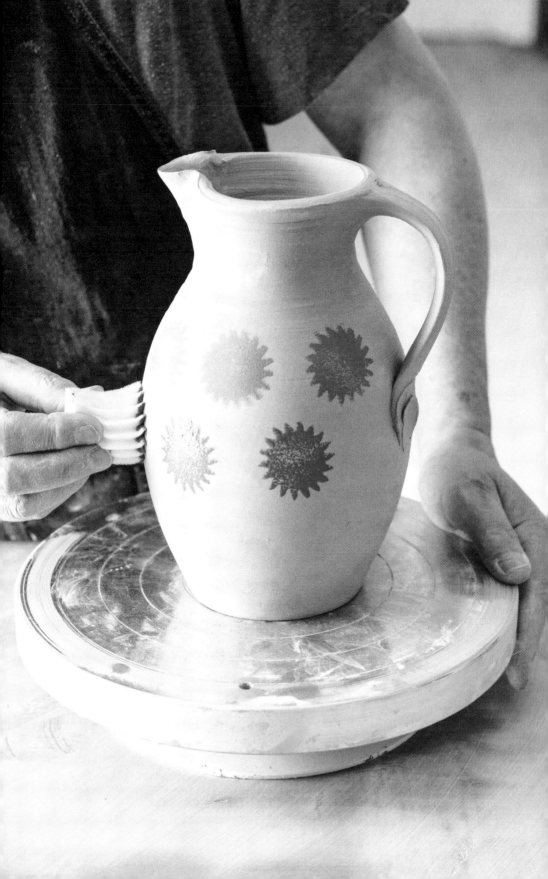

Spraying

Using spray guns and airbrushes requires a steady hand, a mask and proper extraction, such as a wet-backed spray booth, since it's illegal to dispense glaze dust into the atmosphere. Nozzles must be large enough for the glaze particles to pass through without clogging. Spray glaze has chemicals added to prevent it running.

Raw glazing

The technique of firing both pottery and glaze in one process is known as single firing, once firing or raw glazing. It entails glazing a damp or leather-hard clay body, rather than a bisque-fired vessel, so it can allow greater spontaneity and also reduces production time. Although methods of application are similar for both raw glazing and glazing bisque-fired vessels, the glazes used are different. Both the clay and glaze have to shrink by the same percentage, so single-firing glazes usually contain high proportions of clay, which can enable a matte finish if desired.

Masking out and wax resist

To create precise patterns with different colours or textures – or both – masking tape can be used. Masking out is executed on bisque-fired pottery that has been sanded smooth, or on already glazed and fired pots. The masking tape is applied to areas that will not be taking the glaze. Thick or thin tape can be used to make wide or narrow lines. The tape must be smoothed onto the vessel well, so that none of the glaze can run under it. The glaze is then applied with a brush or sprayed on, or the entire object is dipped. Once fired and cooled, the masking tape is peeled off.

Another way of masking pottery is by using the ancient technique of wax resist, where either hot wax, a ready-prepared wax emulsion or latex is used to mask off defined areas on the item. Because the wax repels water-based slips and glazes, it can be used to create patterns or designs before the leather-hard or bisque-fired object is brushed with or dipped into glaze. The wax – or latex – must be allowed to completely dry before any glaze is applied. The wax is either left intact before the glaze is applied, to result in entire shapes kept free of the glaze, or patterns are scratched into it. Glaze adheres to the unwaxed areas on the object but runs off the waxed design. The wax melts away in the kiln, while latex can be peeled off afterwards. Multiple layers of wax can be used for new colour applications, enabling the creation of interesting layers of design.

Salt glazing

Salt or soda glazing – also called vapour firing – produces a decorative effect known as an orange-peel finish. Particularly popular during the seventeenth and eighteenth centuries, it is achieved by common salt or soda being added to the kiln during the firing process. The high temperatures cause it to volatilize, or rise as vapour, which falls on to the surface of the ware and affects the final texture (see pages 87–9).

Under-glazing

Applied beneath glazes, usually on bisqueware, under-glazes are generally a blend of clay, stains and metallic oxides, such as iron, cobalt and copper oxides. Mainly used to impart colour, under-glazes have variable results depending on several factors, including the colour of the clay body or any slip beneath, the glaze that covers them and the thickness of their application. Some under-glazes can also change the texture of the final piece. Most are formulated to have low shrinkage, and their application can be broad as they are available in a wide variety of forms, including liquid (ready to use), powder (to be mixed with water before applying), and chalks, pencils and crayons, which enable quite detailed designs or images to be achieved. If under-glaze is too thick, it can be diluted with water; if it is too thin, it can be left exposed to the air to thicken. Application methods include brushing, spraying, drawing, dipping and printing. Under-glaze painting requires considerable skill, as it can smudge easily and imperfections often become visible only after the firing.

In-glazing

A blend of finely ground ceramic pigments or stains and finely ground flux, in-glazes are colours that are applied on top of unfired glazes, which sink into and bond with the glazes during firing. They can be applied by brushing, rolling or spraying; they can be layered on top of each other to form various colours and intensities, and brushstrokes can be emphasized to give painterly effects. However, they are extremely difficult to correct and after firing they become integral to the glaze.

On-glazing

Also known as over-glazes, on-glazes are used to decorate surfaces that have already been glazed and fired. Like in-glazes, they are made of mixtures of finely ground ceramic pigments or stains and finely ground flux, and they produce intense colours that bond with the glazes during the firing process. Once applied, they are fired again at a lower temperature, which fuses them to the original glazed surfaces. Most on-glazes are opaque and slightly raised from the surface of the initial glaze and, because they are fired at lower temperatures, a wider variety of colours are available than with under-glazes.

Like in-glazes, on-glazes can be applied by brushing, rolling or spraying them on. Using on-glazes allows pottery to be decorated, fired, have more colours added and be re-fired without affecting previous colours, although complex on-glaze decoration must be fired in between applications of colour to prevent muddying the different shades. As colours cannot easily adhere to fired glazes, the on-glaze is best mixed with a colourless varnish or an oil medium to help with application and give a better painting quality.

Kakiemon

From c.1680–1725 Kakiemon ware was produced in Arita, a port in Japan near kaolin-rich Izumiyama. The wares were imported to Europe by the Dutch East India Company and became prized for their quality, rich colours, graceful shapes and Oriental decorations. They were imitated by many porcelain manufacturers in Austria, France, England and Delft, and notably by Meissen.

Japanese potter Sakaida Kakiemon (1596–1666) is thought to be one of the first to apply enamel as an over-glaze to porcelain, called *aka-e* in Japan, so the style became known as Kakiemon. The term is often used to describe any wares made in factories in Arita, but authentic Kakiemon porcelain is still produced by his direct descendants.

The fine china clay, or kaolin, was treated to remove impurities and mixed with porcelain stone, and the resultant milky-white material was formed into elegant shapes and decorated with complex enamel patterns. Predominant colours were coral red, cobalt blue, soft yellow, turquoise green and black. The delicate enamel decoration was sparingly applied to the glazed surfaces of the pottery and then fired again at a lower temperature. The decoration contrasted with the fine porcelain body, known in Japan as *nigoshide*, meaning 'milky-white'. Motifs included birds, flying squirrels, the 'Three Friends of Winter' (pine, plum and bamboo), flowers (especially chrysanthemums, the national flower of Japan) and all kinds of figures. Typical wares included bowls,

dishes and plates, often hexagonal or octagonal, or fluted with scalloped edges.

Production discontinued from the early eighteenth to the mid-twentieth centuries due to the difficulties of manufacturing *nigoshide*. From 1700 Dutch enamellers copied Kakiemon designs using less costly white porcelain, and in parts of France and England tin was sometimes added to the glaze to imitate the milk-white body.

In the 1690s the Kakiemon style became replaced by *kinran-de* style porcelain, which featured more intricate decoration and was painted predominantly in cobalt-blue under-glazing and red and gold over-glazing. *Kinran-de* derives from a silk garment woven or embroidered with gold thread. A similar style, *nishiki-de*, was created to suit European tastes, but also followed the patterning of contemporary brocade-like textiles. *Nishiki-de* means 'in a style of a colourful weaving'. The term 'Imari' became used in the West to describe both styles of elaborately enamelled ceramics that were exported between 1690 and 1740 from Arita. The diverse, ornamental designs feature figures – often courtesans in elaborate kimonos – plus exotic landscapes, trees, birds, flowers and abstract patterns. It inspired countless cheaper imitations in China and Europe.

An eighteenth-century Kakiemon teapot with six lobes decorated in red, green and blue enamels.

Enamels

A form of on-glaze decoration, enamels are frit glazes in a vast range of colours, formulated to melt and fuse with glazes at low temperatures. Like other on-glazes, enamels can be used for detailed or loose designs, and can create multicoloured effects. Different colours require different firing temperatures. While in the kiln, the glaze softens and combines with the enamel to form a permanent, glassy finish. Widely used with ceramics, enamels may require several firings, if there are many colours, and may result in differing levels of glossiness depending on elements within the mix.

Painting and Printing

Apart from slips and glazes, other methods of ceramic decoration include hand painting, gilding, enamelling and printing. All these techniques can be interpreted in fluid, painterly ways or in more precise, graphic approaches.

Painting

Before hand-painting commences, items are usually bisque fired. Ceramic paint is then applied, followed by glaze, and then the objects are fired, causing the colour particles to melt and bond with the glaze. Although this form of decoration is more suited to individual pieces of pottery, painting ceramics has been a common method of bulk decoration for centuries, including much early Asian porcelain and later ware that was manufactured in even greater quantities, such as Meissen's hand-painted porcelain produced from 1713.

Early painted earthenware, faïence and porcelain featured carefully outlined designs that were then coloured in. As technology evolved, styles of hand painting changed and from the nineteenth century fashions for pottery painting became extremely intricate. Ceramic paint can be built up in layers that create particular intensity or depth of colour. In contemporary pottery painting, designs are usually drawn on the bisqueware with ceramic marker pencils first, and these marks evaporate during firing.

Printing

One of the primary methods of decorating ceramics, printing can be accurate and quick, and either painterly and fluid or precise and graphic. Several methods of printmaking work particularly well on ceramics, including transfer printing, screen printing, sponge printing, lithographic printing and pad printing.

Discovered in 1797, lithography was first used for printing on paper, but it was soon discovered that it worked well for pottery, too. Screen printing was first used in the early eighteenth century, but was only used for ceramics from the mid-twentieth century. Transfer printing developed in Staffordshire in England in the eighteenth

century. It relies on pressing – or transferring – images onto bisqueware, producing designs and images featuring fine lines that resemble engravings. This technique has resulted in the mass-production of a specific style of ceramics called transferware.

Stencilling

A method first used in the seventeenth century, ceramic stencilling with paint rather than slip usually employs paper patterns that are cut out, then placed and fixed on the ceramics, and wrapped around any curving objects. Ceramic paint, mixed to a creamy consistency, is applied using brushes held at right angles to dab the colour carefully through the stencils.

Gilding and lustres

A decorative technique that has been practised for centuries, metallic gilding has been achieved with copper, silver and primarily gold being etched, painted or sprayed onto the surface of all kinds of vessels. Sometimes copper, silver or gold leaf is used, available in delicate sheets that are applied with size, a special kind of glue. First the clay objects are bisque fired, then sanded to a smooth finish; all other forms of decoration are undertaken (if any) and then the gilding is applied. Almost always, a clear glaze is applied on top and, finally, the objects are fired to permanently fuse the elements together.

Lustres are thin coatings of metallic compounds, such as copper and silver, which are fired at comparatively low temperatures onto glazed surfaces to produce an iridescent sheen. Commercially prepared lustres can be applied over fired, finished glazes and reheated at low temperatures so that they fuse. Depending on the finish required, lustre can be sprayed, stamped or sponged, stencilled or painted on.

Décor & Design

Ceramics have been part of our daily life for millennia. From Neolithic amphorae used as wine containers to today's coffee mug on the breakfast table, earthen products have long had a particularly close association with the storage, cooking and serving of food and drink. Yet from the earliest times – it is estimated the first use of pottery as food and drink containers dates back to around 10,000 BCE – that association was not simply about fulfilling a function. Amphorae, which were placed near the table, were often decoratively painted to provide visual delight. The pottery drinking vessels in the shape of an inverted bell – which were so prevalent across western Europe at a particular point of prehistory (c.2800–1800 BCE) that archaeologists have termed it the Bell Beaker period – were also often ornamented. Many centuries later, an intricately decorated Sèvres porcelain tea service was an expensive means of conveying both status and taste in a nineteenth-century drawing room. These two roles of domestic ceramics – the decorative and the practical – have gone hand in hand throughout history.

The same holds true when you look beyond the kitchen and the table to other areas in the home. Floor and wall tiles, for example, have many practical advantages – they protect underlying surfaces from moisture, help to regulate indoor temperature because of their ability to absorb and release heat slowly, and withstand superficial knocks, scrapes and bumps. At the same time, they are also one of the most common means of adding the uplift and energy of colour and pattern to interiors in every country around the world.

In the Kitchen

Earthenware pots and vessels have been used for cooking and storing food since prehistoric times. While most pots, pans and roasting tins in today's kitchens are made of metal, ceramics of all kinds still play an important role. By and large inexpensive, and robust if they are handled with reasonable care, their natural properties of moisture control (if unglazed) and of slow cooling and heating make them suitable for a wide range of uses.

Left: Horezu ceramics, handmade in the town of Horezu, Romania, featuring brightly coloured traditional motifs in green, red, blue, brown and off-white.

Archaeological evidence points to the use of clay pots for cooking from the earliest times. Analysis of charred remains on Japanese pottery fragments dating from 15,000 BCE, for example, has demonstrated that such vessels were used to cook fish and shellfish. Throughout ancient times, pots were generally made with rounded bottoms to minimize the risk of cracking. For similar reasons, cooking vessels were supported over an open fire, often by some sort of stand or tripod. An alternative was to set a pot amongst glowing embers, which emitted a much lower heat and so lengthened the cooking time.

By medieval times, various methods were employed to make cooking pots more robust and able to withstand high temperatures, such as mixing sand with the clay when the pot was being formed. In mid-thirteenth-century Germany, stoneware was developed. Made from more malleable and heat-resistant clay than earthenware and fired at a higher temperature, it resulted in a strong and entirely nonporous body.

Gradually, however, metal began to supplant pottery, with the cauldron emerging as an all-purpose cooking vessel. While ceramic dishes were still used for baking, storing and pickling, it was metal cookware that was most often to be found on domestic hearths and stoves.

Oven-to-table ware

A piping-hot casserole brought from oven to table, releasing appetizing aromas, is such a familiar sight at mealtimes, both family suppers and dinner parties, that it is hard to appreciate that this is a relatively recent custom. In most households before the Second World War, food was cooked in one set of dishes before being decanted and served in another. All this changed with the new informal lifestyles of the post-war period, which introduced the open-plan layout to interior design and lowered the barriers between public and private areas of the home.

Oven-to-table ware, promoted by designers such as Russel Wright (1904–76; see page 186) in the late 1940s, was a radical innovation in its day. The practical advantages might have been immediately apparent – one set of multifunctional dishes was cheaper, meant less time and effort spent washing up, and required less space given over to storage – but it took a while before the new, casual style of dining and table setting caught on.

Today, there is a huge range of ceramic cookware on the market in every conceivable shape and size, from small, fluted ramekins to lidded casseroles and baking dishes. The most robust are made of stoneware, which distributes heat evenly and is often preferred by baking enthusiasts for that reason. Le Creuset produces stoneware ovenware alongside its more famous enamelled cast-iron casseroles. The British pottery Denby is another well-known stoneware brand.

Black-topped, red-ware beaker from Nubia
(c.1700–1550 BCE).

The Way of Tea

The Japanese tea ceremony, *chanoyu*, 'the way of tea', is a centuries-old ritual of preparing and serving *matcha*, or powdered Japanese green tea. The aesthetic and spiritual discipline has its origins in temple and monastery rites, dating back to the time when green tea was first imported from China by Japanese monks and priests around the eighth century CE. By the fourteenth century, 200 years after *matcha*, or green tea in its powdered form, had become available, the ceremony had become part of the life of the nobility and warrior classes, from where it eventually spread to all levels of society.

The principles of the tea ceremony are rooted in Zen Buddhism, particularly the concepts of *wabi* and *sabi*. *Wabi*, representing the inner spiritual world, places the emphasis on what is natural, simple and humble. *Sabi*, representing the outer material world, cherishes what is imperfect and marked by time. The tea master Sen no Rikyu (1522–91) had a profound influence on the way the tea ceremony evolved, popularizing the *wabi-sabi* philosophy and introducing simple rustic elements to the ritual. Rikyu favoured small country tearooms as settings for the ceremony and the use of raku tea bowls and other handmade utensils and implements. His precepts of harmony, respect, purity and tranquillity continue to define the tea ceremony today.

Central to the tea ceremony is the tea bowl or *chawan*. The style, size and shape of tea

bowls vary widely. Shallow bowls are used in summer, when the tea needs to cool; deeper bowls in winter, when the tea needs to be kept warm. Many traditional tea bowls are raku ware. If the principles of *wabi-sabi* emphasize the importance of such simple, rustic, hand-thrown wares, imperfection is also valued. A related concept is *kintsugi*, which cherishes signs of repair as part of the life of an object. Broken tea bowls (and other Japanese ceramics) are frequently repaired using powdered gold mixed in with lacquer, to draw attention to the joints and emphasize the passage of time.

Other key elements of the tea ceremony include ceramic *cha-ire*, tea caddies used for making thick tea, and wooden *natsume*,

tea caddies used for making thin tea, along with various bowls, kettles, water containers, whisks, scoops and cloths for ceremonial cleaning.

While the tea ceremony is essentially a gathering at which the host makes tea for guests, observing a number of rituals and customs, beyond the immediate serving and drinking lies a wider appreciation of the setting, expressed in hanging scrolls, tatami mat placement, flower arrangements, landscape and architecture. The purpose is to connect through simplicity to a moment of pure contemplation.

Tea caddy in the Oribe stye, Kyoto, from the Edo period (1615–1658).

Most mass-manufactured ceramic cookware is dishwasher- and microwave-safe and ovenproof up to temperatures of 225°C (435°F/gas mark 7) – and over, in the case of stoneware. Pieces should not be placed on a direct source of heat, such as a halogen burner, electric hob or gas burner, or taken directly from the freezer to a hot oven, or they will shatter and crack.

Chicken bricks

Kitchens tend to accumulate specialist equipment and cookware that languish in cupboards after short-lived enthusiasms. The chicken brick has at times fallen into that category. First introduced to Britain by Sir Terence Conran (b.1931) in 1964, and stocked by his ground-breaking Habitat stores, the unglazed terracotta pot in the form of a small enclosed lidded oven was an instant hit with young couples, although arguably few went on to regard it as a kitchen essential. Lately that has changed, and a few years after Habitat discontinued the chicken brick in 2008, it brought it back due to rising demand.

The principal reasons for this resurgence of interest are a renewed appreciation for authentic flavour and healthy eating. Chicken bricks cook by steaming food. You don't have to add fat or additional water, but you do have to soak the brick in cold water for 10–15 minutes before each use. Then you simply pack it with a chicken, surrounded by a selection of chopped vegetables, place it in a cold oven, turn on the heat and a couple of hours later you will have a delicious roast dinner that has cooked in its own juices. Terracotta's ability to absorb and release heat slowly prevents the meat from burning or drying out, and the unglazed shell of the brick means that the skin crisps and browns as it would if roasted conventionally. Over time and repeated use, the brick will become saturated with flavour and acquire a darkish patina. It should never be washed in detergent or used to cook pungent food, such as fish or curry.

Tajines and tandoori pots

A portable oven traditionally used by North African nomads for cooking in the open over braziers, the tajine is a glazed earthenware vessel with a tall, conical lid, which has given its name to the classic Moroccan meat stew. Like the chicken brick, the tajine is all about slow cooking with steam. Moisture from the simmering meat condenses inside the lid and its conical shape encourages spicy flavours to permeate. Most tajines can only be used in the oven; some, however, can be placed on a gas hob if you use a heat diffuser.

Traditional tajines, made in Morocco (see overleaf), need to be seasoned before use. This involves submerging the tajine in water for an hour, rubbing the inside of the base and lid with olive oil, then placing it in a cold oven and heating it at a low temperature (150°C/300°F/gas mark 2) for two hours. After the tajine has cooled and been washed and dried, it is ready to be used for the first time.

Terracotta tandoori pots operate on similar principles to the chicken brick and tajine, relying on slow evaporation of steam from clay to slow-cook the contents. The result is tender meat permeated with flavour. Traditionally, the clay is raw and unfired to impart the best flavour, but these days most tandoori pots are sold fired – but unglazed – to make them more hygenic and robust. Like the chicken brick, (fired) tandoori pots should be soaked in cold water for 10–15 minutes before each use.

Storage and food preparation

A neat array of ceramic jars, clearly labelled with their contents, is a practical means of kitchen organization for a wide range of staple foodstuffs, particularly ingredients that are in frequent use. Arranged on a shelf, dresser or countertop, such containers have a pleasing uniformity that does not visually distract, unlike conventional packaging, which is much less appealing left out in view.

Size is a key consideration – you want a container large enough to hold a reasonable amount of the ingredient in question, but not so large that you rarely need to refill it and there is a risk of a stale layer lying undisturbed at the bottom. Lids – whether made of matching pottery, wood or another material – should be fitted with an inner seal to keep the contents airtight.

Because they are breathable, unglazed terracotta containers promote airflow. Traditional crocks, for example, provide cool, dark conditions and reduce moisture, keeping bread fresh for longer. The same is true of salt pigs, containers that stop salt from hardening into solid lumps in humid kitchens.

Unglazed terracotta supports have been used for wine storage for centuries – for good reason. Terracotta's inherent characteristics help maintain even levels of temperature and humidity in cool, damp cellars. Systems on the market include individual hexagonal sections that stack neatly together to create honeycomb racks.

From mixing bowls and pudding basins to jugs, juicers and pestles and mortars, earthenware and stoneware products have long been a popular choice for food preparation. Many designs have been unaltered for years – just as there is something comforting about following a recipe that has been passed down in the family, perhaps there is also something reassuring about handling the same dishes our grandmothers would have used. A case in point are the 'caneware' mixing bowls produced by Mason Cash. Made of white and yellow earthenware with a raised bas-relief pattern, the bowls were first designed and manufactured in 1901 and have barely changed since. Blue-and-white striped Cornishware (see page 150) is another long-lasting pattern.

Overleaf: Tajines for sale at a shop in the souk, Meknes, Morocco.

At the Table

Up until the beginning of the eighteenth century, most people in the West ate from wooden bowls, plates and trenchers, with earthenware reserved for jugs and pots that were used for cooking food. All this changed when European factories discovered how to make porcelain, previously a rare and costly import from the East found only in royal and aristocratic collections.

The significance of porcelain, then as now, lies not only in its fineness, whiteness and translucent beauty, but also in its strength. Both the raw ingredients and the high firing temperatures produce a very hard, strong and entirely nonporous body capable of withstanding boiling water.

The alchemist Johann Friedrich Böttger (1682–1719) of Meissen, Germany, was the first European to crack the mystery of hard-paste porcelain manufacture in 1708, guarding both the formula and the production process jealously from other ceramics factories (see page 71). Meissen produced its first dinner services in the 1720s, when it also introduced its crossed swords trademark, one of the first in existence. Meissen's 'Swan Service' (*Schwanenservice*), made between 1737 and 1743 for the manufacturer's director, Count Heinrich von Brühl, comprised more than 1,000 individual pieces.

Although the secret manufacturing process of hard-paste porcelain inevitably began to leak out over subsequent decades, most early European porcelain was soft-paste, an artificial porcelain lacking kaolin, one of the ingredients that gives 'true' or hard-paste porcelain its strength. Sèvres, the French manufacturer that started to overtake Meissen in the artistic stakes in the 1750s, began as a soft-paste porcelain factory, founded at Vincennes, near Paris, in 1740. Its first dinner service was bought by Louis XV of France, who also supplied financial backing to the company. After the factory moved to larger premises in Sèvres, just outside Paris, the king became its sole owner and Sèvres was well on the way to a position of dominance in European porcelain production.

The wider dissemination of the hard-paste porcelain recipe from the 1760s onwards coincided with the beginnings of the Industrial Revolution. Very soon china plates, bowls, platters, dishes – and tea and coffee services – were appearing much more frequently on domestic dining tables. By 1785 in Stoke-on-Trent alone, there were 200 potteries employing 20,000 workers.

Worcestershire 'Willow' pattern plate, made
by Grainger Lee and Company, c.1850.

Cornishware

With its cheerful blue-and-white stripes and simple, practical shapes, Cornishware has long been a kitchen classic. It is also a striking example of how a manufacturer's success can rest on the popularity of one pattern, largely unchanged over nearly a century. A particularly British product, it is collected all over the world today, with older examples being highly prized.

T G Green (or Green & Co Ltd), located in Church Gresley, South Derbyshire, was founded in 1864 by Thomas Goodwin Green. According to the company history, he acquired an existing pottery while on honeymoon with his wife, Mary Tenniel, sister of Sir John Tenniel, the famous illustrator of Lewis Carroll's 1865 book, *Alice's Adventures In Wonderland*.

The blue-and-white striped earthenware first appeared later, in the mid-1920s. The raised coloured bands were created using a lathe-turning method, in which bands of blue slip were stripped away to reveal the white glazed body beneath. The pattern acquired its name when an employee was reminded of the blue skies and white-capped waves of Cornwall. For many people, however, the blue-and-white colour combination is evocative of more traditional wares, such as 'willow' pattern (see page 123) – blue was commonly thought to repel flies and so was believed to be a hygienic choice for kitchens.

During the 1930s, Cornishware was widely sold through leading British stores, and the export business also thrived. A large

proportion of sales during that period were lettered storage jars – flour, sugar, salt and so on – although the factory also produced lettered jars to order, in an early example of personalization. Cornishware became such a familiar sight in British households that it regularly featured in the popular press, in children's books and in advertising.

In the 1960s Scandinavian designer Berit Ternell and British designer Judith Onions joined the pottery from the Royal College of Art. Judith Onions was responsible for restyling the Cornishware range, and those shapes, launched in 1968, are still made today. Both the restyled pattern and the original have a distinctive shield backstamp. Together with designer Martin

Hunt, Onions designed a new range for T G Green, comprising four bold geometric patterns named after the Channel Islands: Jersey, Guernsey, Alderney and Sark.

In 2007, the original Victorian factory closed and the company's new owners moved production to China. The current Cornishware range includes mugs, jugs, plates, bowls, teapots, jars and cookware, all in various sizes. A host of new colours have recently been added so that, in addition to the original blue stripes, the pattern is now available in shades including red, black, green and pink.

Blue-and-white banding makes Cornishware instantly recognizable.

Anatomy of a plate

From the beginning of porcelain plate manufacturing, moulds were used not only to speed production and increase volume, but also to ensure that all the plates in a service were uniformly sized and shaped, a regularity that is very hard to achieve by throwing – as *Throw Down* contestants discovered, when challenged to throw a plate of the widest dimensions they could. The smallest of imperfections will show up.

A typical plate consists of a shallow well, a flat, raised lip of varying width, an outer edge or rim, and a flat base or underside. The chief variant is whether or not the lip is present; on a practical level, it serves to stop food from slipping off the plate, but it also invites decoration. Another variant, apart from size, which chiefly reflects function, is shape. Round is by far the most common, although square plates are associated with Asian cuisines and with modernist styles.

Mixing and matching

The traditional dinner service is all about unity: plates, side plates, bowls, cups and saucers that conform to the same size and shape and are decorated (or not) in exactly the same way. In the past, services were sold as complete sets, which represented a significant outlay. A generation ago, choosing a pattern for a wedding gift-list was part of the ritual of newly engaged couples. More often than not, such services were reserved for 'best', with more ordinary crockery doing everyday duty.

The seeds of change were sown with the arrival of modernism in the 1920s, which offered a radical departure from domestic norms. When this was quickly followed by the slump in trade resulting from the worldwide Depression, manufacturers began to see the sense in selling their ranges as 'open stock', which meant that cash-strapped buyers could pick and choose, adding to their collections as need and financial circumstances dictated. After the Second World War the 'open stock' approach gained greater headway. The more recent vogue for collecting vintage finds has given an added impetus to mixing and matching.

One of the most collected brands of china in the United States and a prime example of the concept of mixing and matching, 'Fiesta', or 'Fiestaware' (see right) first came on the market in 1936. The range, which is still in production today, is manufactured by the Homer Laughlin China Company, based in West Virginia. At a time when most dinnerware was sold in matching services, traditionally decorated, 'Fiesta', with its Art Deco forms and vibrant colours, made an immediate impact. From the very beginning, the intention was to promote mixing and matching, and the china was accordingly sold from open stock. An early promotion proclaimed that 'Fiesta' gave 'the hostess the opportunity to create her own table effects'.

'Fiesta', an American brand of china, first came on the market in 1936. Produced in a range of bright colours, the intention was to promote the concept of mixing and matching.

'Fiesta' was originally produced in five colours: red, blue, cream, light green and deep gold. Turquoise was soon added. In 1950 four new colours were introduced and some of the originals were dropped; over the years, similar changes were made to the range of colours on offer. Today, you can find old and new 'Fiesta' in almost 40 different colours, with collectors paying premium prices for the rarer ones.

Although 'Fiesta' shapes have also been redesigned over the years, the concentric Art Deco ridging has been a constant. The discontinuation of 'Fiesta' in 1973 coincided with a vogue for Art Deco design among young homemakers, and it was the rising prices they were prepared to pay that led to the Homer Laughlin China Company reintroducing the range in 1986.

Chocolatières

Chocolate, an expensive commodity that was extremely popular among the wealthy elite in seventeenth- and eighteenth-century Europe, was consumed as a hot beverage. The *chocolatière*, or chocolate pot, usually made of silver or porcelain, was similarly luxurious. The typical design was a tall, slender body, on three feet, with an ornate handle. Most characteristic of all was the hinged finial on the lid, which concealed a small opening. This was to allow the chocolate, which had a tendency to settle, to be stirred at intervals with a stick called a *molinet*. Viennese manufacturers and German producers such as Meissen were well known for the elegance of their chocolate sets.

Coffee sets

The practice of coffee drinking, first introduced to Europe from the Middle East in the early seventeenth century, rapidly grew into a craze. By the end of the century coffeehouses, informal meeting grounds where business was conducted and ideas were shared, had sprung up in all major centres, from where they subsequently spread to the New World. Many of these were affiliated with specific trades or professions. Edward Lloyd's Coffee House in London – first located in Tower Street (1688–91) and then in Lombard Street – which was patronized by ship owners and marine insurance brokers, was the antecedent of the Lloyds insurance business. After the Boston Tea Party in 1773, Americans rejected tea as unpatriotic and coffee drinking grew even more popular.

Coffee was also drunk at home, and coffee sets were often produced as part of an extended tea service. Early on, coffee was either made directly in the pot by adding boiling water to freshly ground coffee, or boiled in a separate pan. Pots were tall, had sharp spouts and swelled towards the bottom or in the middle to trap the grounds.

Another popular method of making coffee was infusion, whereby a linen bag full of ground coffee was placed in boiling water. A refinement of the same idea was the French biggin, which was developed in 1780 (and widely used in the United

States). This was a pot consisting of two levels. Boiling water was poured into the upper level, which contained the coffee wrapped in a cloth, and the flavoured liquid subsequently dripped through to the lower level.

By the nineteenth century, new ways of making coffee using steam, pressure and percolation were being developed. The coffee pot, no longer a coffee maker, became simply a coffee container, a decorative addition to the table.

Tea services

When tea was first imported into the West from China during the mid-1600s, it was a luxury affordable only by the rich, as were the porcelain teapots for brewing it and the porcelain cups for drinking it, which arrived at the same time. A century later, as duties were lowered, tea drinking began to eclipse coffee drinking, which up to that point had dominated (sober) social gatherings.

Following the loss of the American market after the American War of Independence (1775–83), tea duties were slashed to the bone to keep afloat the interests of the East India Company, which had a trade monopoly. Along with the growth of mass manufacturing at the end of the eighteenth century and beginning of the nineteenth, this resulted in the widespread popularity of tea drinking across all sectors of society. By the time of the Great Exhibition in London's Hyde Park in 1851, when Britain showcased the products of its new factories alongside goods from across the world, the British love affair with tea had well and truly arrived.

Tea services have always been the means of displaying taste and aspiration – keeping up with the latest shift in decorative style and investing in a family heirloom. Traditionally comprising a teapot, set of cups and saucers, cream pitcher and lidded sugar bowl, they have been elaborated modelled, decorated, gilded and even mounted with silver or gold throughout history.

Unsurprisingly, considering the British addiction to tea drinking, some of the most sought-after bone china tea services are by British manufacturers, past and present. Spode sets, very popular in the nineteenth and twentieth centuries, were noted for their transfer-printed under-glaze designs and for their hand-painted decoration. Minton, which began making hard-paste porcelain in 1821, produced tea sets with rather more elaborate and self-consciously 'artistic' patterns, such as those displaying Art Nouveau motifs at the end of the nineteenth century. Shelley tea sets, by contrast, are characterized by more delicate floral patterning.

Overleaf: Sèvres tea set in soft-paste porcelain, c. 1765–70, by Etienne-Henri Le Guay, displaying Rococo shapes combined with Neoclassical painted decoration.

Clarice Cliff
(1899–1972)

Bold, jazz-age patterns in vivid colours characterize the much-loved work of British ceramics designer, Clarice Cliff. Born in Staffordshire, Cliff went to work as a gilder and apprentice enameller at the age of 13, joining A J Wilkinson Ltd at Burslem four years later. There, her inherent talent and range of skills, further developed by the classes she attended at Burslem School of Art, soon attracted the attention of her boss, 'Colley' Shorter (1882–1964). In 1927 Shorter sent her to study at the Royal College of Art in London. Following her return, she was given her own studio at Wilkinson's Newport factory.

'Bizarre' (1927–36), the umbrella name of Cliff's first range for Newport, had all the hallmarks of what would become her distinctive style – semi-abstract stylized motifs hand painted in orange, yellow, red, blue and green, the on-glaze enamels producing much more vivid colours than under-glazes. It proved immediately popular and generated substantial profits for the pottery. At first Cliff painted her designs on standard white blanks. Soon, however, she took the opportunity to model her own forms, which more closely expressed the angular, stepped Art Deco or 'moderne' style and provided flatter surface areas for her patterns: handles were often solid and triangular; teapots had flat sides; plates and bowls were hexagonal rather than round. The cone was another favourite shape, and was a marked feature of her 'Ravel' range (1929–35).

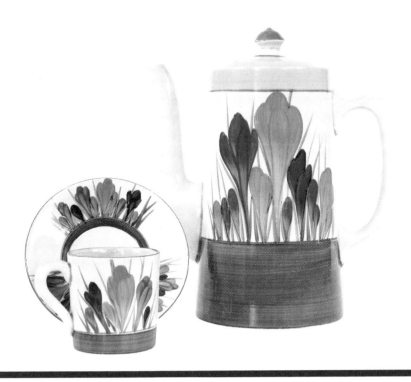

'Bizarre', like 'Fantasque' (1928–34), the range that succeeded it, was stocked by leading retailers around the country and widely exported. By 1929 demand was such that Cliff was overseeing a team of 70 young painters, chiefly women, to carry out the designs. The following year she was made art director of Newport.

All of Cliff's ranges included a number of different patterns, some more popular than others and thus manufactured in higher volumes. Many took inspiration from nature, albeit in an abstracted form. One of the most popular was 'Crocus' (1928–64), a hand-painted pattern of bold orange, blue and purple petals with thin green leaves, held within yellow and brown banding. Throughout the 1930s

a team of 20 was exclusively engaged in painting 'Crocus' ware, which carried on selling right up to the point at which Cliff eventually retired in 1964.

Canny promotions, dreamt up by Cliff and Shorter (they married in 1940 after the death of his first wife), helped to ensure the success of the pottery throughout the Depression years, despite the fact that the pieces were relatively expensive for the time. A revival of interest in Art Deco during the 1970s has ensured that Cliff's work remains highly collectible.

'Autumn Crocus' coffee pot and cup and saucer (c.1930). The coffee pot is in the tankard shape.

The Brown Betty teapot is a British classic of utilitarian design. Made from red clay discovered in Staffordshire in the late seventeenth century, which was found to have superior heat-retaining qualities, early Brown Bettys were shaped more like coffee pots. By the mid-nineteenth century they had acquired their familiar full-bellied form and deep-brown colour, the result of what was known as the 'Rockingham' glaze, composed of iron and manganese. This glaze was originally brushed on and allowed to drip down the sides, but subsequently it was applied in a uniform layer all over the clay body. The dark-brown glaze disguises tea staining, while the rounded shape provides a greater volume for the brewing tea.

The British practice of adding milk to tea is a custom not widely shared by the rest of the world. Whether you should add the milk to the cup first or second eventually became a matter of some considerable debate. Second is widely regarded to be posher. This rule of etiquette has surprisingly practical origins. In the early days of tea drinking, most teacups were made of soft-paste porcelain, which is not as strong as hard-paste and is prone to cracking. Adding milk to the cup first meant that there was less risk that the cup would shatter when hot tea was poured into it. Those who could afford expensive imported hard-paste cups could safely add the milk second, signalling that their tea service was a cut above.

Children's crockery

Tableware designed especially for the nursery has long been a profitable sideline for many ceramics manufacturers. One of the best-loved and longest-running ranges is 'Bunnykins' by Royal Doulton. With its familiar brown rabbits chasing each other around the rims, and charming domestic scenes full of detail decorating the sides of cups and the centres of plates and bowls, the crockery has been cherished by many generations of children the world over. Scaled to suit smaller portions and hands, each piece had pictures printed on the bottom, intended to encourage children to eat up all their food. There were also dishes incorporating hollow square-sectioned rims that could be filled with hot water to keep food warmer for longer. When children did finish their meal, they were rewarded with the sight of bunny families – dressed in human clothes – cooking, eating, fishing, dancing and seesawing in playgrounds.

Up to 1950 all the 'Bunnykins' scenes were painted by Barbara Vernon Bailey (1910–2003), the daughter of Cuthbert Bailey, general manager of Royal Doulton. By the early 1930s she had entered an enclosed Roman Catholic convent in Sussex, where she would spend the rest of her life as Sister Mary Barbara. Soon after, on one of his visits, her father suggested that she paint the farmyard scenes she had so enjoyed growing up as a child in Shropshire – although untutored in art, she had always had a talent for drawing and a love of animals. In 1934 he proposed that her watercolours might be used on a new range of nursery china. At first, the convent

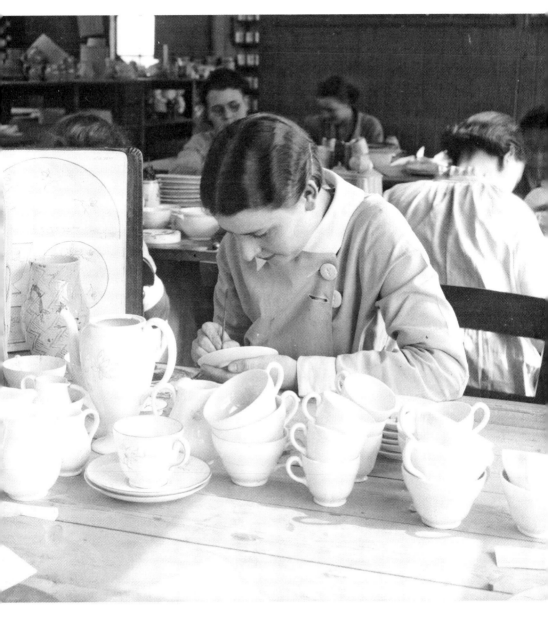

Painting designs by hand on stoneware at the
Wedgwood factory, 1936.

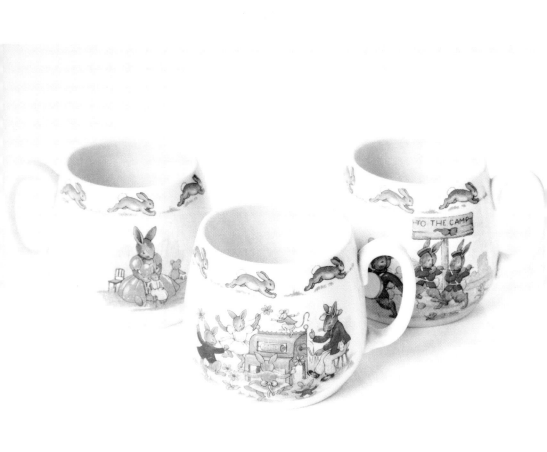

Three 'Bunnykins' fine china cups,
from the popular nursery range made
by Royal Doulton.

was reluctant to agree, but then the prioress gave permission on the grounds that no money would change hands, that the project would be kept quiet and that Sister Mary Barbara would not allow her painting to interrupt her devotional and teaching duties. Working at night and by candlelight (the convent had no electricity supply), Sister Mary Barbara painted more than 1,000 pictures of cosy domestic life. The range, which quickly found its way into the royal nursery of the young princesses Elizabeth and Margaret, was an immediate success when it was launched in 1934.

Another popular range of children's china dating from around the same time was Shelley's 'Boo Boo' range. The British illustrator Mabel Lucie Attwell (1879–1964) was already making a name for herself in magazine and book illustration when the pottery asked her to design a pattern for them in 1926. Atwell's designs, featuring cuddly twee infants, animals and green elves called 'Boo Boos', appeared on a number of different ranges – and also on nursery chamber pots. One 'Boo Boo' tea set featured a teapot in the form of a mushroom house, a mushroom-shaped sugar bowl and a milk jug in the shape of a pouring Boo Boo.

Flights of fancy
The potential for decorative modelling offered by clay has led to a distinct strain of whimsy running through tableware design. Appropriately enough for products intended to serve food and drink, many of these flights of fancy do not stray far from what is being consumed. Plates shaped like leaves; milk jugs in the form of cows, whose curving tails serve as handles; ceramic caneware egg nests, brooded over by ceramic hens – there is something irresistibly engaging about these tabletop puns.

Along with the humour has also gone considerable artistry. The Chelsea porcelain factory arguably attained artistic heights during its 'red anchor period' (c.1752–6), so-called because of its red anchor trademark. Dating from this time is a distinctive porcelain tureen in the form of a tied bunch of asparagus, with one stem looped upwards to form the handle (see overleaf). By the late eighteenth century, Josiah Wedgwood (1730–95; see page 26), ever the innovator, was experimenting with caneware pie dishes modelled to resemble piecrusts, eventually producing examples that looked so realistic that they were sometimes mistaken for real pies. Game pie dishes of this kind came into their own during the Napoleonic blockades of British ports (1806–14), when flour became so scarce that its use was banned even in the Royal Household.

Perhaps the most famous type of modelled clay vessel is the toby jug, typically a tin-glazed earthenware drinking jug that features the consumer, not what is about to be consumed. First produced in Staffordshire in the 1760s, toby jugs were later

made all over the world. The boozing, seated figure, his tricorne hat forming the lip of the spout, is thought to have been modelled on a famous engraving of 'Toby Philpot' that illustrated a popular song of the day called 'The Brown Jug.'

Where flights of fancy really take off is in novelty ware. What do typewriters, elephants, Liquorice Allsorts, radios, cupcakes, frogs, telephones, country cottages, dancing couples and Coleman's Mustard tins have in common? They're all teapot designs.

Messages and memes

When is a mug not simply a mug? When it is also a meme or a brand. In recent years, digital printing has seen the humble tea or coffee mug transformed into a vehicle for putting a message across. It was inevitable, after the wartime 'Keep Calm and Carry On' poster was rediscovered in a Northumberland bookshop in 2000, that the phrase would soon find its way onto the side of mugs. The rapid spread of the meme means that variants such as 'Keep Calm and Drink Tea' operate as an in-joke.

Between 2002 and 2012 Penguin Books developed a merchandizing project under the direction of Tony Davis, whose inspiration was to translate the iconic original Penguin paperback jackets, designed in 1935 by Edward Young, into a range of lifestyle products. Penguin's book mugs soon proved among the most popular of the range. After all, what could be more appropriate than curling up on a rainy day with a book and a mug of tea, both of which bear the title *Wuthering Heights*? Pantone has undertaken a similar marketing exercise with their bone china mugs issued in a range of numbered Pantone colours.

Lighting

Ceramics of all kinds have been widely used as components of light fittings, from pendant shades and wall sconces to delicate chandeliers. It is easy to see why. Firstly, there is the decorative potential offered by glazing, which allows for a broad range of colours and patterns. Secondly – and with particular reference to porcelain – there is the evocative way in which light shines through translucent or pierced elements.

Candlesticks

Before gas and electric lighting, oil lamps and candles were the chief sources of domestic illumination. Oil lamps, the use of which dates back thousands of years, were often made out of earthenware and typically took the familiar form of the genie's lamp in *Aladdin*. While oval-shaped slipper lamps for burning oil were generally hand shaped, simple wheel-made lamps were a feature of ancient Egypt and Greece. Later, lamps were more elaborately modelled with scroll, vine and wreath reliefs; some were decorated with red slip.

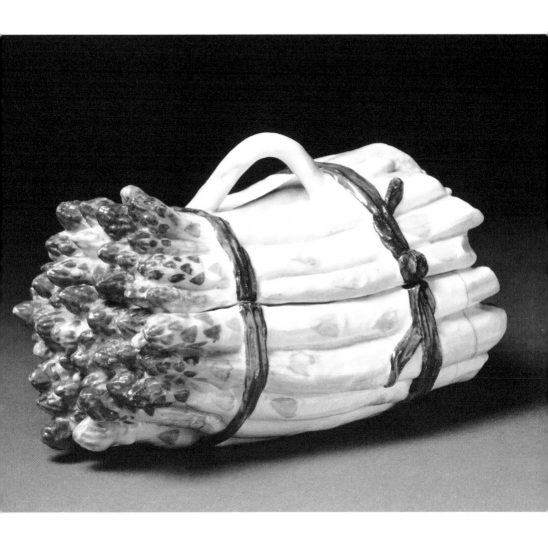

Lidded asparagus box made in soft-paste
porcelain and painted in enamels, by
Chelsea porcelain factory, c.1756.

Candlesticks were also commonly made out of ceramics, from simple glazed pottery to highly elaborate porcelain designs. Many well-known manufacturers, including Wedgwood and Sèvres, produced candlesticks in characteristic period styles.

As *Throw Down* contestants discovered, throwing a candlestick on the wheel is a considerable challenge. The application of even pressure is critical. The delicate cup or holder at the top needs to be shaped first while there is sufficient support in the clay body underneath – starting to model the profile from the base risks weakening the entire form.

Bases
Perhaps the most common ceramic lighting element is the lamp base. These come in a huge variety of styles, sizes, colours, patterns and shapes. The more traditional bases often take the form of vases and feature classical decoration – such as blue-and-white Chinoiserie patterning or delicate floral designs. More contemporary examples are tall, cylindrical or asymmetric mid-century modern shapes, where the hand-worked quality of the clay is emphasized in expressive textural finishes or loose, painterly glazing.

Shades
Ceramic shades are widely available for every type of light, from pendants to wall sconces. The main distinction is between opaque shades, which may or may not be glazed, and the more evocative, translucent porcelain varieties. Porcelain shades emit a gentle, warm, almost papery glow, which can be further accentuated by piercing to create intriguing light effects.

British-based American studio ceramicist Daniel Reynolds creates hand-cast porcelain pendants inspired by organic or industrial sources. In addition to shades in the form of lettuce leaves, gourds and other natural shapes, he also produces a range of pendants inspired by common domestic objects – teapots, cafetières, milk cartons and kettles – which add wit and humour to interior décor.

Chandeliers
The branched form of the chandelier, which transforms the central fixture into many twinkling points of light, especially lends itself to ceramic work. Traditional chandeliers, often made of glass, crystal or metal, require little or no shading because candlelight is inherently lacking glare. The same is not true of electric chandeliers, where bulbs require some form of diffusion.

Right: An explosion of light: German designer Ingo Maurer's redefinition of the chandelier, 'Porca Miseria!' (1994).

Soon after the use of electric lighting became established in the home, the problem of glare was identified. Early solutions, by modernist designers such as Poul Henningsen (1894–1967), were to shade the central light source by overlapping planes or reflectors. Henningsen's iconic 'Artichoke' light (1958), a development of his earlier PH series, is a case in point.

In a ceramic chandelier, it is the individual (generally) porcelain elements that serve as light diffusers. Here, there is the opportunity to experiment with organic, irregular shapes – to showcase hand-working rather than machine-like precision. One of the most demanding *Throw Down* projects undertaken by series contestants was to create a chandelier from fine bone-china shapes using the slip-cast method (see page 66). Liquid clay was poured into a mould, where it hardened into a thin layer. After excess was tipped out, the clay shape could be extracted from the mould, shaped, cut and dried before the final hurdle, which was to suspend all the shapes on wires so that they created a sculptural form that diffused the light source evenly.

The German designer Ingo Maurer (b.1932) is renowned for his redefinition of the form of the light, from his early overscaled 'Bulb' (1966), a tribute to Thomas Edison's 1879 invention, to his whimsical 'Lucellino' (1992), a winged light bulb. 'Porca Miseria!' (1994) extends that same sense of dramatic playfulness to the chandelier (see page 167). Sculptural, emotional and highly theatrical, the chandelier consists of fragments of broken porcelain plates suspended on wires, along with pieces of metal cutlery. A domestic dispute captured in mid-air, the impact of the explosive form owes a great deal to the highly evocative quality of light shining through layers of translucent porcelain. The design is a limited-edition piece. White porcelain plates are smashed with hammers or dropped on the floor. It then takes four people five days to assemble the finished piece. The name – *Porca Miseria!* – is an Italian expression that roughly translates as 'holy cow' and is said to have been inspired by a comment made by an Italian visitor when the design was unveiled at its private launch.

Surfaces and Finishes

Robust, hard-wearing and generally waterproof, ceramic materials bring undoubted practical benefits to the interior. That is to say nothing of their decorative verve. From the rhythmic grid inherent in even the plainest of tiled surfaces to the vibrant colour and rich patterning of hand-glazed vernacular styles, there is great scope for adding richness and depth to the interior.

Terracotta and ceramic tiles warm up slowly and retain heat for longer than other materials. This makes them an excellent choice for flooring in areas of the home designed to benefit from passive solar strategies or for use over underfloor heating. Elsewhere, it is tiling's water- and stain-resistant qualities that recommend it as a covering for walls in steamy, humid locations such as bathrooms and kitchens. Wall tiles are generally lighter and thinner than those designed for use as flooring. Only fully vitrified nonporous tiles are suitable for outdoor use. In all cases, size and format vary widely, from standard squares to octagons and rectangles, to the tiniest of all, mosaic or tesserae.

Tiling is most effective when it is extended over a significant area – an entire plane of a wall, for example, rather than a skimpy splashback edging a countertop. While it would be a tall order for most home potters to produce enough tiles of consistent quality to cover such an expanse, it is well within most amateurs' capabilities to create single feature tiles to enliven an otherwise plain tiled surface or to compose a border of individual designs.

Terracotta tiles

While terracotta tiles were in widespread use for flooring in Roman times, the technique seems to have fallen into abeyance until the thirteenth century when the Moors reintroduced it to Spain. From there it spread to northern Europe and to Spanish colonies in Central and South America.

Antique versions, between one and two centuries old and generally reclaimed from old agricultural and domestic buildings, are known as pammets. The format is typically 25cm (10in) square. Antique Blanc Rose, one of the rarest and most expensive types, hails from a small area of France.

Unglazed terracotta tiles have a strong, mellow, countrified look. They are highly porous, and therefore require sealing before use, a treatment that needs to be renewed at regular intervals to prevent them from staining. They are produced today in a variety of locations around the world, with colours and textures reflecting their area of origin: yellow for Bordeaux, pink for Provence, deep red for Burgundy, ochre for Tuscany and orange for Mexico. With a leathery patina that deepens with age and use, they are coarser and less regular than manufactured versions, which undoubtedly adds to their appeal, although this can also make them more difficult to install. Hand-glazed terracotta tiles are not as robust as ceramic versions but have great depth of character. Some, but not all, are suitable for use as wall tiles.

Susie Cooper
(1902–95)

The prolific British ceramics designer Susan 'Susie' Cooper, whose work is widely collected all over the world, was born in Burslem, Stoke-on-Trent, the youngest of seven children. Her talent for drawing led to her being awarded a scholarship to Burslem School of Art. Her original intention was to go on to study fashion at the Royal College of Art in London, but she lacked the required work experience. To remedy this, she took a post with A E Gray, a local pottery, on the recommendation of Gordon Forsyth, with whom she later collaborated.

Starting at the pottery in 1922, Cooper initially trained as a painter. She made such quick progress that before long she was made in-house designer and,

in recognition of the popularity of her designs, she was given her own factory mark. In 1929 Cooper established her own pottery, first at premises in Tunstall and then at the Chelsea Works in Burslem, where she employed six painters. Like Clarice Cliff (1899–1972; see page 158), with whom she is often bracketed, she favoured bold, abstract, Art Deco designs and stylized flowers during this period, the decoration hand painted in strong colours. All of her pre-war work was executed in earthenware, much of it on blanks – or 'white ware' – made by other Staffordshire potters.

In 1931 Cooper moved to larger premises, the Crown Works, conveniently located next to her principal supplier, Wood

& Sons. By now she was designing her own shapes, had a new 'leaping deer' trademark and was moving away from hand painting in favour of lithograph patterns. 'Dresden Spray', a delicate floral design and one of her most famous, was launched in 1935; her 'Kestrel' shape had appeared three years earlier.

During the war, a fire destroyed most of Cooper's lithographs and her pottery was forced to close. When it reopened again in 1945, she returned to hand painting for a while, supplemented by airbrushing and sgraffito. In 1950 she acquired a factory in Longton that made bone china. 'Quail', a range that featured curved forms decorated with sgraffito scrolls, was expressly designed for china. The

same shape was used for her 'Lion and Unicorn' pattern, which was displayed at the Festival of Britain in 1951.

In the late 1950s Cooper merged her company with another, resulting in access to larger-scale production. The business was subsequently bought by Wedgwood, where she continued designing popular patterns throughout the 1960s and 1970s. The revival of interest in Art Deco in the 1970s brought her work to new collectors. Initially it was her early hand-painted designs that were most sought after, but today there is a market for the full range.

Susie Cooper 'Kestrel' hot-water pot, c.1936, made of earthenware.

Encaustic tiles

The technique of making encaustic tiles dates back to the medieval period, when they were widely used to create floors in ecclesiastical buildings. Unlike glazed tiles, where the decoration is applied to the surface, the design or pattern of encaustic tiles is inlaid. Early versions were created by stamping the damp clay tile with a wooden block carved with a pattern in relief. The incised design was then filled with white slip or clay, glazed and fired. Typical motifs included heraldic devices and religious symbols; occasionally, a pattern might be built up in sections of four to sixteen separate tiles.

The encaustic tile might have remained a historical curiosity had it not been for the mid-nineteenth-century Gothic Revival, which renewed interest in pre-Renaissance art and craft. At that time, Herbert Minton (1793–1858), son of Thomas Minton, founder of the eponymous Stoke-on-Trent pottery, began to mass produce encaustic tiles, influenced by his association with Augustus Pugin (1812–1852), the architect and designer responsible for the interior of the Palace of Westminster. Minton's encaustic tiles were exhibited all over the world, notably at the Smithsonian Institution in Washington DC, where they were later used to create a magnificent floor at the United States Capitol building, seat of Congress.

On a rather less exalted note, encaustic tiles became a hugely popular feature of many Victorian and Edwardian homes, chiefly as flooring for entrances, halls and porches. Today, contemporary encaustic tiles are commonly produced, along with Victorian reproductions.

Iznik tiles

Pottery from Iznik, a town southeast of Istanbul in Turkey, was first recorded in the mid-fifteenth century and included blue-and-white bowls and dishes featuring intricate scroll-like patterns. By the early sixteenth century, the range of colours used had expanded, free, painterly, floral decoration became more common and tiles for mosques were the main output.

Delft tiles

One of the best-loved traditional tiles is Delft. Like maiolica and azulejo tiles, Delft tiles (and Delftware generally) are made of tin-glazed earthenware, where the clay is covered with a white tin glaze that is allowed to dry before being hand painted and fired. They are sometimes then covered with a clear glaze to imitate porcelain.

Delftware (see page 123), which originated in the Netherlands, dates back to the sixteenth century, with the finest work having been produced between the mid-seventeenth and mid-eighteenth centuries. Aside from Delft, the main centre, potteries were also established in other Dutch cities, including Amsterdam and

Rotterdam; later, Dutch potters also brought the technique to Britain, where 'English Delft' became an established tradition.

Tiles were one of the most popular Delft products, with an estimated 800 million being produced before the end of the eighteenth century. Charming hand-painted scenes of windmills, milkmaids, fishing boats and such like were typically executed in blue on the white tin-glazed ground, although crimson, sepia, green and polychromatic decorations were not uncommon.

There is something inherently domestic about Delftware that makes these tiles an ideal choice for kitchens, bathrooms and pantries. Traditionally, they have also been used as fire surrounds and to clad Continental-style stoves. Antique examples command high prices, but many contemporary manufacturers produce their own Delft ranges for those who are looking for a nostalgic, country-style look.

Azulejo tiles

A striking feature of the external and internal walls of traditional Spanish and Portuguese buildings, both public and domestic, are large-scale panels of azulejo tiles, many of which depict historical, allegorical or mythological subjects. Curved, floral or geometric patterning is also characteristic. Such tiled surfaces have the not inconsiderable side effect of helping to keep interiors cool.

An early example of azulejo tilework can be seen at the Alhambra Palace in Granada, Spain, where tiles glazed in single colours were cut and laid into bold geometric patterns. The technique spread from Moorish Spain to Portugal in the thirteenth century. By the early eighteenth century, following the reconstruction of Lisbon after the 1755 earthquake, the style had reached its zenith, with many Portuguese buildings, from royal palaces to domestic houses, covered inside and out with azulejo panels. Many contemporary artists have also worked in the tradition, a notable example being the Portuguese-born artist Paula Rego (b.1935), who has produced memorable hand-painted tiles featuring her characteristically disturbing fairy-tale subjects.

Talavera tiles

Produced in the Mexican city of Puebla and nearby towns, Talavera pottery dates back to the sixteenth century and is closely related to both majolica and the azulejo traditions. Decoration, which is applied over a milky-white base, is limited to six colours: yellow, black, green, blue, orange and purple. Floral designs are characteristic. Tiles have been an important part of Talavera production, and have been used traditionally to adorn both the interior and exterior of buildings, particularly kitchen walls. Because the tiles have always been expensive to produce, such application was a symbol of a family's wealth.

Seventeenth-to-eighteenth-century Delftware
tiles featuring maritime and rural scenes.

Iznik tiles from the Topkapi Palace, Istanbul. Iznik pottery
is named after the Anatolian town where it was produced
from the fifteenth to the seventeenth centuries.

William De Morgan
(1839–1917)

One of the towering figures of ceramic art, William De Morgan (1839–1917) was a British designer, potter, inventor and stained-glass artist. Although he pursued many and varied interests throughout his lifetime, from the construction of bicycle gears to the devising of telegraph codes, and achieved his greatest financial success as a novelist, he is best remembered for his pottery, in particular for his revival of lustreware.

De Morgan's enthusiasm for ceramics began in the early 1860s, when he entered into a collaboration with William Morris (1834–96), an association that would last until Morris's death. De Morgan was soon producing his own tile designs for Morris & Co, the ground-breaking company that launched the Arts and Crafts Movement. Shortly after, he opened his own studio in Chelsea, where he was able to fully investigate all ceramic techniques. Unlike many other commercial potters, who used commercial blanks for their tile designs, De Morgan made his own. He is most famous, however, for reviving the lost art of lustreware, the metallic finish typical of Moorish pottery and Italian majolica. After much experimentation in the chemistry of glazes, he was able to include copper, gold and silver lustres in the same design, where they glowed against a dark blue background.

A major commission he undertook was work on the Arab Hall at Leighton House, the grand London residence of Frederic,

Lord Leighton (1830–96). Leighton, a noted artist himself, was an avid collector of Turkish, Persian and Syrian tiles. De Morgan's role was to arrange the tiles in situ – more than 1,000 in total – and to replace those missing or broken in transit, which he did to such effect that it is difficult to tell the replacements from the originals. A key factor in his success was his invention of a new means of pattern transfer, which gave his designs consistency from tile to tile without sacrificing any of the liveliness of a handmade product. The Arab Hall was conceived as the centrepiece of the entire house; linking spaces, such as the Narcissus Hall, feature luminous De Morgan tiles in peacock blue. Later, he went on to produce tile decorations featuring fantastic cityscape scenes for the smoking rooms of 12 P&O ocean liners.

De Morgan's style was characterized by a palette derived from fifteenth- and sixteenth-century Iznik ware, notably dark blue, turquoise, green, dark red, yellow and purple. Motifs ranged from Middle Eastern-style geometrics to natural subjects, such as flowers, and mythological creatures. One of his best-known and most widely reproduced designs is the Fish Panel, which currently forms part of the V&A tile collection. The museum holds 1,200 original De Morgan tile designs.

William de Morgan's hand-painted earthenware Sunflower tiles, 1898.

Hearths, fire surrounds and stoves

Decorative tiled panels were a feature of fireplace design from the Victorian era well into the twentieth century. These were typically mass produced to slot into flanking inserts in cast-iron surrounds, generally in sets of ten. Many were floral and reflected changing decorative styles, from Arts and Crafts to Art Nouveau and Art Deco. As well as repeat motifs, some depict running patterns, where the entire panel features a continuous image. Replacements for missing tiles in original fireplaces can often be found by trawling architectural salvage yards. Alternatively, a number of tile manufacturers produce reproductions of historical designs.

The ability of ceramic materials to absorb and radiate heat slowly is a key feature of the ceramic, masonry or tiled stove. Unlike conventional fireplaces, which devour fuel and send much of the heat up the chimney, ceramic stoves are an extremely efficient means of maintaining even, warm temperatures in the coldest climates. For centuries, ceramic stoves have been used in Russian, Finnish, Swedish, Austrian and German households, variously termed *pystyunni*, *kachlugn*, *steinofens* and *kachelofens*.

A noted figure in ceramic stove design was the Swedish architect and inventor Carl Johan Cronstedt (1709–79), who was commissioned by the King of Sweden to improve the design of stoves so that they would burn less fuel. He achieved this by coming up with a system of flues that snaked around the interior of the stove so that more heat was radiated from the exterior.

Eighteenth- and nineteenth-century ceramic stoves were typically very elaborate in appearance. Freestanding, often in the corner of the room, they were richly decorated to blend in with interior schemes.

Bathroom Fittings

Sanitary ware – sinks, toilets, bathtubs and bidets – are among the most common ceramic items in the home. Traditionally white, smoothly modelled and made in a range of sizes, shapes and formats, these utilitarian fittings are rarely meant to attract attention. Yet handmade, decorative fixtures can add visual pleasure to daily ablutions.

In recent years there has been a vogue for show-stopping sinks and washbasins. Glass vessels or stone troughs that sit atop vanity units are but two examples of this more expressive trend in bathroom design. There is something elemental, too, about substituting simpler forms for the familiar bathroom fitting.

Right: Nineteenth-century Swedish tiled
stove. Corner positions were typical.

Stig Lindberg
(1916–82)

A leading practitioner of the mid-century style that became known as Scandinavian Modern, Swedish designer Stig Lindberg worked in ceramics, textiles and glass, overlapping spheres of interest that often showed his preoccupations with whimsy, folk art and organic form. His original intention was to be a painter and later in his career he illustrated children's books.

After graduating from the University College of Arts, Crafts and Design in Stockholm, where he studied between 1935 and 1937, Lindberg went to work as a faïence painter for the renowned Gustavsberg ceramics factory, established in 1825. At that time Gustavsberg's artistic director was Wilhelm Kåge (1889–1960), whose 'Praktika' range (1933) of stackable dinnerware was an early example of functionalism. Kåge's training proved a great influence, as did periods spent studying abroad, in Denmark and France, where Lindberg was exposed to the work of contemporary artists such as Marc Chagall (1887–1985) and the Surrealists.

Lindberg was to spend two long periods at Gustavsberg, between 1937 and 1957, and between 1970 and 1980. In 1949 he succeeded Kåge as art director, a post he would subsequently hold from 1972 to 1978. He produced studio pieces, dinnerware and other mass-produced lines, in earthenware, stoneware and porcelain. Many of his designs show an interest in folk art, expressed in highly coloured, stylized figurative decoration.

Whimsical ceramic figures, such as his stoneware animals and birds, fall into this category, as do his large coloured vases and lamp bases, many of which feature deeply indented repetitive textural patterns.

The other significant strand to his work is more refined and sculptural, a direction that characterized his work of the 1950s and 1960s. Dating from this time is the supremely elegant bone-china 'Pungo' ('Pouch') vase. Inspired by natural, organic forms, the vase is asymmetric, with a narrow split neck swelling to an open curved bowl. During this time Lindberg also designed dinnerware and tea services, including the 'Ceylon' tea service, with its delicate ribbed decoration, and the 'Darts' coffee set. Among the most popular of his services is the 'Berså' range (1960–74), with its graphic leaf patterns. Leaf-shaped plates and serving dishes were similarly decorated, with stylized veining in bright, freely applied strokes of colour.

Alongside Lindberg's ceramic work were his designs for glassware and textiles. One of his most famous textiles, still in production, is 'Pottery' (1947), featuring motifs of vases and other vessels. Lindberg was a senior lecturer at the University College of Arts, Crafts and Design between 1957 and 1972. For the last two years of his life, he worked at his studio in Italy.

Stig Lindberg's Gustavsberg leaf-shaped plates with stylized veining.

One exacting *Throw Down* challenge was to create a washbasin from hand-rolled coils. Coiling, an ancient technique dating back 15,000 years (see page 45), poses many tests for the potter. There is the need to roll consistent coils and to ensure that the joins between the coils are seamless, so that no air remains where it might cause cracking later during the firing. But the beauty of the technique, like so much in pottery, is that it allows for spontaneity in the making, for intriguing asymmetrical shapes and for truly one-off design and decoration. Overtly textured effects, however, can be a little more problematic, as one contestant discovered to their cost. Smooth, glazed finishes are infinitely preferable – when you immerse your hands in water, you don't want to risk scratching your skin on a rugged surface.

Hand building a toilet fit for use was a natural follow-up to the washbasin challenge and a chance to revisit the flushing WC's more colourful past. Although the earliest flushing water closet was designed and installed during the reign of Elizabeth 1, by a certain Sir John Harrington (1561–1612), it was not until 1778 that Joseph Bramah (1748–1814), a locksmith and prolific inventor, came up with a successful valve system. Bramah's 'valve closet' was essentially a pottery bowl set within a panelled wooden casing that housed metal working parts. While it never saw widespread use outside the homes of the privileged, it remained in production for over a century.

By the second half of the nineteenth century, a wide range of water closet designs had begun to appear on the market. Notable manufacturers included Twyford, which produced the first all-pottery pedestal closet, and Shanks. Thomas Crapper (1836–1910), one of the most famous names associated with the development of the WC, introduced refinements, notably a 'water-waste-preventer' and disconnecting trap. Originally trained as a plumber, he set up in business in Chelsea making a range of bathroom fittings, the high quality of which eventually earned his company a series of Royal Warrants. Crapper's other surprising innovation was the first-ever bathroom showroom, a shocking and adventurous strategy in an age of prevailing prudery.

Contrary to popular belief, Crapper's surname was only tangentially implicated in the common vulgarity. 'Crap' was an old English term for rubbish, which had fallen out of use by Victorian times – in Britain, at least. In the United States, however, it had lingered on, brought over to the continent by early English settlers, and it was American servicemen stationed in Britain during the First World War who amusedly coined the term 'crapper' for toilet, after seeing the manufacturer's name in *situ*. Similarly, the use of 'lavatory' as a polite term for toilet or loo originated as a euphemism. Washbasins and sinks were originally termed 'lavatories', from *lavare*, the Latin word for 'wash'; this usage is still common in the United States. The phrase 'Going to the lavatory' originated as a genteel way of mentioning the unmentionable.

Pedestal Wash=down Closets.

The "Invictas."

Combination No. 5.

The "Lennox."

Combination No. 6.

No. 5 Combination, comprising White and Printed "Invictas" Closet, with Fig. 211 Polished Mahogany Seat and Back Board, and 2 Gallon Fig. 219 Water Waste Preventer with 1½ in. Fittings, and China Pull and Brackets ... £3 6 3

	£	s.	d.
No. 6 Combination, comprising Strong Cane & White Fire-Clay "Lennox" W.C.	1	0	6
Fig. 211 Polished Mahogany Seat with Back Board	1	1	3
2 Gallon Fig. 814 Valveless Water Waste Preventer with Cover, and China Pull	1	2	3
Iron Brackets	0	1	0
	£3	5	0

Thomas Crapper was a leading Victorian manufacturer of sanitary ware.

Early WCs were generally highly decorative, as befitted an up-market product. Ornate transfer decoration (along with the manufacturer's name) and moulded detailing were common. So, too, were high-level cisterns, which were necessary to provide a sufficient head of water pressure for the flush.

Chamber pots

While the WC is a relatively recent introduction to the domestic scene, chamber pots made of various types of ceramic material go back a very long way. Early Ancient Greek examples, made of earthenware, have been dated to the sixth century BCE. Chamber pots – or 'pos', from the French *pot de chambre* – were a common feature of bedrooms. Some were set in chairs to semi-disguise their function – 'close stools' – while others were hidden within cabinets or commodes. In most ordinary households they were simply placed under the bed, furnishing a convenient means of relieving oneself that did not involve a trip to an outdoor privy in all weathers. Ironstone and porcelain were commonly used to make chamber pots, with the latter often displaying elaborate decoration. Lids were also a typical feature, allowing the pot to be discreetly removed, usually by a servant, and its contents disposed of.

Detail and Display

From small-scale architectural details to more eye-catching displays, ceramic products play an important aesthetic role within the interior and have done so for centuries.

Doorknobs and handles

Earthen materials invite touch. Ceramic and porcelain doorknobs and handles feel right in the hand. In terms of adding decorative detail to the home, they also provide a vehicle for flourishes of both colour and pattern. A simple way of revamping an old chest of drawers, for example, or adding an element of character to a standard mass-produced door, is to change the handles to designs that display more singularity. When it comes to mixing and matching, a little goes a long way. To prevent visual overkill, ring the changes with only one variable – colour, pattern or shape, not permutations of all three.

From vintage to contemporary, there are many styles on the market, with patterns ranging from cheery spots and hearts to hand-painted leaf and floral designs. Antique or vintage knobs and handles, along with matching escutcheons and backplates, are also widely available from architectural salvage yards.

Scale is an important consideration. The handle should be the right size to function effectively but not so large (or small) that it looks out of proportion. Modern suppliers generally offer a range of sizes to suit different uses.

Vases

A typical vase – if there is such a thing – consists of a foot, a base, a body, a shoulder (where the body narrows), a neck and a lip. Wide variations in size, shape, modelling and decoration – not to mention use – have occurred throughout history. Today, we chiefly think of a vase as either a container for flowers or a decorative object to be displayed for its own sake. Yet Ancient Greek vases or urns, for example, fulfilled various different functions, ranging from containers for storing or transporting wine and oil to drinking cups and vessels used in funerals or other ceremonial rites. Many were painted or incised with scenes of everyday life. Earthenware is relatively durable and these artefacts have survived in such great numbers – more than 100,000 vases have been recorded – that they provide historians with an important resource for understanding Ancient Greek society.

Early Chinese vases – dating from before the invention of porcelain during the Han Dynasty (206 BCE–220 CE) – consisted of earthenware or stoneware bodies fired with celadon glazes to imitate jade. By the time of the Song and Mongolian Yuan Dynasties (960–1368 CE), Chinese porcelain vases began to take on a more familiar form, with bone-white bodies richly decorated with blue representations of flora and fauna. Porcelain is fired at high temperatures and during that period blue was the only colour that could withstand the heat. All this changed by the Ming Dynasty (1368–1644 CE), when technical developments meant that intricate designs could be created in a wide range of colours. The Qing dynasty (1644–1911/12 CE) saw porcelain classified according the predominant shades it displayed: famille verte featured green and red, famille jaune had a yellow background, famille noire a black ground and famille rose was pink and purple. Such wares were greatly treasured in the West and commanded high prices.

From the late seventeenth century Japanese porcelain also began to be exported to the West. Much of this was Imari porcelain, which commonly featured a blue under-glaze with designs executed in gold and orangey red. Like Chinese porcelain, Japanese wares were soon imitated by Western manufacturers such as Meissen and Spode. Satsuma ware, including crackle-glaze vases made of earthenware or stoneware, also found a ready market in Europe.

One of the most significant vases in the history of ceramics is the copy of the Portland Vase by Josiah Wedgwood (1730–95), first successfully executed – after four years of trial and error – in 1789. The original, which dates from between c.1 CE and 25 CE and was unearthed in a Roman tomb in 1582, was made of deep-blue glass with a relief of white cameo. Wedgwood's version was made of black jasperware, the matt ceramic he had devised in the 1770s. The white relief designs were modelled by John Flaxman Jr (1755–1826). A particular challenge was to achieve the same delicacy of the original's cameos, a technique that he had perfected by 1790.

Russel Wright
(1904–76)

A key figure in establishing a contemporary version of American Modernism in the late 1940s and early 1950s, Russel Wright believed that design had an important role to play in creating an easier, more casual and more efficient way of living. The interwar period had seen great changes in American society, particularly once the Depression set in. Domestic servants had gone from the majority of households and, along with them, many of the old formalities. After the Second World War a new generation were avid consumers, not only of Wright's products but also of his message.

After displaying an aptitude for art at Princeton, where he was following family tradition and studying law, Wright went to work for Norman Bel Geddes (1893–1958) as a set designer in the mid 1920s. By the late 1920s he and his wife Mary (1904–52), a designer, sculptor and businesswoman, had established a home accessories company, Wright Associates.

Wright's most famous design – arguably the best-selling American dinnerware of all time – was 'American Modern', first produced in 1939 by Steubenville Pottery Company in Ohio and selling more than 250 million pieces up to 1959. Like similar Scandinavian examples, here was crockery for both special occasions and every day. Forms were organic and biomorphic, expressing the plasticity of clay in their curves and indentations. Colours were inspired by nature – a

gentle palette of yellows, browns, blues and greens. The reverse of each piece was stamped with Wright's trademarked signature. Another highly successful range was his 'Casual' ware (1946), produced for the Iroquois China Company, which included oven-to-table ware with indentations in place of handles. Featuring similar rounded shapes to 'American Modern', it was produced in solid colours, including pink, ice blue and lemon yellow.

Wright also created popular mass-produced furniture ranges as well as a limited number of designs for the commercial sphere. One of his interests was in the potential of plastic, which resulted in his 'Melmac' melamine resin dinnerware. The first Melmac range, 'Residential' (1953), for home rather than restaurant use, was another huge seller.

The Wrights' 1950 book, *Guide to Easier Living*, described how to plan and maintain the home in order to reduce chores and increase leisure time. From ideas on how to accommodate the 'rough and tumble' stage of toddlerhood, through sensible nursery furnishing, to 'The Kitchen Buffet', where guests help themselves, the entire thesis, as the Wrights stated, was 'formality is not necessary for beauty'.

'American Modern' was one of the best-selling ranges of American dinnerware in the 1950s.

Throughout history, vases have always been the vehicles for changing decorative styles. Occasionally, they have also mirrored specific enthusiasms. *Tulipières*, for example, were produced at a time when tulip mania had the Netherlands and other parts of Europe in its grip. These eccentric-looking ornate objects had many individual spout-like protuberances, each designed to hold a single bulb for growing indoors. While they were essentially planters rather than vases, they were sometimes also used for cut flowers. Most extreme versions were pyramid-shaped and floor-standing.

Other variants included tiny bud vases and cuboid flower bricks, with pierced tops where single flowers could be inserted one at a time to make an arrangement. Even more specialized were 'spill' vases, which were designed to sit on the mantelshelf and hold a collection of spills for lighting the fire. Some of the most fanciful were made by Staffordshire and featured bucolic modelled figures of ducks, swans and sheep.

In the Garden

From planters, troughs and flowerpots to garden ornaments and water features, ceramics are particularly at home in the garden. On one level, there is the natural association of earthenware with the soil; on another, and particularly important in these environmentally conscious times, such products can be readily recycled, unlike their plastic counterparts.

Unglazed terracotta containers of all descriptions provide ideal growing conditions for a wide range of plants. Breathable and absorbent, they allow air and moisture to reach fine roots and help to prevent waterlogging, which can lead to rot. Because of their thermal mass, they help to protect plants from swings in temperature. Aesthetically, they also complement all types of flowers and foliage. Specialist pots, such as strawberry pots, which have individual side pockets for planting the fruit, are also available. Vintage or antique terracotta pots display a charming irregularity.

Gardens are not simply about growing plants. Other kinds of decorative display can be achieved in pottery, glazed or unglazed. *Throw Down* contestants have risen to the challenges of constructing a large garden feature, using the slab building technique, and a working pump-operated water feature. Natural organic forms provide great inspiration for pattern, texture and shape. The much-mocked garden gnome, the epitome of kitsch, has its origins in the grotesque earthenware figures of dwarves and hunchbacks, or *gobbi*, that were a feature of Renaissance gardens. But the familiar bearded figures wearing pointed red hats date from nineteenth-century Germany, where they were manufactured in great numbers. Serious gardeners regard gnomes and other humorous animal figures as being of questionable taste, which has done little to dim their perennial popularity.

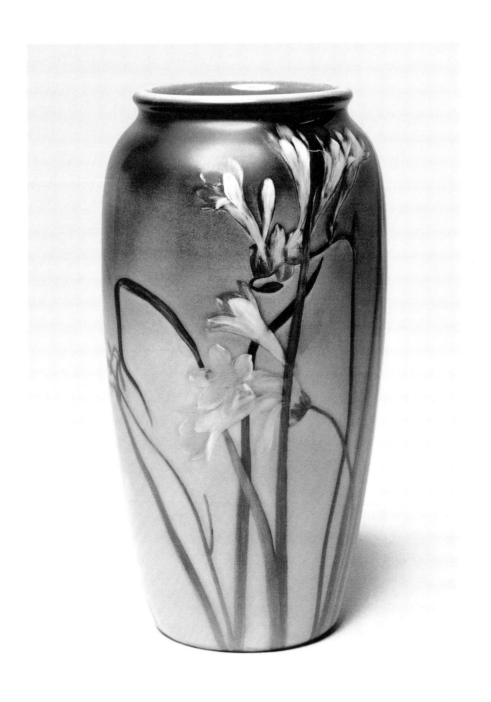

Art Nouveau vase, c.1900, by Rookwood
Pottery, Cincinnati, Ohio.

Ed. Garnier, del.

Gillot, sc.

Maison Quantin, imp.-éd

Eighteenth-century
Sèvres jardinières,
illustration by
Edouard Garnier,
*The Soft Paste Porcelain
of Sèvres*, 1891.

Kaj Franck
(1911–89)

'Smash the services' was the rallying cry of Finnish designer Kaj Franck, who was instrumental in raising the standards of tableware in the post-war period and bringing good design within the financial reach of ordinary families. Traditional dinner services, which were typically produced and marketed in complete sets, were too expensive for many people. Convention also dictated separate sets for 'best' and everyday, and different dishes for cooking and serving. Franck's ceramics were designed as separate multifunctional pieces that could be bought singly or in small numbers. A full place setting could be built up over time, and individual items could be easily replaced. That this is hardly a radical approach today can be seen as a measure of Franck's widespread influence.

In the 1930s, following his training as an 'interior architect' at Helsinki's Central School of Industrial Arts, Franck worked as a window dresser, interior designer and textile designer. After the war, he went to work for Arabia, a leading Finnish ceramics manufacturer, serving as director of its design and planning studio from 1946 to 1961. There he was able to put into practice his belief that design could be an instrument of social change. Out of this period came his 'Kilta' range (1952), later redesigned and reissued as 'Teema' (1977–80), a classic of mid-century modern design.

Affordable, quality mass-market ceramics were not new. The 1933 'Praktika' service designed by Wilhelm Kåge (1889–1960)

and the 1936 'Sinivalko' tableware by Kurt Ekholm (1907–75) were both pioneering examples arising from the 'Funkis', or functional, movement in Scandinavian design. Franck's 'Kilta' range, however, went further by emphasizing a multifunctional approach – so much so that when they were first put on the market, the Arabia studio had to spell out to customers the advantages of this revolutionary break with domestic tradition. The heat-resistant earthenware pieces could be used for cooking and serving – oven to table. They were clean-lined and strongly coloured, suitable for any occasion whether formal or informal. Above all, they displayed all the humane simplicity that is the hallmark of Scandinavian modern.

Franck created designs of the utmost practicality, often removing unnecessary detail. For example, his plates have no flat decorative rims, to allow for easy stacking. The forms were based on pure geometric shapes (the circle, square and cone), which gave them a timeless appeal. Like many Finnish designers, Franck was inspired by his country's landscape, which is echoed in the glazing's blues, browns and yellow-greens. Also a noted glassware designer, Franck's famous 'Kartio' range (1958) for Iittala featured coloured tumblers, jugs and vases based on the form of the cone.

The 'Teema' range (1977–80), a redesigned version of Franck's original 1952 'Kilta' range.

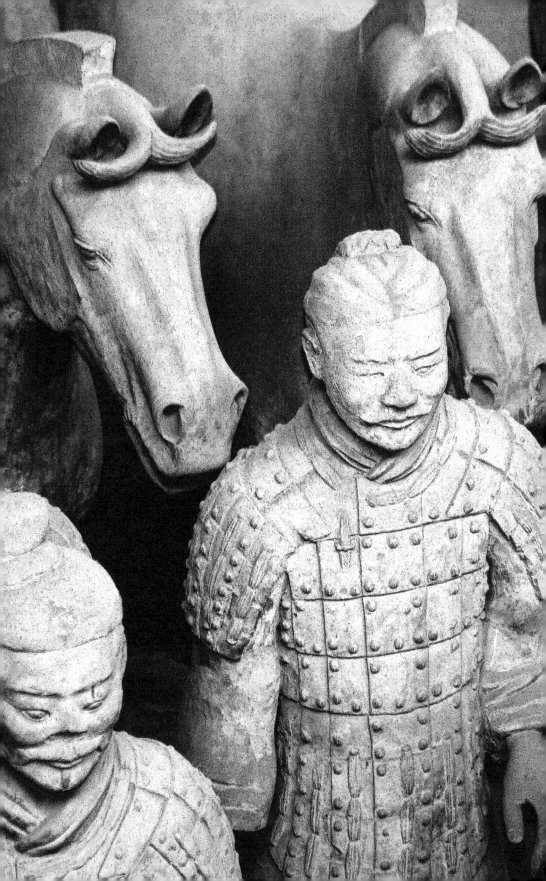

Ceramic Art

The boundaries between craft and art have long been contested. While some people maintain that certain materials – including ceramics – make a work craft rather than art, others suggest that it is all to do with how the maker learnt his or her skills. There are also those who say that something usable is a craft object, while something with no clear practical purpose can be called art. However, that does not take into account the decorative crafts, nor how all successful works of creativity demonstrate a high level of craft – or skill – in combination with imagination and artistic mastery. So the lines are always blurred, often contradictory, and seem to evade any definitive specifications. In a vast range of cultures, many ceramic objects have been made for little or no other function than to delight the eye, such diverse things as eighteenth-century porcelain garnitures, Delft tulipières or Meissen figurines, for example.

Ornaments and Figurines

Some of the earliest ceramic figures played a role in burial or other religious rituals, such as the ushabti or shawabti funerary figurines that were placed in ancient Egyptian tombs, or the first Emperor of China's Terracotta Army (see page 16). Centuries later, ceramic figurines were produced by various cultures purely as decorative objects.

From the late seventeenth century and through much of the eighteenth, in various areas of design, the styles of Baroque, Rococo and the Orient predominated. Lavish, exuberant ceramic ornaments and figurines were created to be displayed in bourgeois and aristocratic homes. Small figures or figurines became especially popular, usually made by slip casting (see page 66). As the moulds can be reused, slip casting enables detailed and intricate forms to be made repetitively, and porcelain in particular was ideally suited to the delicate and often elaborate styles of the time. The European interpretation of Oriental ideas became known as Chinoiserie, and included lattice and fretwork, pagodas, dragons and Chinese figures, often adorning plates, vases, ornaments and garnitures. Deriving from the French word garnir for garnish, garnitures were groups of decorative objects made as a set, usually in groups of three, five or seven, to be prominently displayed. The Chinese first created export porcelain garnitures and European porcelain makers copied the idea.

Left: The life-sized terracotta warriors and their horses have all been intricately made with individual expressions and extremely detailed armour.

After Meissen had discovered the secrets of porcelain manufacture in 1708, further porcelain factories proliferated across Europe, usually supported by wealthy backers. Many employed trained painters and sculptors to produce elegant art pieces, such as Johann Josef Niedermayer (1710–84) at the Vienna manufactory, and at Meissen, the painter Johann Gregor Höroldt (1696–1775), who developed a vibrant range of enamel colours, and Johann Joachim Kändler (1706–75), who produced figures in dramatic poses with draped clothing, theatrical gestures and a sense of movement. Heading the painting workshop of the Doccia porcelain manufactory, founded near Florence in 1735, was the Viennese porcelain painter Johann Carl Wendelin Anreiter von Zirnfeld (1702–47), followed by the Baroque painter Giuseppe Romei (1714–85), while local sculptor Gaspero Bruschi (1710–80) was the chief modeller. Using wax models and casts made by the Baroque sculptors Giovanni Battista Foggini (1652–1725) and Massimiliano Soldani-Benzi (1656–1740), the Doccia factory produced grand groups of porcelain figures. In Bavaria the Nymphenburg Porcelain Manufactory became famed for the work of its chief modeller, Franz Anton Bustelli (1723–63), who gained a reputation as the greatest of all the eighteenth-century porcelain modellers.

Each new porcelain manufactory aimed to outshine its rivals. In 1743 in Naples, the Capodimonte porcelain manufactory was founded by Charles VII, King of Naples and Sicily. Married to the daughter of the Elector of Saxony, he had seen the prolific porcelain production at Meissen and determined to emulate it. With the Florentine sculptor Giuseppe Gricci (c.1700–70) as chief modeller, the Capodimonte factory became famed for its detailed, delicate figures, tableware, vases and snuffboxes in soft-paste porcelain with subtle, over-glazed enamels. In England between 1743 and 1745 the Chelsea porcelain manufactory began producing soft-paste porcelain tableware and ornaments. Its ornamental figures, perfume bottles and thimbles, made from about 1760 and inspired by Sèvres porcelain, became highly sought-after.

Sèvres had originally been established in 1738 as the Manufacture de Vincennes. In 1756, largely due to King Louis XV's mistress, Madame de Pompadour, it moved to Sèvres, near her château. Initially known for its superior soft-paste porcelain that was usually signed and dated by the painter and often by the gilder as well, it contrasted with other manufactories where the artists generally remained anonymous. Hard-paste porcelain was introduced in 1769. Widely imitated, Sèvres porcelain was characterized by its intricate detailing and delicacy. During the eighteenth century the factory became famed for its bisqueware Rococo figures. In emulation, during the 1830s, Britain's Wedgwood company formulated Parian porcelain, a hard white soft-paste porcelain that resembled Paros marble and did not need glazing.

Repairing a bisque sculpture in a workshop
in the Sèvres factory, c.1914.

Edmund
de Waal
(b.1964)

Known for his large-scale installations of porcelain vessels and his bestselling books, Edmund de Waal took his first classes in ceramics at the age of five at the Lincoln School of Art. He was educated at The King's School in Canterbury and at 17 he began a two-year apprenticeship with the potter Geoffrey Whiting (1919–88), deferring his entry into the University of Cambridge. After making hundreds of pots, de Waal took up his place at Cambridge to read English, graduating in 1986, before going on to set up a pottery studio in Herefordshire. There he made functional stoneware pots in a style akin to Bernard Leach (1887–1979; see page 94), but he soon moved to Sheffield and began experimenting with porcelain. In 1990 he spent a year studying Japanese and

then travelled to Japan, where he worked and studied at the Mejiro Ceramics Studio while writing a monograph on Leach. He described the book, *Bernard Leach*, published in 1998, as 'the first "de-mystifying" study of Leach'.

In 1993 de Waal moved back to London, where he began producing distinctive porcelain vessels in various forms, mainly in classical shapes but with indentations and a pale celadon glaze, which became extremely sought-after. He also started to create large installations, predominantly with porcelain, which have been exhibited in various galleries and museums. Some of his work focuses on an interpretation of Song Dynasty porcelain styles, blended with modernist ideas, particularly inspired

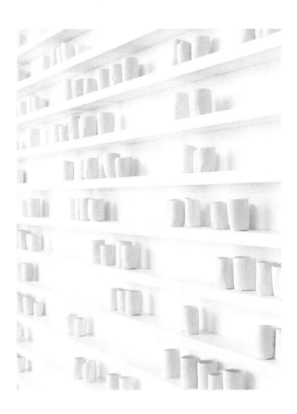

by the Bauhaus; many of his works are also inspired by music, architecture and literature. De Waal described a huge wall that he made, comprising hundreds of individual porcelain vessels: 'There are rhythms in that wall that completely come out of Baroque music.' He often creates groups or series of objects that function as one complete piece and has produced several major public commissions – for Tate Britain, Cambridge University and the V&A Museum in England, and the Kunsthistorisches Museum in Vienna, among others.

De Waal completed his Senior Research Fellowship in Ceramics at the University of Westminster in London in 2002. In 2010 his book *The Hare with Amber Eyes:*

A Hidden Inheritance was published, retracing the history of his Jewish relatives through stories about 264 Japanese netsuke that were handed down through his family and eventually given to him by his great-uncle. The book received critical and literary acclaim. In 2011 he was bestowed with an OBE, and he also published *The Pot Book*, an illustrated digest of 300 ceramic pieces. Four years later *The White Road* was published, offering an expressive account of the history of porcelain and exploring how the 'white gold' became an obsession for so many.

Detail of *breathturn, IV*; 2013, which comprises 336 porcelain vessels in an aluminium and plexiglass cabinet.

English hand-painted flatback Staffordshire figurines
of two Prussian generals, made in 1870.

In the nineteenth century, one of Meissen's chief modellers, Ernst August Leuteritz (1818–93), modernized and reissued many Rococo figurines. They were popular with industrialists, merchants and bankers, who ostentatiously displayed their newly established wealth in extravagantly appointed homes. The figures and ornaments were characterized by lacework details (made from actual lace dipped in slip and then fired), exaggerated draped fabrics and the 'snowball technique' – a method of applying multiple tiny flowers. One of the most popular styles of figurine, first made at Meissen and then at other porcelain manufactories that opened in and around Dresden, became known as Dresden shepherdesses. These were delicate, detailed figurines, fashionably attired in 'country clothes' and idealized, with pink cheeks, styled hair and coy gestures. They included young men as well as young women.

Gradually, figurines and ornaments became pared-down as designers and artists reacted against the excesses of the Baroque and Rococo styles. Reflecting the classical elements of ancient Greece and Rome, the more austere approach later became called Neoclassicism. More ceramics were also mass-produced and, as the birthplace of the Industrial Revolution, England became one of the largest and most renowned pottery-producing centres in the world, particularly Stoke-on-Trent in Staffordshire. Ornamental figures began to be produced for the mass-market, often with unpainted flat backs, as they were made to be displayed on mantelpieces and shelves. At first, most flatback figures were colourfully over-glazed, but by the 1870s they were more frequently white, with some gilding applied after firing.

Towards the end of the nineteenth century, flowing Art Nouveau styles pervaded all forms of design and many potteries capitalized on the trend for lithesome female figures. Inspired by Japanese stoneware on display at the Paris Exposition Universelle in 1878, sculptor Jean-Joseph Marie Carriès (1855–94) began creating his own stoneware figures of pagan gods, biblical figures, mythical creatures and street urchins. His work initiated a new interest in stoneware. More ceramicists also began using earthenware instead of porcelain and experimenting with new types of glaze, such as flambés, which often produced streaked or speckled finishes. In 1898 sculptor Agathon Léonard (1841–1923) produced fifteen bisque-porcelain figures based on the exotic scarf dancer Loïe Fuller for the 1900 Paris Exposition Universelle at the Pavillon de Sèvres. Iridescent and lustre glazes were used abundantly to complement the sinuous styles.

Left: This late-nineteenth-century hand-painted terracotta bust was designed by French artist Auguste Leveque (1866–1921) and crafted at Vienna's Goldscheider Porcelain Manufactory.

In Vallauris, in southern France, the Massier family pottery had been producing lead-glazed decorative ware for decades. In the 1880s Clément Massier (1845–1917) set up on his own at Golfe-Juan on the Côte d'Azur, where he experimented with a dramatic copper oxide flambé that had originated in China during the Song Dynasty (960–1279 CE). He used an original, intensely vibrant colour palette on his majolica, including hot pink, speckled turquoise, yellow-orange, deep purple, pale green and peacock blue.

In 1885 Friedrich Goldscheider (1845–97) founded the Goldscheider Porcelain Manufactory and Majolica Factory in Vienna, which subsequently extended to various other cities and became one of the most influential ceramic manufactories of the time producing terracotta, faïence and bronze objects, particularly in the fashionable styles of Art Nouveau and then Art Deco. Goldscheider employed a large number of artists, including the famed sculptors Josef Lorenzl (1892–1950) and Stefan Dakon (1904–92), and ceramic artists Michael Powolny (1871–1954) and Vally Wieselthier (1895–1945).

Studio pottery

In 1856, when all around ceramics were being mass-produced, Joseph-Théodore Deck (1823–91) established his own faïence workshop in Paris, where he began experimenting with styles and technology, laying the ground for the art – or studio – pottery movement that quickly followed. Following the Arts and Crafts movement that had started in Britain with William Morris (1834–96), who reacted against the overly embellished or cheaply produced machine-made goods that had come to dominate the market, the studio pottery movement became widespread in Europe and the United States from the late nineteenth century. Like the Arts and Crafts designers, studio potters rejected industrialization and followed the medieval pattern of small workshops, with craftsmen and women making goods by hand through all stages, taking pride in their work and producing individual items or small runs. As time passed, increasing numbers of individual workshops opened, inspired by further diverse and international influences, such as the Bauhaus – the pioneering German art and design school founded in 1919 and closed by the Nazis in 1933. Many studio potters helped spread the ideas widely through their teaching positions in several major international art schools.

In 1988, recalling the days working with Hans Coper until 1958, Lucie Rie said: "I am a potter, but he was an artist." Although their styles were different, they complemented each other.

Lucie Rie

(1902–95)

Born in Vienna, Lucie Rie was educated at home. At the age of 20 she entered the Kunstgewerbeschule, a school of Arts and Crafts attached to the Wiener Werkstätte, which had been founded in 1903 with the intention of bringing good design and craft into all areas of life. Rie was taught by Michael Powolny (1871–1954), who worked for the Goldscheider Manufactory. Her work attracted the attention of Josef Hoffmann (1870–1956), one of the co-founders of the Wiener Werkstätte, who sent some of her pots to the Exposition des Arts Decoratifs et Industriels Modernes in Paris in 1925 – the exhibition that propelled Art Deco to the forefront of design.

In the late 1930s, to escape the Nazis, Rie left Austria for Britain. She established a small workshop near Hyde Park in London and began producing delicate, angular pots in stoneware and porcelain, some decorated with sgraffito. Her inspirations included an uncle's collection of ancient Roman pottery, visits to France and Italy, and Wiener Werkstätte ideals of harmonious design. Initially her lack of access to a kiln forced her to raw-glaze her pots – or to apply glaze to unfired clay and then fire them together. This one-firing process later became an essential feature of her pottery.

In 1946 Rie hired the young Hans Coper (1920–81) to help fire the ceramic buttons she had been making to earn money during and just after the Second World War. Soon they began collaborating on more creative ceramics, and Rie made Coper a partner.

He continued to work with her until 1958. Together, they produced tea and coffee sets and other tableware that reflected the pared-down tastes Rie had absorbed at the Kunstgewerbeschule. The pottery was elegant, austere and thin-walled, produced in a limited range of neutrals, including dark brown, beige, black, grey and white.

While Rie admired the philosophies of her friend Bernard Leach (1887–1979; see page 94), her delicate, modernist ceramics contrasted strongly with his more subdued, Oriental-inspired work. In 1951 she was invited to exhibit at the Festival of Britain – a national exhibition held to promote the British contribution to science, technology, industrial design, architecture and the arts – and she was subsequently commissioned to supply tableware for Heal's department store. As her style and Coper's began to diverge, he left; her work continued, delicate and glazed to give a rugged, pitted surface, and often brightly coloured, including vibrant blues, greens and yellows. She sometimes incised her work, then applied glaze and wiped it off, creating a textural appearance. From 1960 until 1972 she taught at London's prestigious Camberwell College of Arts, but she never enjoyed teaching, always preferring to explore new forms, textures, glazes and decoration.

This delicate blue bowl with a gold-glazed rim reflects Lucie Rie's fascination with ceramics of the East.

One of the first artist-potters, Deck explored historical processes, reinterpreting them for modern ceramics. He investigated forgotten Renaissance practices and the elusive iridescence of Iznik pottery. He succeeded in devising a vivid palette of glazes and obtaining a spectacular luminosity similar to that found in many Islamic ceramics. In 1861 Deck presented his first 'Persian' faïence at the Exposition des Produits de l'Industrie Française in Paris, and the following year he introduced metallic lustre glazes that he had developed after seeing Hispano-Moresque – or Andalusian – wares at London's 1862 International Exhibition.

Ernest Chaplet (1835–1909) was another pioneering studio potter. After beginning his career as a decorator at a firm that manufactured earthenware, painted ware and majolica, he developed 'barbotine decoration', a method of painting earthenware with slip that resembled the impasto paint applications of the Barbizon and Impressionist artists. From 1886 until 1895 the painter Paul Gauguin (1848–1903) often worked with him, decorating Chaplet's stoneware with Breton scenes in distinctive coloured glazes with dark outlines.

The studio pottery movement was particularly strong in Britain. Bernard Leach (1887–1979) was a British studio potter who had studied art in London and ceramics in Japan (see page 94). From 1920 he set up a studio at St Ives in Cornwall with the Japanese potter Shōji Hamada (1894–1978). The two created handmade pottery inspired by traditional Japanese, Chinese and Korean ceramics, combined with Western techniques such as slipware and salt-glazed wares. Published in 1940, his book, *The Potter's Book*, became essential reading for a generation of potters and Leach's influence was resounding. Hans Coper (1920–81) joined the London workshop of Lucie Rie (1902–95) from 1946 until 1958. Although their styles differed, they influenced and collaborated with each other. Coper usually worked on a potter's wheel, then altered pieces by hand to achieve his often abstract forms. Although his work is generally functional, it became increasingly sculptural. In 1958 he set up his own studio, where he produced distinctive and unusually shaped pots, often with rough textures and a range of intense colours. He was one of many studio potters who also taught in colleges, and the far-reaching influence of these artists gave the movement an even greater impetus.

Meanwhile, in the United States many potters built on the ideas of the Arts and Crafts movement but also reflected several new fine art movements that were developing. After collaborating with the Dada artist Marcel Duchamp (1887–1968) and writer Henri-Pierre Roché (1879–1959) on the publication of an avant-garde journal, *The Blind Man*, artist Beatrice Wood (1893–1998) enrolled in ceramics classes in the 1940s. She dedicated the next 50 years to creating imaginative pottery showing diverse influences including folk art and modernism in both bright and earthy coloured glazes. Finnish-born Maija Grotell (1899–1973) studied painting and

sculpture before ceramics. After moving to New York in 1927, she made large ceramic vessels decorated with innovative coloured slips and glazes, including a vivid blue produced from copper oxide. Her success as a studio potter augmented her teaching at several colleges, and after becoming the head of the ceramics department at the Cranbrook Academy of Art in Michigan, she was often described as 'the mother of American ceramics'. Henry Varnum Poor (1887–1970) was an American architect, painter, sculptor, muralist and self-taught potter, who produced hand-painted, sgraffito-decorated pieces, while Otto Natzler (1908–2007) and his wife Gertrud (1908–71), who had emigrated from Austria to Los Angeles just before the outbreak of the Second World War, produced some of the most admired artistic ceramic pieces of the period. Gertrud was primarily the potter, while Otto glazed and painted.

By the twenty-first century, studio pottery had become established. No longer a rebellious movement opposing industrialization, it had become a powerful part of the ceramics and art industries, with many artist-potters continuing to experiment with glazes and approaches, producing both functional and decorative ware.

Fine art

When Ernest Chaplet invited Paul Gauguin into his studio to paint, Gauguin became fascinated by Chaplet's art and the process of making pottery. He began making his own coil pots and went on to produce more than 300 ceramic pieces, including, for instance, Dish of 1887–8. For Gauguin, it was a work of art more than a practical vessel, and he was just one of countless artists who used pottery as an expressive form of art rather than a functional item. For him, as for innumerable others, ceramics was a form of sculpture.

Pablo Picasso, for example, became entranced by the feel and possibilities of clay and used it to shape and express his ideas (see pages 210–11). Similarly, his friend and colleague Georges Braque (1882–1963) developed an interest in ceramics and worked with the Spanish artist-potter Josep Llorens Artigas (1892–1980), who also collaborated with Picasso, Joan Miró (1893–1983) and Raoul Dufy (1877–1953). Artigas, 11 years younger than Picasso, had also moved from Barcelona to France, where he opened a studio in Paris, attended the Sorbonne and wrote a thesis on Egyptian pottery and especially Egyptian blue glazes. He worked with Picasso during the 1920s and in the following decade worked closely with Braque, Dufy and others, creating expressive, individual works of art. During the 1950s he collaborated with Miró at his studio near Barcelona. The two made over 200 ceramic works, which were exhibited in New York and Paris. In 1957 they were jointly commissioned to create a tiled mural for the UNESCO Headquarters in Paris, The Wall of the Moon, which won them the Guggenheim International Award the following year.

Pablo Picasso
(1881–1973)

In 1946 Pablo Picasso was holidaying in Vallauris in the south of France, a location rich in clay deposits with a history of ceramics stretching back to the ancient Roman era. After visiting the annual ceramics fair there, he became entranced by the medium and soon began working with the potters Georges (1901–76) and Suzanne Ramié (1905–74) at their factory. Picasso experimented with the possibilities of the clay, the colours and textures of different glazes and methods of application, and creative forms. His input at the Ramiés' factory varied: he painted or decorated their plates and dishes; took their vases straight from the wheel and reshaped them into creative, unexpected forms; and made his own pottery from start to finish. Within a short time he had created some

extraordinary and unique pieces, and his presence at Vallauris boosted the prestige and tourism of the small town.

Between about 1947 and 1948 Picasso produced around 2,000 items of ceramic art. Some were household objects, such as plates and bowls; others were spectacular works of art, including vases and figurines. Many pieces were sinuous and curving, while others were more robust, often witty, and featuring elements of art of the past. Some were innovative interpretations of ancient Greek jugs and vases. Others were anthropomorphic or zoomorphic, resembling figures, horses, bulls, goats and doves, for instance. And while some of his ceramics parody the black and red vases of classical Greece, or depict creatures

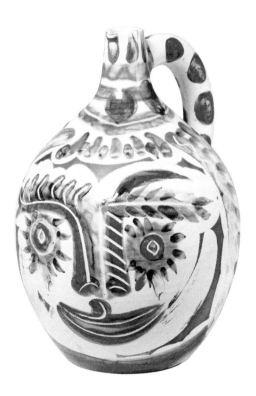

from mythology that had first appeared in some of his paintings in the 1920s, others take influence from French folk pottery. Flowers and food were frequently featured in his painted embellishments, while other decorations were more abstract. Some pieces made reference to Cubism, which Picasso had invented with Georges Braque (1882–1963) earlier in his career. One Cubist experiment, for instance, involved a pottery collage with parts of different vessels joined together to create something new. And, as he did in his paintings, he often created ceramic expressions of his current *amour* in a variety of styles.

Arguably the greatest artist of the twentieth century, Picasso was a prolific painter and printer, and after he 'discovered' clay, he became a prolific potter. In around 1950, when his ceramics were first exhibited, they were dismissed by influential potters, including Bernard Leach, and viewed with embarrassment by the art world. Despite this disdain, a young generation of English potters were impressed by his free, spirited style, his respect for materials and the past, his disregard for convention and range of approaches. For the rest of his life, he combined his energetic production of ceramics with painting, printmaking and sculpture, and they now form an integral part of his total body of artwork.

Partially glazed, this laughing-eyed face pitcher was produced by Picasso in Vallauris in 1969.

For many artists, ceramics has been a powerful creative medium. London-born William Staite Murray (1881–1962) contrasted with many other studio potters. Influenced by contemporary avant-garde art, he studied pottery at Camberwell School of Arts and Crafts and then set up his own workshop in London. Aiming to create pottery that was seen as equal to painting and sculpture, he always regarded his work as fine art, rejecting functionality with his individual pieces of stoneware. He was a member of the Seven and Five Society of painters and sculptors, who formed after the First World War, aiming to focus on traditional art in regular exhibitions.

Just two years before the Seven and Five Society formed – in 1917 – one of the most influential works of art ever was presented by Marcel Duchamp. *Fountain* was a gentleman's porcelain urinal, turned upside down and signed 'R Mutt'. Duchamp submitted it for the exhibition of the Society of Independent Artists, but even though the rules stated that all works would be accepted from artists who had paid the Society's fee – and Duchamp had – it was rejected. Initiating Conceptualism, which became one of the most significant art movements of the twentieth and twenty-first centuries, *Fountain* changed the direction of art.

Another artist whose ceramic work has often been controversial and has changed both attitudes and approaches is Grayson Perry (b.1960, see pages 216–17). Winner of the prestigious 2003 Turner Prize, Perry produces elegant and colourful fine art pottery, reminiscent of the forms of ancient Greece but with contemporary and often disquieting messages. In 2011–12 he combined his own works with historical artefacts from the British Museum collection in a highly acclaimed exhibition at the London museum, called *The Tomb of the Unknown Craftsman*.

The diversity of clay continues to be explored for its broad scope. For 20 years, from 1963 to 1983, Troika art pottery was made in Cornwall by Leslie Illsley, Jan Thompson and Benny Sirota. The name derives from the Russian, meaning 'a set of three', and their intention was primarily to create pottery art, with less concern for function. Through the Cornish summer tourist trade and lucrative contacts with some London department stores, Troika pottery became known for its creative and distinctively designed earthenware vases, lamp bases, tableware, tiles and wall plaques made with plaster moulds and decorated with muted, flecked colours and abstract designs.

Between 1989 and 2003 the British sculptor Antony Gormley (b.1950) created *Field* (see overleaf). This comprised seven installations in seven locations of thousands of tiny naïve-looking clay figures, with only the addition of simple, deep-set 'eyes' to make them appear human. While the earliest two installations were arranged with the figures facing inwards in concentric circles, the subsequent works became denser, with the figures filling the entire installation space and requiring up to 125 tonnes of clay to produce. The individual figures are about the size of a hand,

A stoneware vase made by Josep Llorens
Artigas and Joan Miró, 1941.

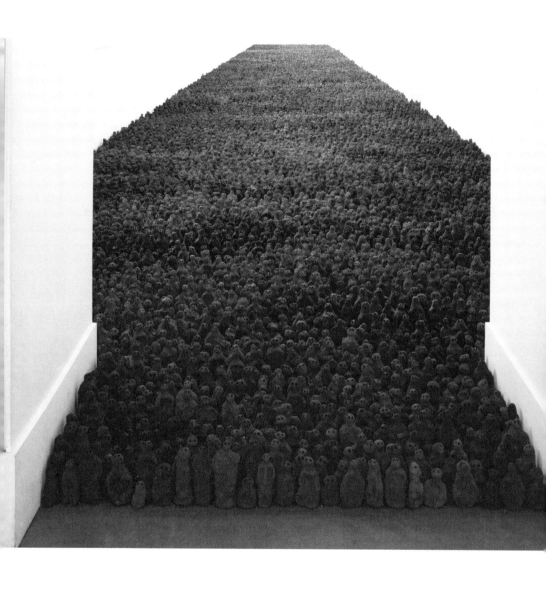

Field For the British Isles (1993), by Antony Gormley, installed in the
Irish Museum of Modern Art, Dublin. Gormley says of his project:
'From the beginning I was trying to make something as direct as
possible with clay: the earth...'

and are positioned with all the eyes facing in one direction. The powerful physical presence conveys a message about our responsibilities for the world and its future. Although each installation was originally designed for and displayed in a specific location, they have all since been on display in numerous different locations and are still shown around the world today (except for *Field for the Art Gallery of New South Wales* which has remained in the gallery).

Although Edmund de Waal (b.1964; see pages 198–99) insists he simply makes pots, his internationally acclaimed and exhibited elegant work in porcelain, often large-scale installations, can really only be described as fine art. An example is his 2013 *Atemwende*, (*Breathturn*), after a 1967 poetry collection by Paul Celan (1920–70). The work comprised a series of large black aluminium display cases containing porcelain vessels arranged in various rhythmic sequences. The black-and-white work deliberately suggested the sequences and patterns of a musical score.

Repeatedly proving that pottery is both craft and fine art, artists' provocative use of clay in original and creative ways continues to surprise and shock. Compelled by his social conscience, the artist and writer Ai Weiwei (b.1957) often delves into his Chinese heritage, frequently recycling historical materials, such as Han Dynasty porcelain vases, and uses traditional methods to amalgamate ancient and modern aesthetics. In 2010 he created *Sunflower Seeds*, pouring 100 million handmade life-sized porcelain sunflower seed husks into Tate Modern's vast Turbine Hall. As each seed was individually sculpted and painted by specialists in workshops in Jingdezhen, it invites viewers to consider the circumstances of porcelain workers in Chinese factories. In an artwork of 2015, *Remains*, Ai again used Chinese porcelain to replicate some bones, believed to be human, that were excavated at the site of a labour camp in operation under Chairman Mao in the 1950s.

Grayson Perry
(b.1960)

After winning the prestigious Turner Prize in 2003, Grayson Perry shot to fame for his classically styled, elegant pots with their uncomfortable scenes of issues he perceives to be inherent in society. He has become almost as well known for his sub-personality Claire, as he often dresses in girly outfits with bright, overt make-up.

Born in Chelmsford, Essex, Perry often absorbed himself with his fantasy life in an attempt to escape from his stepfather's violence. It was a world of imagination and wars, with his teddy bear, Alan Measles, as the central hero. After a conventional education at the King Edward VI Grammar School, he took an Art Foundation course at Braintree College of further education and then a BA in fine art at Portsmouth

Polytechnic. An exhibition of 'Outsider art' in London in 1979 greatly influenced him. It comprised pictures and sculptures by people with no formal art training; many living outside conventional society and some mentally ill, eccentric or reclusive. Perry was drawn to the work of reclusive, obsessive, eccentric American artist Henry Darger (1892–1973).

In 1982 Perry joined a pottery class and became fascinated by the subject, particularly by its folk art and classical associations. Working with the traditional coiling method, he began producing large, classically shaped, delicate-walled pots, adorned with sgraffito drawings, texts – both handwritten and stencilled – photographic transfers and colourful

under-glazes, glazes and lustres. The decoration and imagery includes figures, maps and family trees, and alludes to dark subjects such as environmental disasters, political conflicts, child abuse, bondage and sadomasochism. Many also convey episodes from Perry's childhood, Claire and Alan Measles, and the longstanding art-versus-craft debate, particularly over pottery. The incongruity between the elegant forms, bright colours and often shimmering glazes of his ceramics and the controversial images and messages that adorn them is intentionally challenging and paradoxical. Yet Perry presents these ideas with a range of expression, from wit and nostalgia to fear and anger. Symbolism is often incorporated to suggest absurdity and arouse curiosity.

Every pot is unique, and he tries out his ideas as he is making each one, rather than experimenting beforehand. So he might work with new colours, a different glaze or transfer application on a final piece, and he often applies a gold lustre to cover up any mistakes. Continuing the craft-art issue, he also creates artwork using other traditional craft methods of embroidery and tapestry. In 2012 he was made a Royal Academician; in 2013 he received a CBE; and in 2015 he was made a Trustee of the British Museum and Chancellor of the University of the Arts London.

World Leaders Attend the Marriage of Alan Measles and Claire Perry, Grayson Perry, 2009.

Glossary

Alchemy – a form of chemistry and philosophy practised from the fifth to seventeenth centuries and perceived by many contemporaries as a form of magic.

Barbotine – an industrial decoration technique commonly referred to as slip trailing, applied to the surface of a leather-hard pot.

Baroque – a style of art produced from the seventeenth to the early eighteenth centuries that portrayed biblical stories with exaggerated tonal contrasts and dramatic gestures to create tension, exuberance and grandeur and promote the Catholic Church.

Bisque/biscuit firing – the first firing, done to prepare pottery for glazing.

Blunge – to form a suspension by mixing clay with water.

Bone china – an extremely white body made in imitation of porcelain, with a fixed recipe of china clay, bone ash and Cornish stone.

Casting slip – liquid clay for use in plaster moulds. Formed by adding chemicals to clay to create fluidity (unlike decorating slip which is clay mixed with water).

Delftware – English term used to describe the blue-and-white earthenware and tin-glazed pottery made in and around Delft in the Netherlands.

Earthenware – pottery fired to a relatively low temperature. The body remains porous and usually requires glazing if it is to be used for food or liquids.

Enamels – also known as on-glaze, over-glaze or china paint, these are low temperature colours containing fluxes, usually applied on top of a fired glaze. They require a further firing to render them permanent.

Feldspar – a naturally occurring mineral consisting of alumina, silica and a flux of potassium or sodium.

Fluxing materials – these lower the melting point of silica and so are essential in glazes. They are made of oxides, each having its own characteristics that interact with other components in glazes or clay bodies.

Garniture – a set of decorative ornaments or accessories.

Glaze – a thin, vitreous coating on clay objects that is fired to fuse it to the surface. It is applied as decoration and/or to make the item waterproof.

Greenware – unfired pottery which has dried to a point firm enough to handle without distortion, but remains damp enough for other wet clay to be attached.

Grog – Crushed or ground fired clay that is added to clay bodies to give texture or 'tooth', reduce shrinkage and warping and to increase strength.

In-glaze – ceramic colours applied on top of an often unfired glazed surface, which sink into the glazed surface when fired. The colours can include metallic oxides, stains or coloured glazes.

Kaolin – also called china clay, a pure white substance with few impurities and low plasticity.

Kneading – manipulating clay to distribute moisture evenly and prepare it for use.

Leather hard – the stage during the drying process when clay becomes firm and no longer pliable, but is still damp enough to join other parts to it using slip and without it becoming distorted.

Lustre – metallic surfaces on glazes derived from precious metals. They can be applied to unglazed surfaces and must undergo reduction firing.

Maiolica – tin-glazed ware decorated with oxides or underglaze colours on a white opaque background, such as Delft, faience and galleyware.

Molochite – pure white porcelain grog made from firing raw, low-iron china clay to high temperatures.

On-glaze – also called enamels, china paint or over-glaze, these are oil- or water-based colours made of a soft melting glass and metal oxides.

Overglaze – see Enamels and Onglaze.

Oxide – the combination of an element with oxygen. Basic oxides are metals, while acid oxides are non-metals.

Plasticity – the workability or flexibility of a clay body, which is influenced by the clay's particle size and water content.

Pug mill – a piece of equipment that compresses and mixes plastic clay to a homogeneous state. If the clay is used immediately, it does not need to be wedged or kneaded.

Raku – a low-firing technique that involves removing fired work from a red-hot kiln and reducing it in a combustible material such as sawdust.

Reduction firing – the process of denying oxygen to the kiln during the firing process. Oxygen is instead drawn from the pottery and its glazes, resulting in dramatic transformations of colour.

Rib – a wooden or plastic smooth tool used to apply even pressure when throwing.

Rococo – eighteenth-century style of design and fine art that originated in France, characterized by elaborate, graceful elements and often featuring asymmetrical patterns and shapes.

Sgraffito – from the Italian word *sgraffire*, this describes cutting or scratching through an applied coating of colour, such as slip or glaze, to reveal a different-coloured body beneath.

Slip – clay mixed with water to a thick, fluid consistency that can be used for decorating, such as slip trailing.

Slurry – a mixture of clay and water, made from pieces of bone dry clay, used as 'glue' for joining clay pieces together.

Under-glaze – colour usually applied to greenware or bisque-fired pottery, often with a transparent glaze on top.

Vitrification – firing so that clay particles fuse together and become vitreous – so durable and waterproof.

Wax resist – a masking technique involving the application of wax to bisqueware before applying a glaze. The wax is later melted, leaving the area free of any glaze.

Wedging – a method of combining clays of different types or consistencies and introducing additions such as grog, done by cutting and slapping together alternating layers until fully mixed.

Places to Visit

Victoria and Albert Museum, London
www.vam.ac.uk
The finest collection of ceramics in the world, with pieces dating from 2500 BCE to present day. Highlights include ceramics from China, Japan and the Middle East, Italian Renaissance majolica, Dutch Delft, British and European porcelain, 19th-century art and exhibition pieces, modern studio ceramics and tiles. Over 3,000 objects on display and 26,000 viewable by appointment.

British Museum, London
www.britishmuseum.org
Ceramics from all cultures and periods, including a gallery dedicated to Ancient Greek pots and a new gallery housing the superb Percival David collection, 1,700 of the finest Chinese ceramics dating from the third century to the twentieth.

The Wallace Collection, London
www.wallacecollection.org
Large collection of 18th-century Sèvres porcelain.

Leighton House, London
www.leightonhouse.co.uk
Home of Victorian artist Frederick, Lord Leighton, and designed and built to his specification, the house features superb tiled rooms lined with Leighton's collection of Islamic tiles, and tiles specially commissioned from William de Morgan.

Museum of London
www.museumoflondon.org
Over 20,000 pieces from the Neolithic period to the present day. London factories making porcelain are well-represented.

Crafts Council, London
www.craftscouncil.org.uk
Collections and exhibitions of contemporary ceramics.

Ashmolean Museum, Oxford
www.ashmolean.org
Fine collection of pottery and porcelain, including Ancient, Chinese, Japanese, European and English examples

The Fitzwilliam Museum, Cambridge
www.fitzmuseum.cam.ac.uk
Important collection of European, Middle Eastern and Far Eastern ceramics. Tableware, tiles, vases and sculptures in both earthenware and porcelain, including iznik, majolica, Delft, Ming, Imari, Meissen and Chelsea.

Waddesdon Manor, Aylesbury, Bucks
www.waddesdon.org.uk
The home of the Rothschild Collection of decorative art and paintings, ceramics include Sevres, Meissen and sixteenth-century majolica. Modern ceramic artists exhibit regularly, including Edmund de Waal and, more recently, Kate Malone, judge on *The Great Pottery Throw Down*.

Brighton Museum and Art Gallery
www.brightonmuseums.org.uk
Features Willett's Popular Pottery, 2,000 novelty ornaments, jugs, cups and figurines collected in the late nineteenth century.

Wightwick Manor, Wolverhampton
www.nationaltrust.org.uk/wightwick-manor-and-gardens
Collection of William de Morgan tiles and ceramics displayed in Arts and Crafts interiors.

Coalport China Museum, Telford
www.ironbridge.org.uk
One of the ten Ironbridge Gorge Museums, the china museum has a collection of Coalport and Caughley china and holds demonstrations and workshops in the original factory.

Lady Lever Art Gallery, Liverpool
www.liverpoolmuseums.org.uk
Wedgwood and Chinese porcelain collections.

Middleport Pottery, Burslem, Stoke
www.middleportpottery.org
Visitor attraction featuring factory and bottle kiln tours, demonstrations and workshops.

Wedgwood Museum, Barlaston, Stoke
www.wedgwoodmuseum.org.uk
Superb collection of Wedgwood products, demonstrations and lectures.

The Potteries Museum & Art Gallery, Stoke
www.stokemuseums.org.uk
The world's best collection of Staffordshire pottery.

The Royal Crown Derby Porcelain Museum, Derby
www.royalcrownderby.co.uk
Museum featuring extensive collection of Derby figures and wares, factory tours and demonstrations.

Museum of Royal Worcester, Worcester
www.museumofroyalworcester.org
Over 10,000 pieces of Worcester porcelain from all periods

Shugborough Hall
www.shugborough.org.uk
A working estate. Collection includes rare porcelain brought from China by Admiral Lord Anson, the 'Father of the British Navy', and eighteenth-century Meissen.

Picture Credits

Index